PRAISE FOR *for all the small schools*

"HISTORY IS LOST unless it's recorded. Dave and Barb Else have a keen eye and ear for the details of Iowa school life across recent decades. This book is a labor of love that will spark fond memories for many Iowans who will enjoy reminiscing with friends and sharing stories with their kids and grandkids about the local school as not only a place of education, but also as a community center and social hub."

- U.S. Senator Chuck Grassley of Iowa

"A FANTASTIC BOOK! If you live in Iowa or have lived in Iowa, this book is a must. It will bring back many fond memories—at least it did for me—as I remember being in some of these buildings. The school was certainly the center of daily life in 'small-town' Iowa. The pictures are great, and some of them will put a smile on your face. I thank Barb and Dave for making this book possible, and I guarantee that you also will love this book."

- Bernie Saggau, retired executive director of the Iowa High School Athletic Association

"I CAN NEVER QUITE DECIDE how I feel when I stop outside old abandoned, or converted, school buildings in Iowa. Do you focus on how sad they look now, especially if they are sitting in ruins? Or do you enjoy the thought of how much life and spirit they once held? Dave and Barb Else, career educators who are fans of all things Iowa, have had those same feelings while visiting hundreds of those old schools around the state. In *For All The Small Schools*, the Elses share their photographs and some of the stories they found out there. They will have you smiling, occasionally wincing, and maybe even shedding a tear. Their book is an important and entertaining addition to the printed history of the state."

– Chuck Offenburger, former Des Moines Register *"Iowa Boy" columnist*

for all the
small schools

for all the small schools

a photographic pursuit
of Iowa's forgotten schools

WRITTEN & PHOTOGRAPHED
BY BARB & DAVE ELSE

ISBN: 978-0-9916528-1-5

Published and printed in the United States of America by the Write Place. Cover and interior design by Alexis Thomas, the Write Place. For more information, please contact:

the Write Place
709 Main Street, Suite 2
Pella, Iowa 50219
www.thewriteplace.biz

Copies of this book may be ordered from the Write Place online at
www.thewriteplace.biz/bookstore.

Schools shown in the cover artwork: the Wyman school building, Henry County (front cover, top); center court, New Providence Roundhouse Gymnasium (front cover, bottom); and the Numa school building, Appanoose County (back cover).

Photo on page 142 courtesy of Jana Huebsch, clerk, City of Mitchell, Iowa.
Photo on page 227 courtesy of McCallum Museum/Brunson Heritage House, Sibley, Iowa.

DEDICATION

For *All the Small Schools* is dedicated to our children: Jim and Linda Else, Jennifer and Jeff Hartman, Travis and Julie Else, and Tucker and Marchelle Else. All are products of Iowa's schools. They had the opportunity to grow up and develop through the dedication and nurturing nature of Iowa school teachers and leaders.

Additionally, energy and excitement we enjoyed while putting the book together is dedicated to our grandchildren: Aubree, Savannah, Jacob, Lauren, Ian, Sophie, Tamrick, Brennan, Alloree, Luke, Annie, Isaiah, Kianna, and Andenet. Each is either currently learning in Iowa schools or will be shortly.

Finally, this book is dedicated to all those Iowa teachers and school leaders who have devoted their lives to the young people of this state.

TABLE OF CONTENTS

Introduction

by Barb Else

Our quest to discover Iowa's forgotten high schools began by chance as we traveled through Indiana one summer. Growing up in the Iowa towns of Treynor, Villisca, Greene, Whitten, Holstein, Atlantic, and Cedar Falls, our four children competed in sports and music throughout junior high and high school. Before each basketball game, our family would watch the movie *Hoosiers*, based on the story of the small school in Milan, Indiana, advancing on to the state basketball tournament, winning the championship against huge Muncie High School in 1954. After watching this movie many times with our children, we decided to try finding the old school. We phoned our son Jim, an optometrist in Oskaloosa, and he pointed us in the direction of Knightstown, Indiana, where the gym in which *Hoosiers* was filmed is located.

The town of Knightstown is small and the school was easy to find. It is a handsome, brick, two-story building, similar to many schools built in Iowa in the early to mid-1900s. The front doors were locked, so we peeked in the windows, and it was there that we discovered cases filled with trophies from years of sports glories past.

Years of practice, competitions, defeats, and victories earned by young men and women throughout their four short years of high school. Years when the small towns closed their businesses and did chores early so they could get to the gymnasium for the tip-off. Years when spectators piled onto wooden bleachers, bought a bag of popcorn, and cheered for their school, the backbone of the town.

When we returned home from the Indiana trip, we began reminiscing about our old school in Sibley, where we graduated in 1963. The school burned to the ground in the '70s, and so the old gym where we played basketball and cheered, joined our friends for pep rallies, and attended homecoming was just a photo in our yearbook. While we talked about the many schools across Iowa that had closed, Dave was thumbing through a program he'd kept from the 1958 boys state basketball tournament and noticed that most of the small schools that played then no longer exist today. Schools like Keystone, Calumet, Russell, Hospers, St. Mary's, Lowden, Joice, and Macksburg.

Our decision to strike out across Iowa to photograph the state's old schools truly began taking shape in May 2000. Living in Cedar Falls, our pursuit of old schools began in northeast Iowa. Following an Iowa map, we drove from town to town searching for a large building, usually brick, standing on either the east or west end of town. This process served us well for many years; however, much time was wasted

if the school was no longer standing. About five years ago we began contacting reorganized school districts throughout the state inquiring if there were any old schools left in the district. This saved hours of time.

We found that some schools are in very good shape but sit idle. Some are in fair shape but are used for something else. Some are in disrepair. Some are gone. Sometimes although the schools are gone, the gyms remain. Is that because the gym was where young and old gathered to visit, cheer, and show pride in their school and in their town? Townspeople often still use the gyms for community or recreation centers.

Many of Iowa's old schools have been put into further service, but many are surrounded by trees and weeds, fallen bricks, and broken glass. Buckeye's gym is now the fire department while Ellsworth makes use of its school as a community center. Lakota has done a beautiful job constructing a banquet center and apartments. The school in Lamont is now home to the Lamont Sign Company. An antique mall occupies space in Marquette's building and Moorland uses its old school as a computer center. The Newkirk School now houses apartments, and in Rockwell City, the old school is the Calhoun County Museum. The Rodman School is now home to the person to whom it was sold, and the U.S. Post Office has been added onto the school in Stanley. When the high school closed in Stanley in 1958, it was known

to have the largest fleet of buses in Iowa. The Swaledale School is now a manufacturing company.

The school in Harvey was dedicated in memory of the deep vein coal miners, while Lovilia High School, located in the coal mining center of Iowa, stands alone near a beautiful pine tree. New Providence's roundhouse gymnasium was built in 1936 as a Works Progress Administration (WPA) project. The WPA was started in 1935 under Franklin D. Roosevelt. The school has been lovingly cared for and placed on the Historic Register along with the stately school in Lansing. In What Cheer, the brick school museum is open on the Fourth of July.

This book contains photos of these schools and many others throughout Iowa that have either fallen into disrepair or been revitalized for other uses. Dave and I have enjoyed our Iowa schools project immensely, mainly because we have had a chance to travel roads we'd never taken, seeing the beautiful scenery Iowa has to offer. We have lived in many towns throughout the state, but never took the time to see the real Iowa as we have the past several years. We were lucky enough to visit Deep River during their Donut Days, where 250 dozen homemade donuts are made each year. While visiting with the folks in New Providence, we were told to come back in April for their Omelet Day. We discovered that there are some very tasty mom-and-pop

cafes in these small towns, many serving homemade pie and homemade mashed potatoes and gravy.

As we made our journey through Iowa, the urgency of our project to preserve the memories of these small schools became clear. In 1950, Iowa high schools with athletic programs numbered 775. As farms became larger, families grew smaller, and more citizens of Iowa moved out of the state or to larger towns, fewer high schools were needed. Today, there are only 346 districts. We have visited and photographed more than 220 old high schools that are left standing which house no students. We have also travelled to numerous communities where the school has been torn down.

What follows in this book is a photographic presentation of our pursuit of the forgotten schools of Iowa. Under each school's photo is listed the school's name and the county where it is located. Next comes the school's colors and mascot, if they are known, as well as any other interesting tidbits we could find on the school. Also interspersed throughout the book is information about the development of education in Iowa and what schools have meant to Iowa communities. We hope you enjoy following along on our journey. ◆

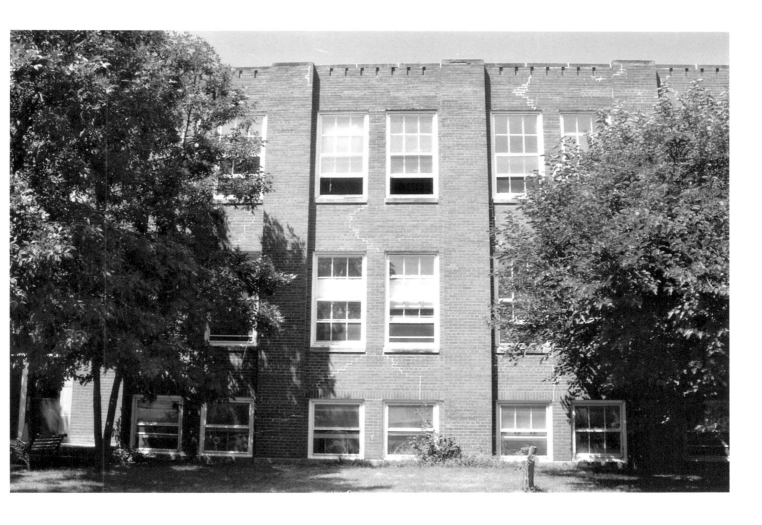

Agency | Wapello County | Red/White

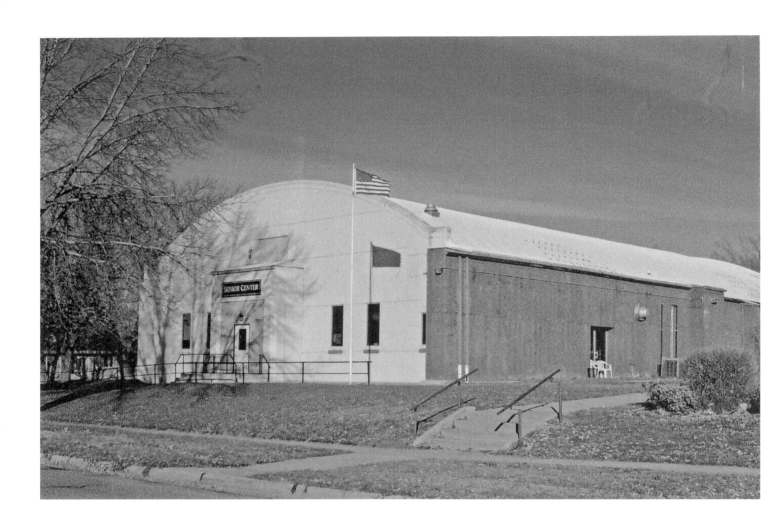

Akron | Plymouth County | Red/White | Red Raiders

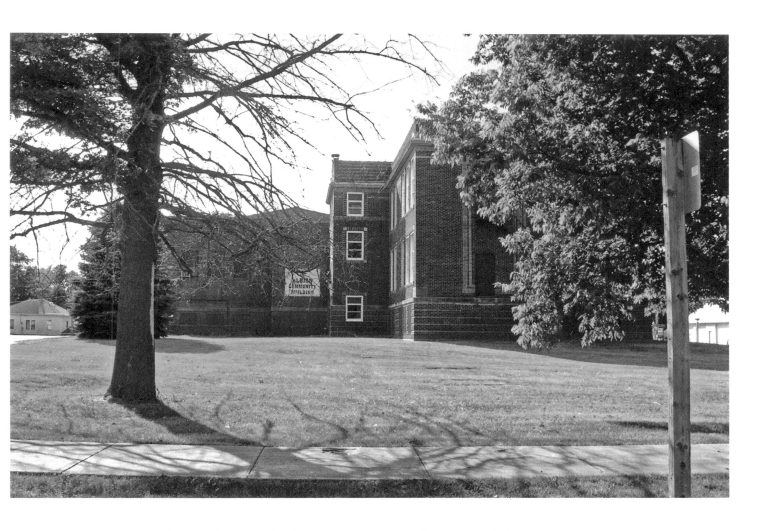

Albion | Marshall County | White/Red | Warriors

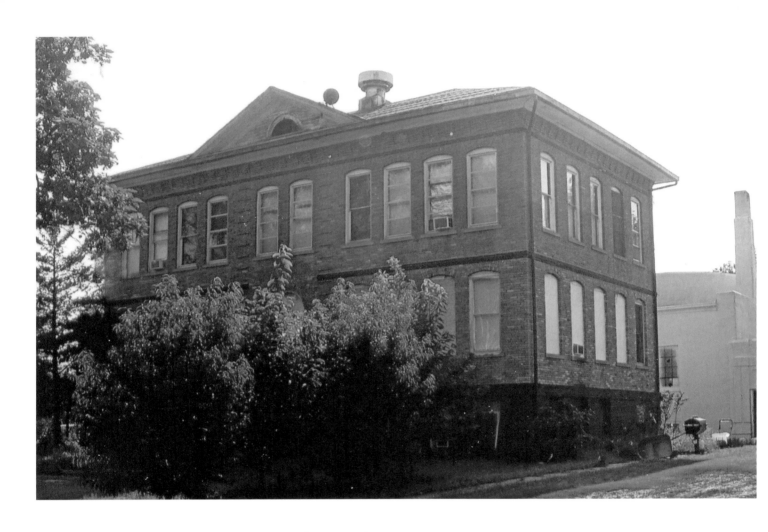

Anderson | Fremont County

A sign in town reads "993 miles from Washington D.C."

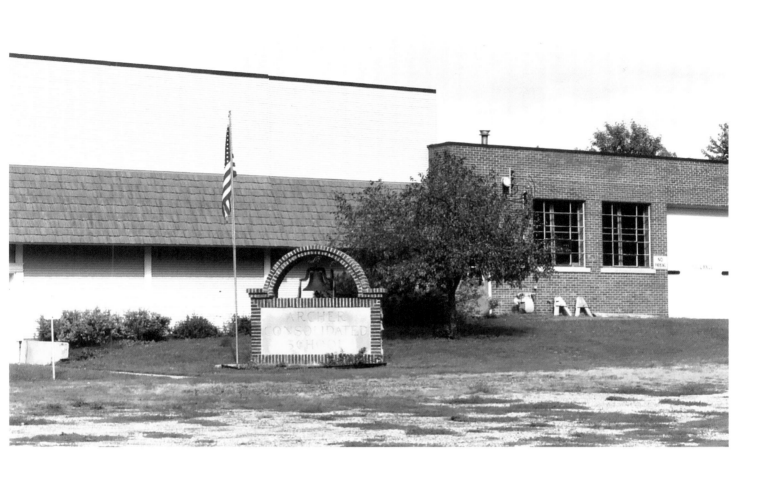

Archer | O'Brien County

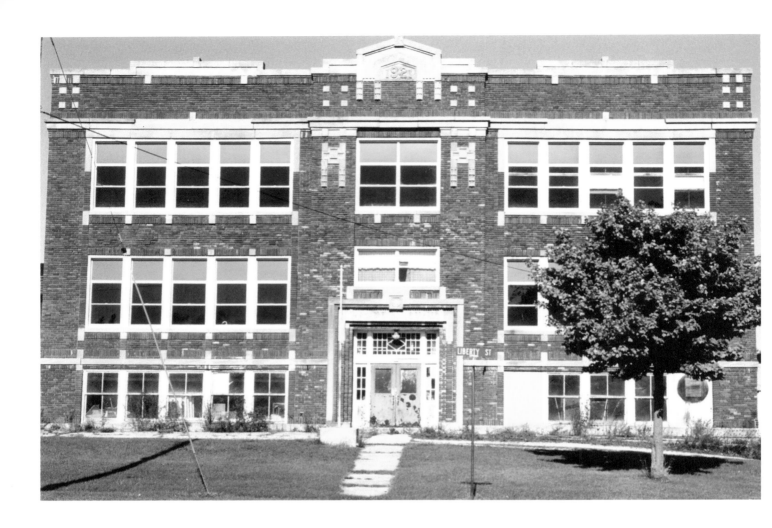

Arlington | Fayette County | Red/White | Indians

"Where hills and prairie meet."

Barb Johnson, Basketball Hall of Fame, 1954

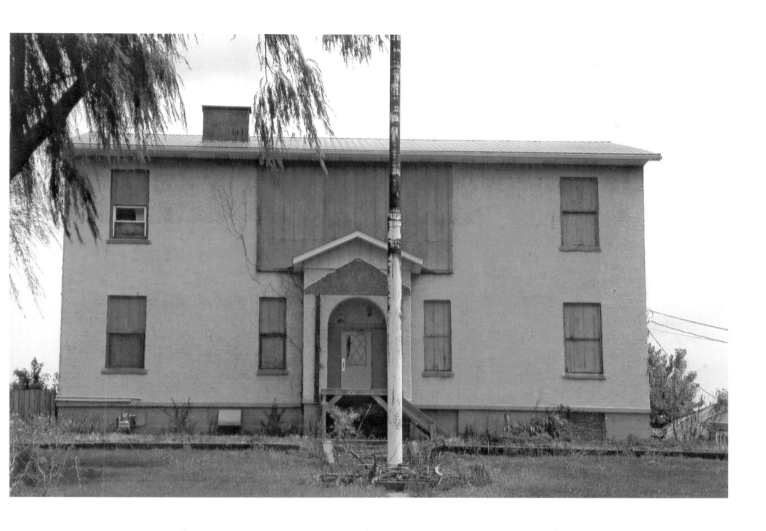

Atalissa | Muscatine County | Burnt Orange/Blue | Indians

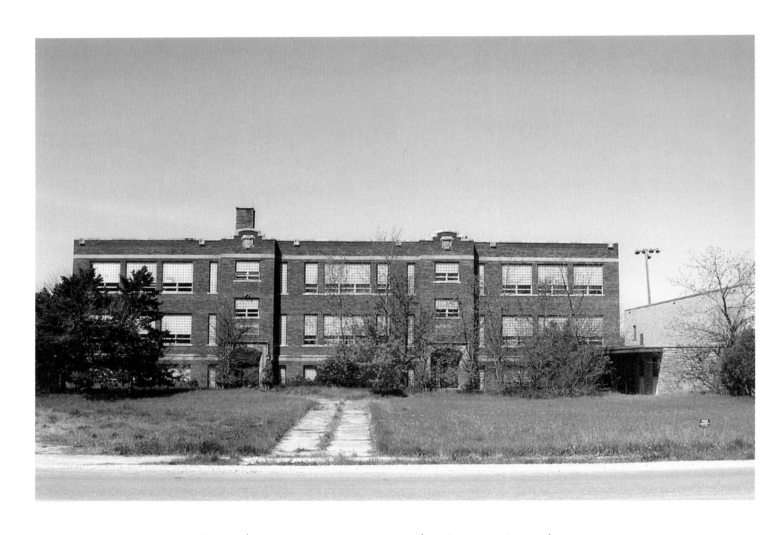

Ayrshire | Palo Alto County | Blue/White | Beavers

This gym was said to be the best in the area.

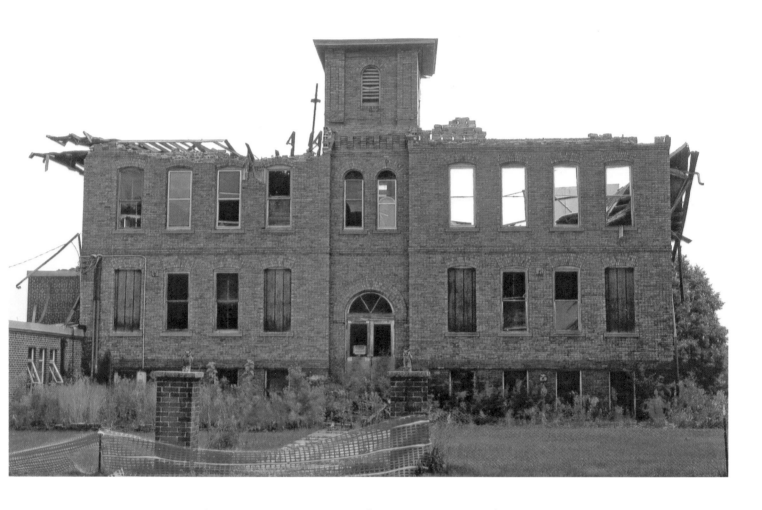

Bagley | Guthrie County | Blue/White | Blue Devils

Jordan Carstens, who played for the Carolina Panthers, grew up here.

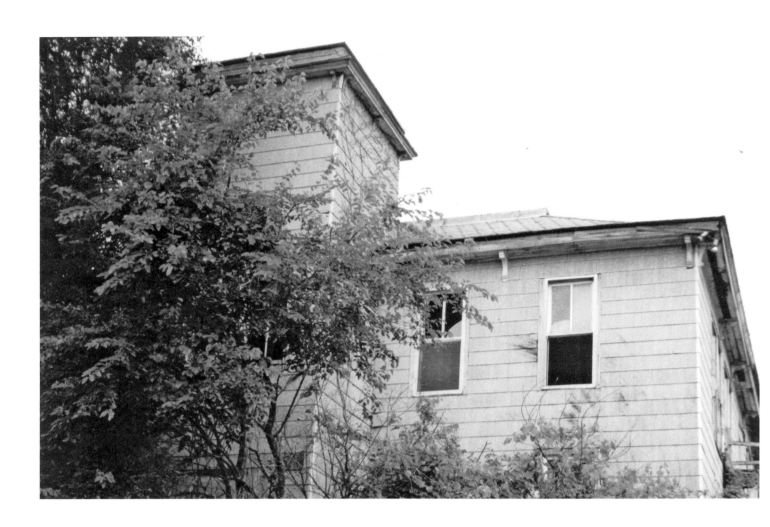

Baldwin | Jackson County | Red/Black | Bobcats

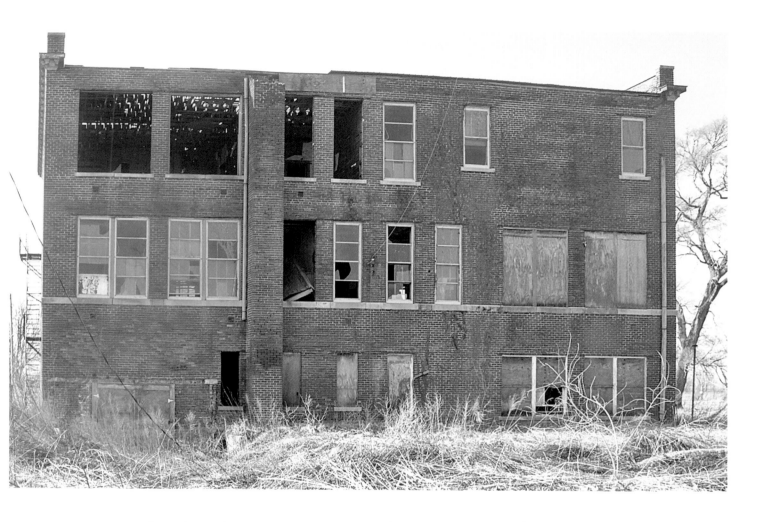

Bartlett | Fremont County | Purple/Gold | Eagles

Bartlett consolidated with Randolph and Tabor in 1959.

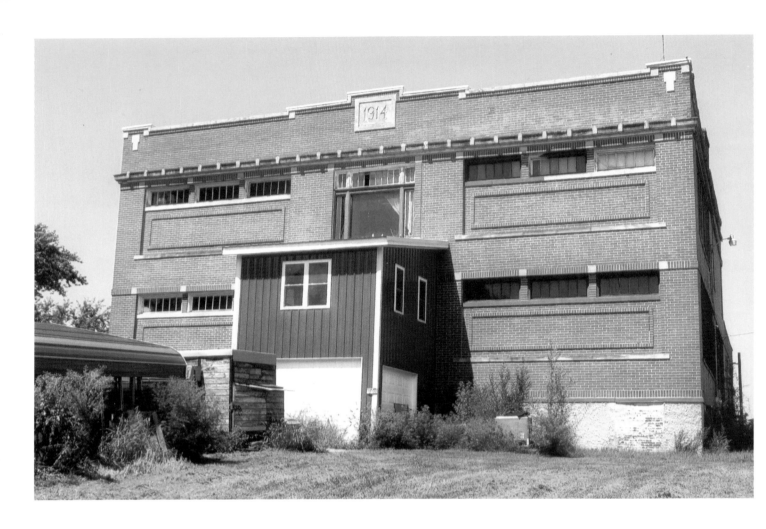

Batavia | Jefferson County | Blue/Gold | Warriors

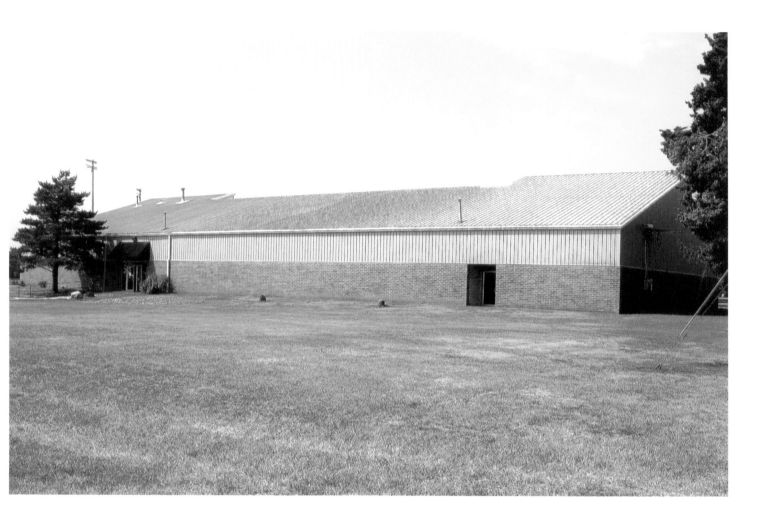

Bayard | Guthrie County | Red/White | Redettes (Girls)/Reds (Boys)

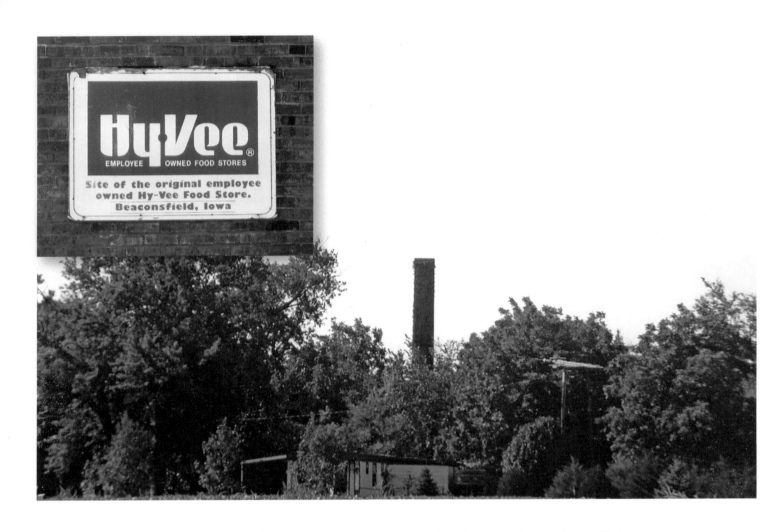

Beaconsfield | Ringgold County | Blue/White | Bulldogs

The chimney and the north wall of the school are surrounded by trees.
David Vredenburg and Charles Hyde opened their first Hy-Vee store here in 1930.

Beaman | Grundy County | White/Black | Wildcats later became Eagles

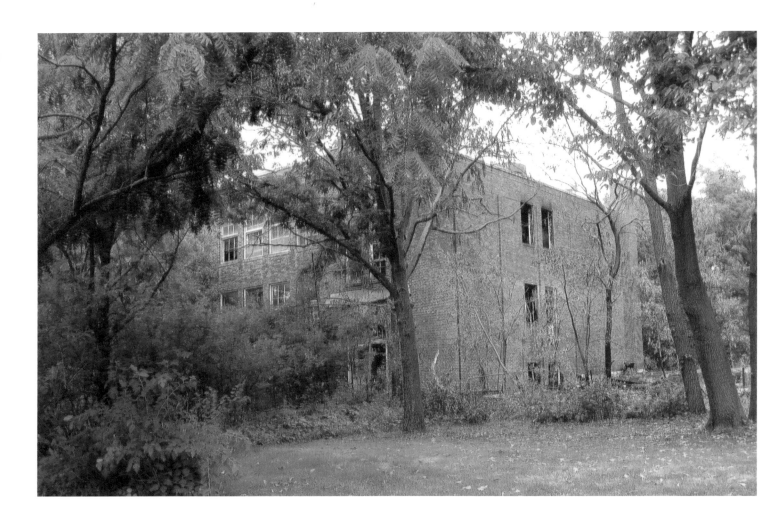

Beaver | Boone County | Green/White | Beavers
Jim Doran, Football Hall of Fame, 1945

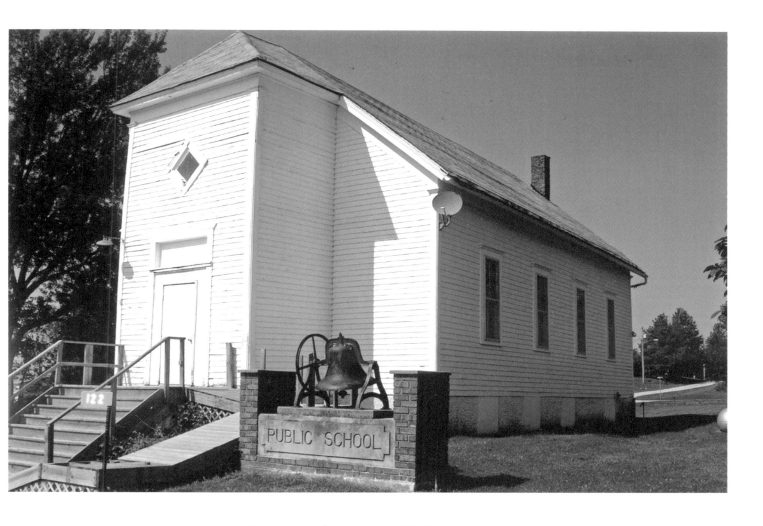

Benton | Ringgold County

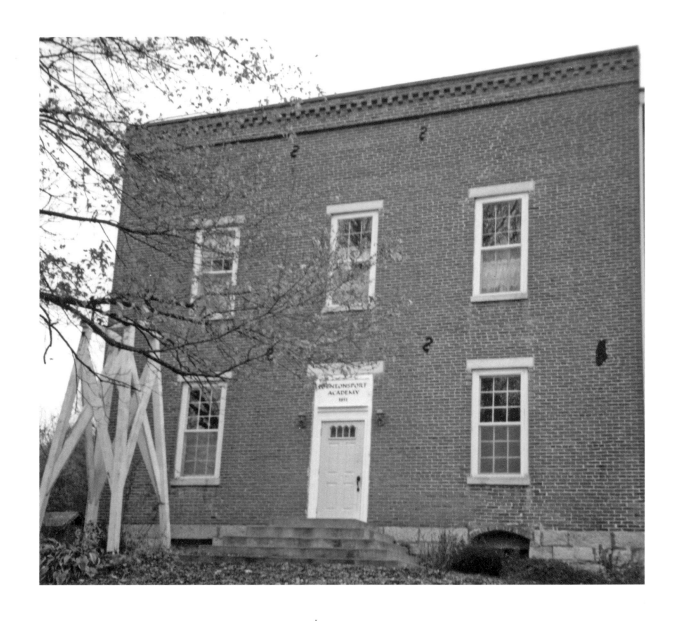

Bentonsport | Van Buren County

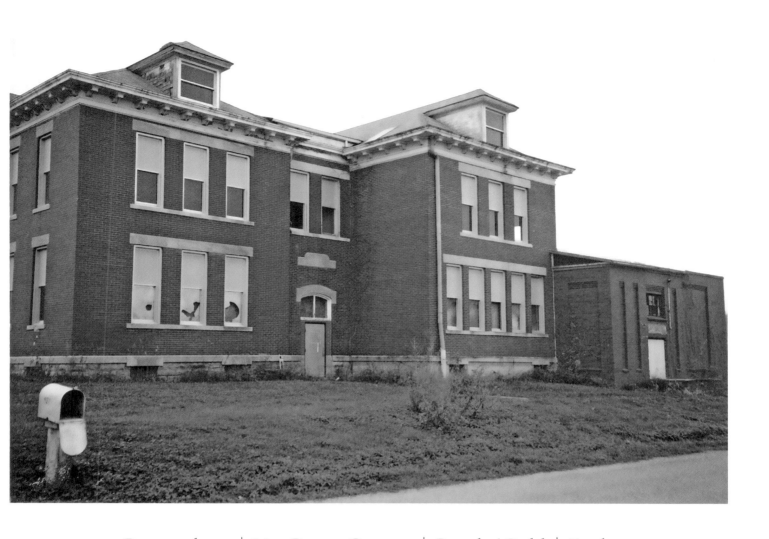

Birmingham | Van Buren County | Purple/Gold | Eagles

Birmingham's first graduating class was in 1888. It had the oldest alumni association in the county.
The school burned in 2008.

Played in 1951 Boys State Basketball Tournament

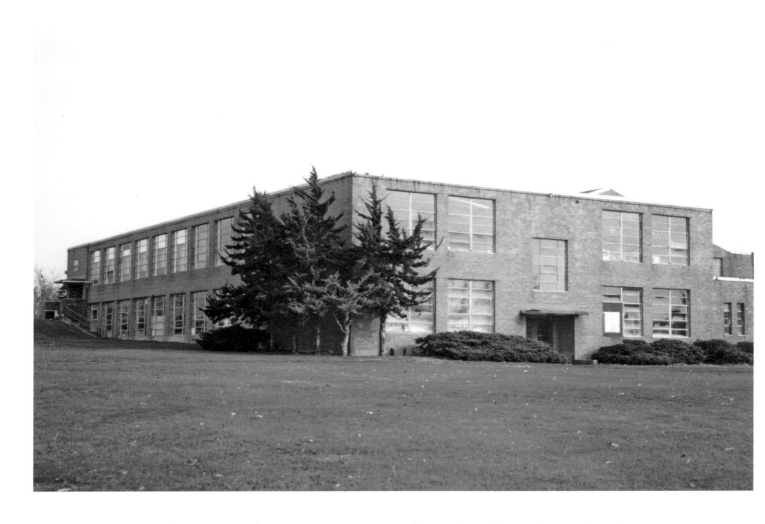

Blairstown | Benton County | Red/White | Cardinals

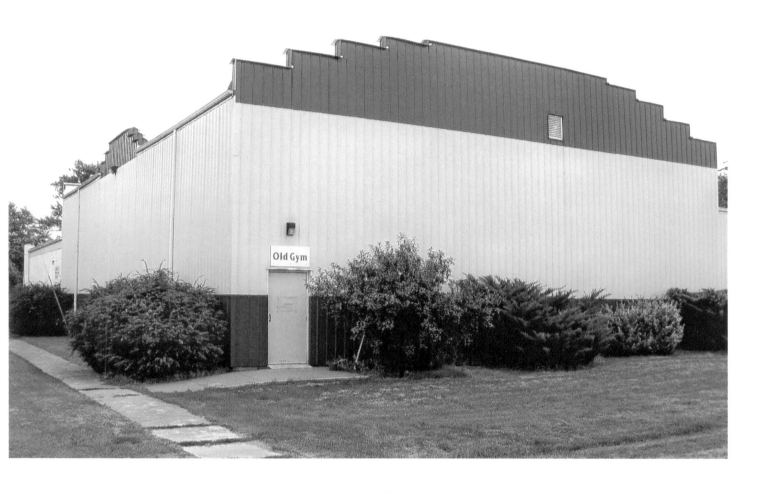

Blakesburg | Wapello County | Green/White | Wildcats

Girls State Basketball Tournament Semifinalists, 1957, 1962

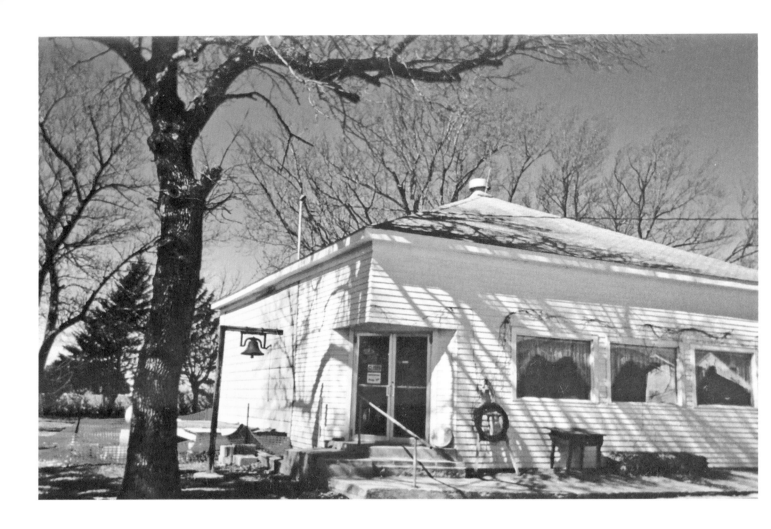

Bolan | Worth County

Built in 1923, Bolan High School is now used as a cultural center.

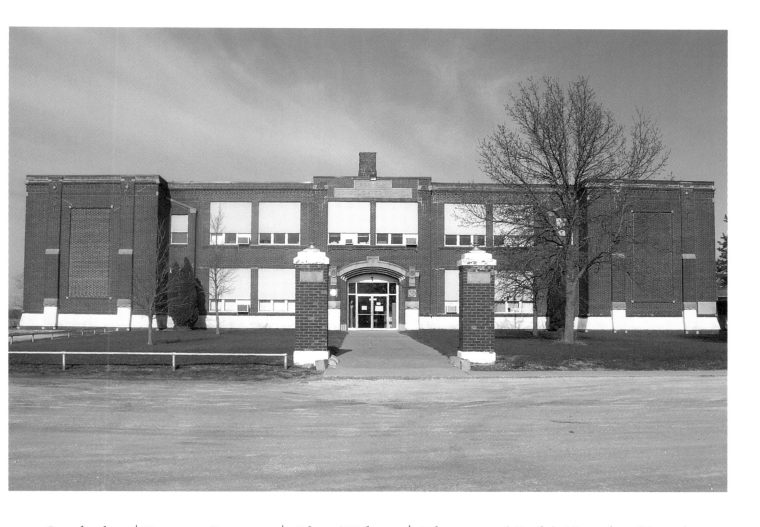

Boxholm | Boone County | Blue/White | Bluestars (Girls)/Swedes (Boys)

Boys State Basketball Tournament Consolation Winner, 1932

Rita Peterson, Girls Basketball Hall of Fame,1960

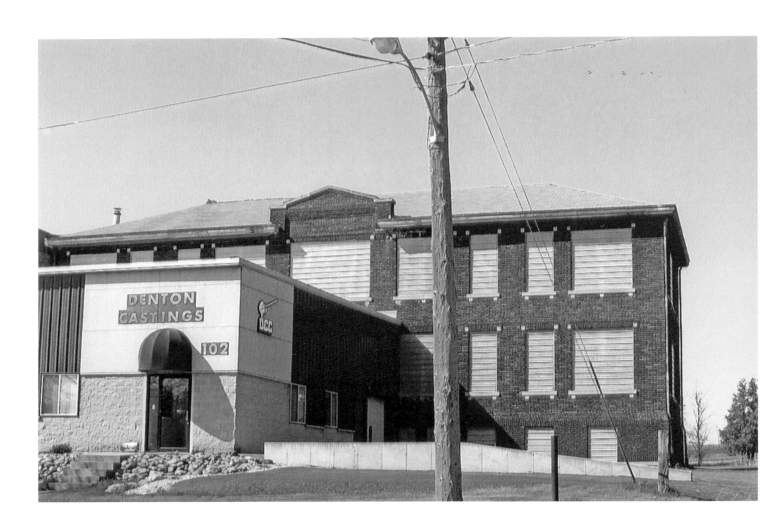

Brandon | Buchanan County | Tigers

After the Brandon school closed it became a factory.

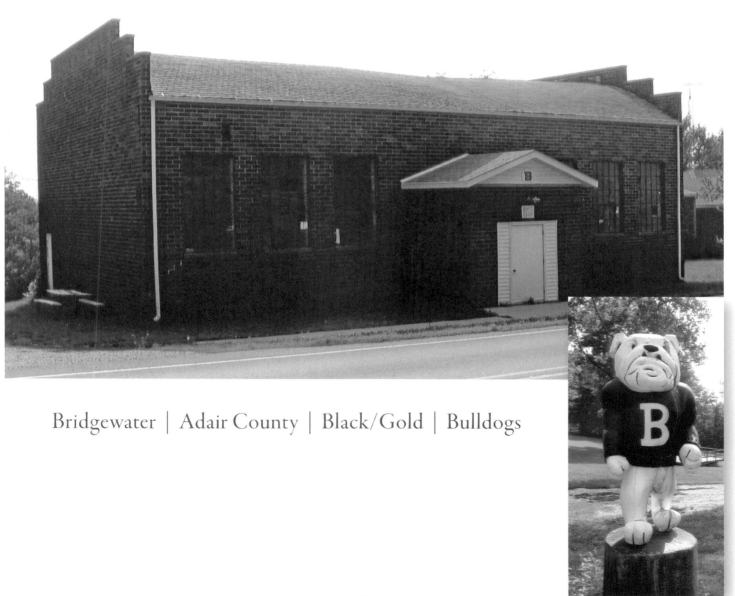

Bridgewater | Adair County | Black/Gold | Bulldogs

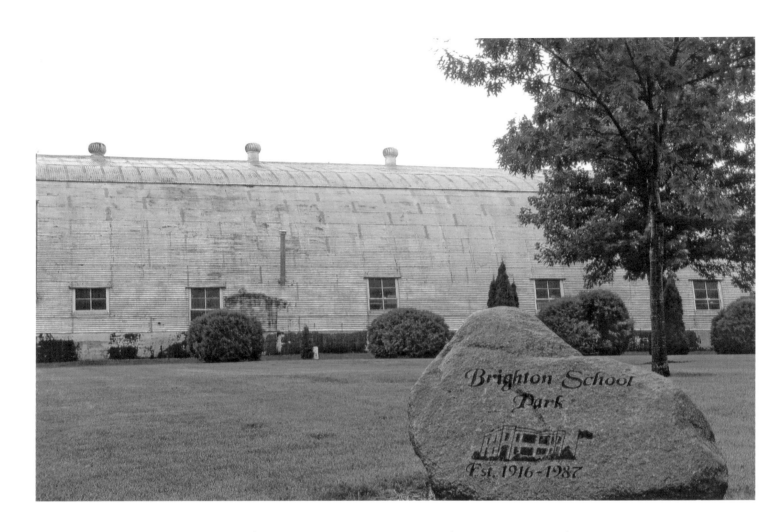

Brighton | Washington County | Red/Black | Bears

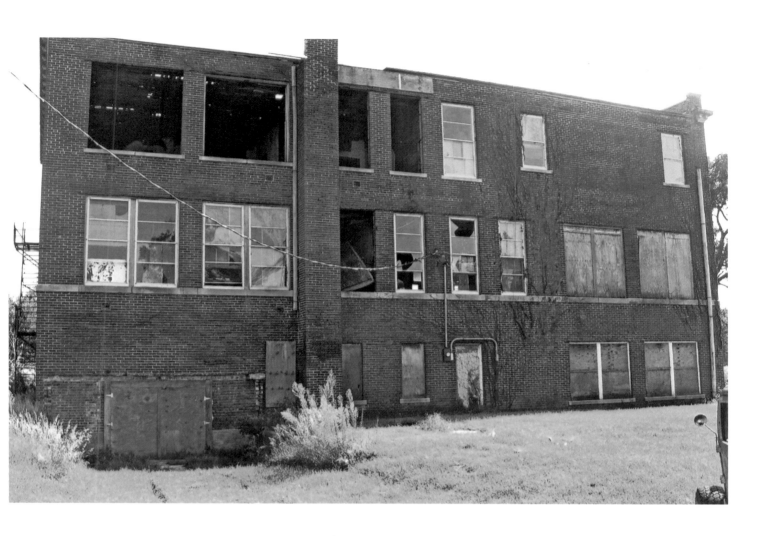

Brooks | Adams County

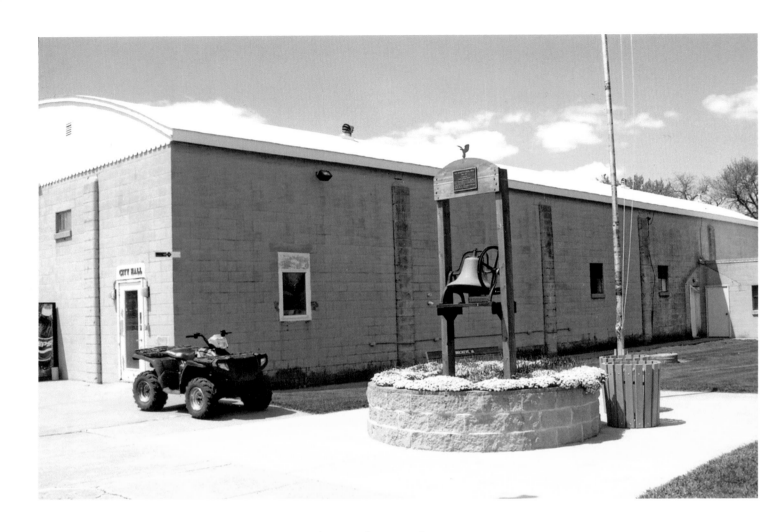

Buckeye | Hardin County

The Buckeye gym now serves as the fire department.
The bell is in memory of teachers, principals, and bus drivers.

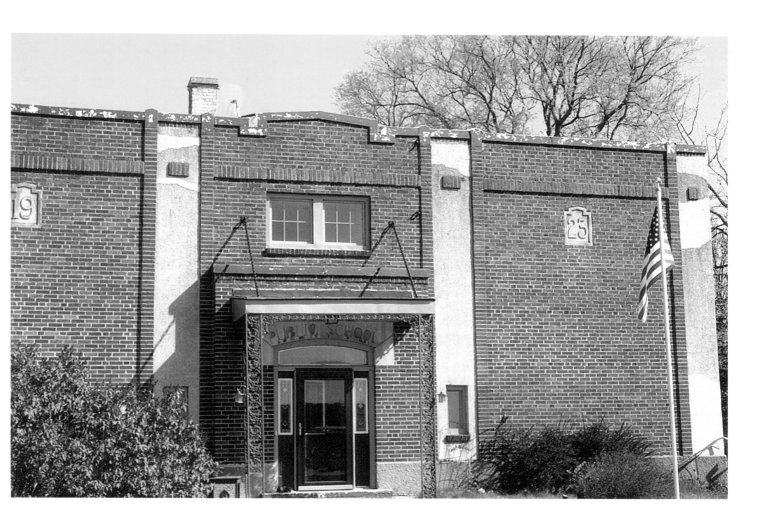

Buckingham | Tama County | Purple/Gold | Wolves

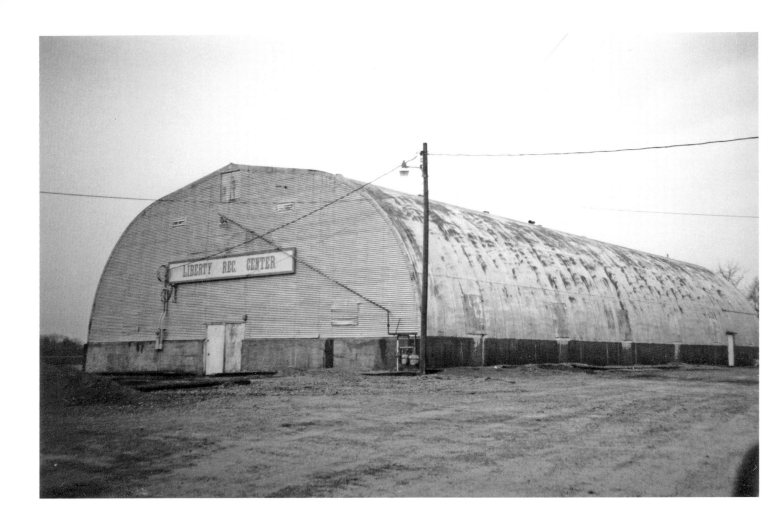

Bussey | Marion County | Purple/Gold | Yellowjackets

The original Bussey gym was constructed in the 1940s by putting two Quonset huts together.
The floor was cement with painted lines. Later asphalt tile covered the floor.

From Many to Few

Consolidation in Iowa schools

From Many to Few
Consolidation in Iowa schools

In 1953, there were 4,558 school districts in Iowa with all the one-room rural schools. Because all one-room country schools were subsequently required by law to attach to a high school district, the number dropped to 1,065 in 1965. The following year the number of districts decreased again to 455 because some of the country schools missed the deadline for attaching to a high school district a year earlier. In the 2012-13 school year, Iowa had 346 school districts ranging in size from 68 students in LuVerne Community School District to more than 32,000 students in Des Moines Independent School District. That same year there were 56 school districts in Iowa with less than 400 students. It is likely we will see many more consolidations and empty high schools in the future.

Were the emotions as high back then when they had to close a school and send kids somewhere else? The feelings were most likely the same as they are today when school systems think about reorganizing. When Dave and I were fortunate enough to find someone in the town who could share some history about their school, it was usually quite a few minutes before we could move on. Their eyes sparkled when they talked about the good old days, and we could sense that they were reliving those happy times as they spoke to us. ◆

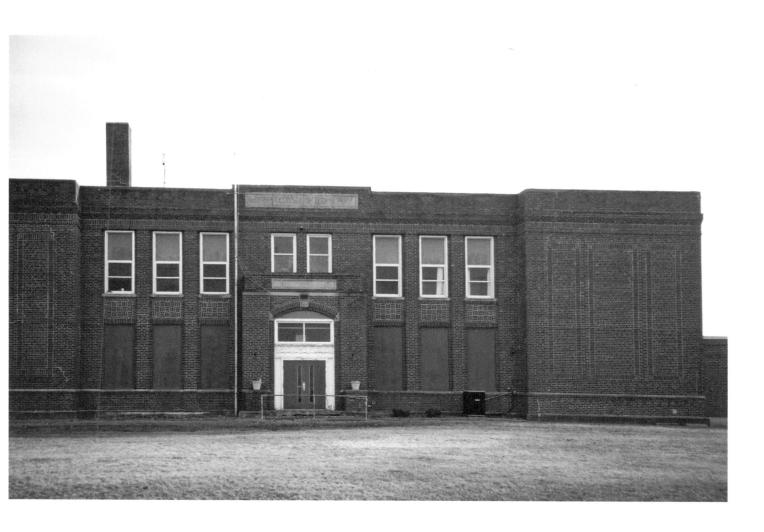

Cambria | Wayne County | Blue/White | Comets

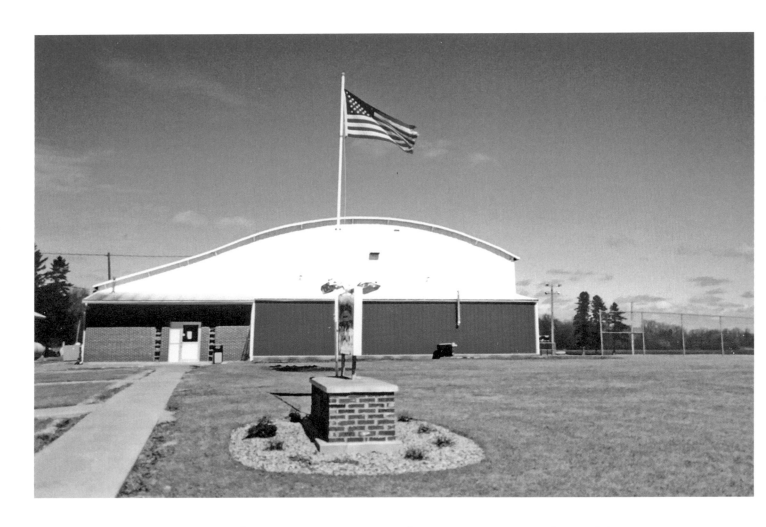

Carpenter | Mitchell County | Maroon/Gray | Wildcats

Carpenter school was known by its lighted softball field.
Consolidation took place in the 1960s.

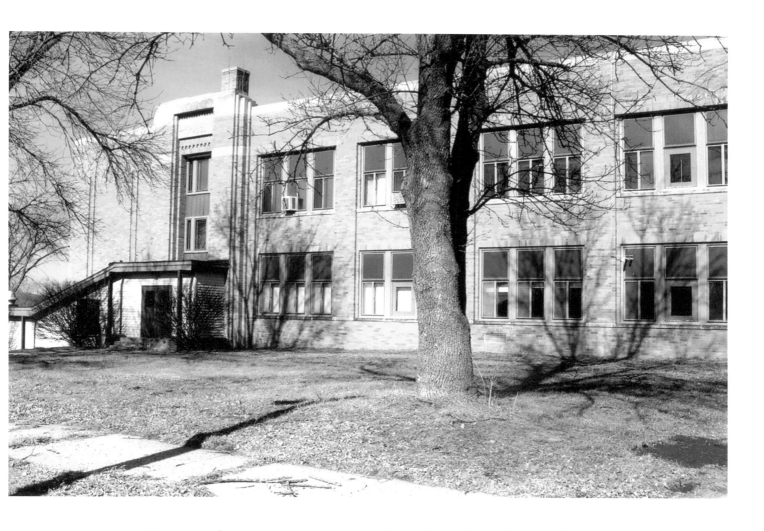

Castana | Monona County | Red/White | Panthers

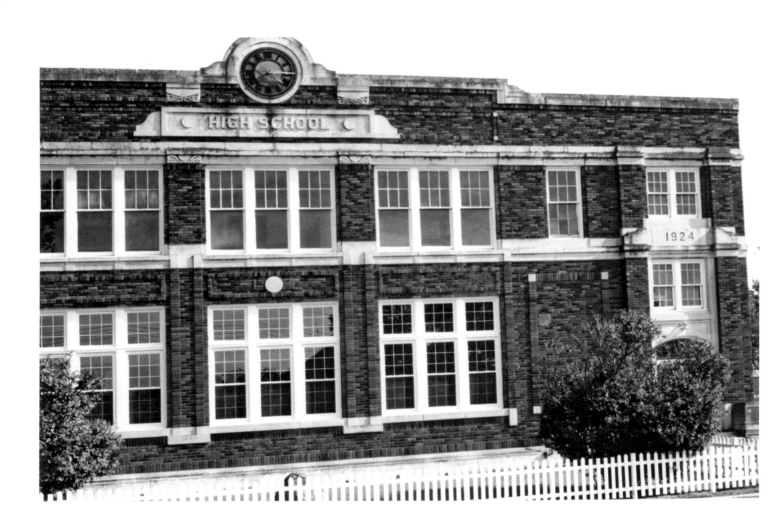

Clermont | Fayette County | Orange/Black | Commanders

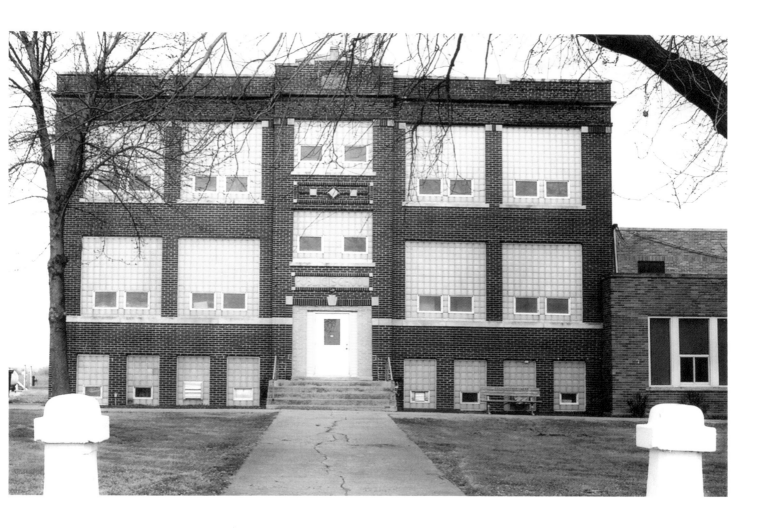

Climbing Hill | Woodbury County | Orange/Black | Hawks

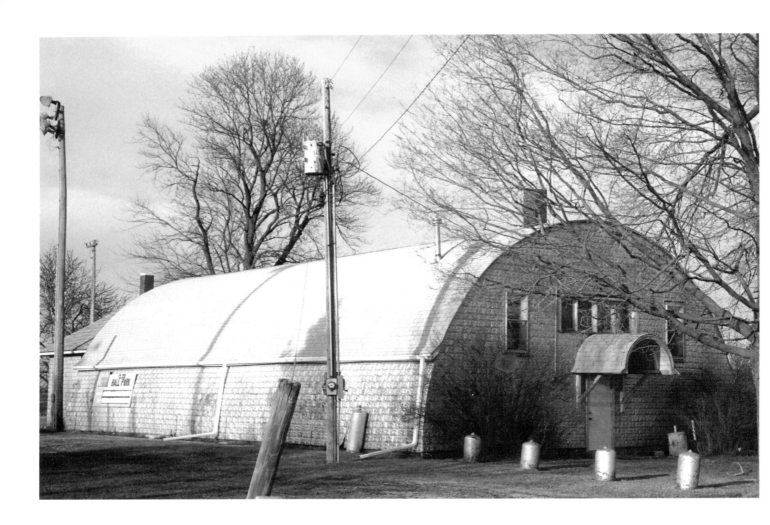

Clio | Wayne County | Purple/Gold | Tigers

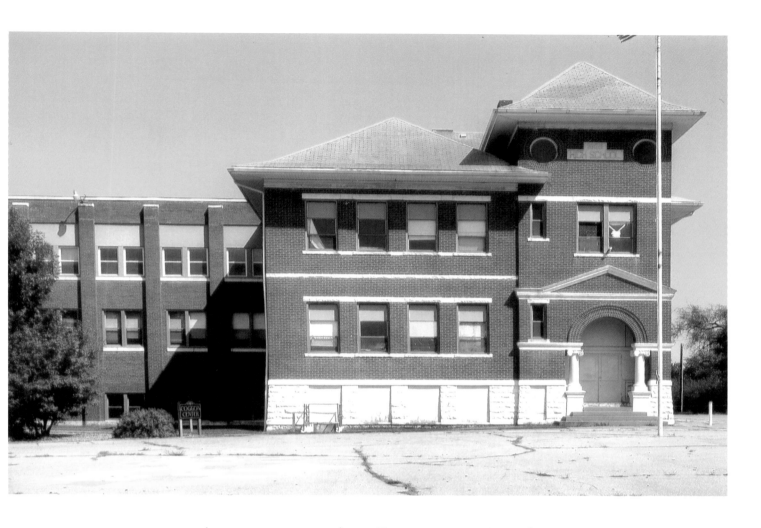

Coggon | Linn County | Kelly Green/White | Rockets

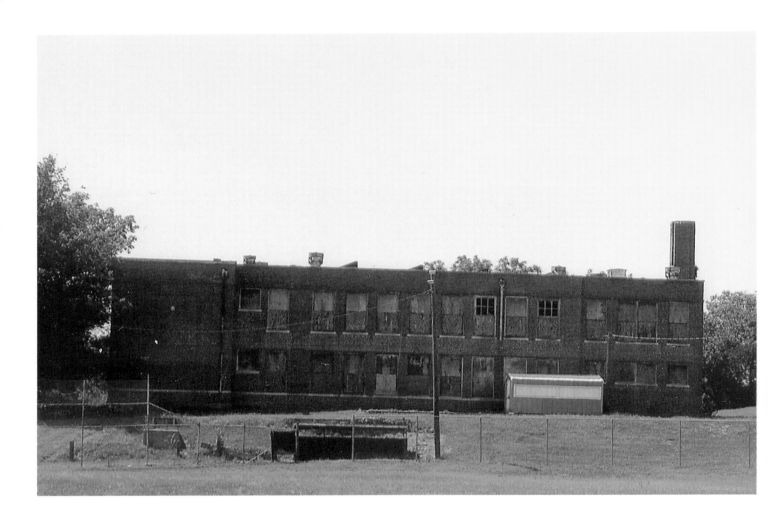

Coin | Page County | Wine/White | Tigers

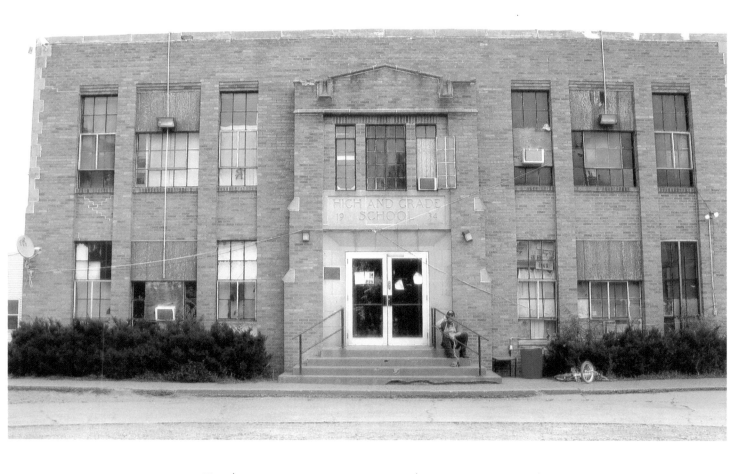

Conesville | Muscatine County | Red/White | Tigers

State Baseball Champions, 1939

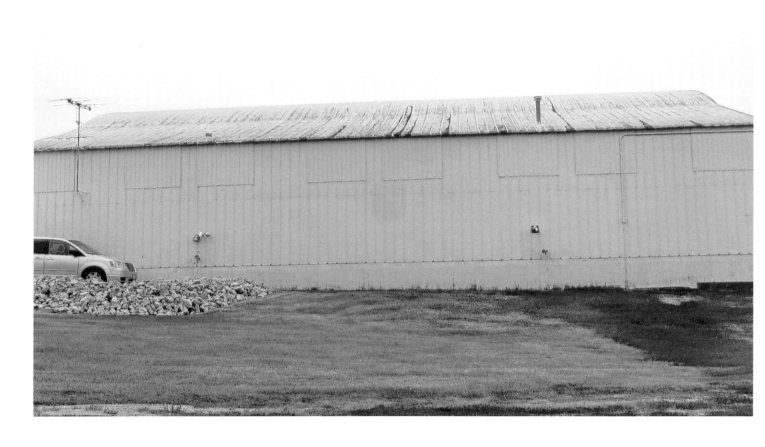

Conroy | Iowa County | Green/White | Comets

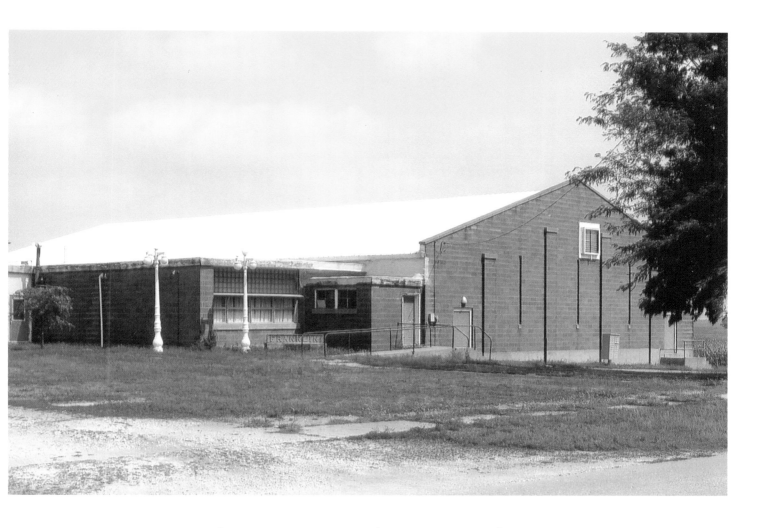

Cooper | Greene County | Red/White | Cardinals

Chuck Offenburger, former Des Moines Register *columnist, resides in Cooper.*

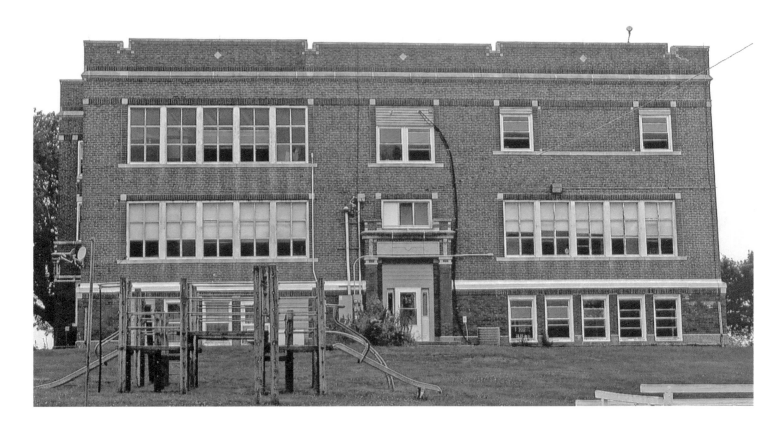

Cotter | Louisa County | Blue/Yellow | Blue Devils

The original school was destroyed by fire and the "new" school was built and dedicated in 1921.

Cumberland | Cass County | Red/Black | Demons

Girls State Basketball Tournament Runner-Up, 1936

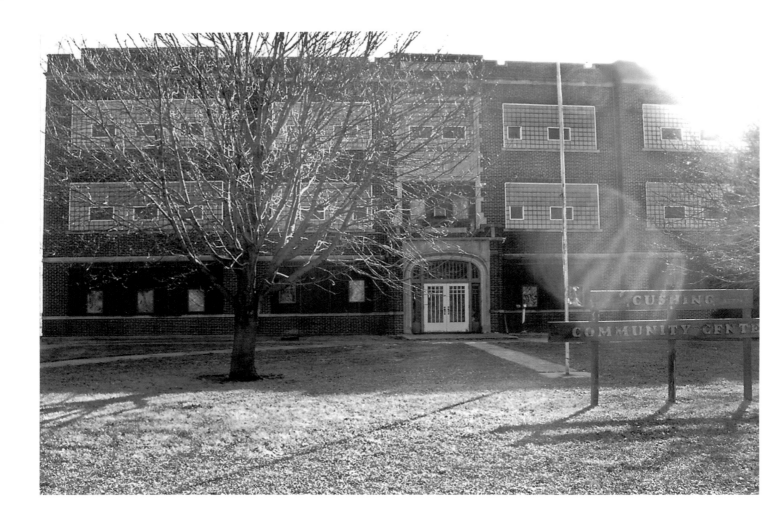

Cushing | Woodbury County | Maroon/White | Eagles

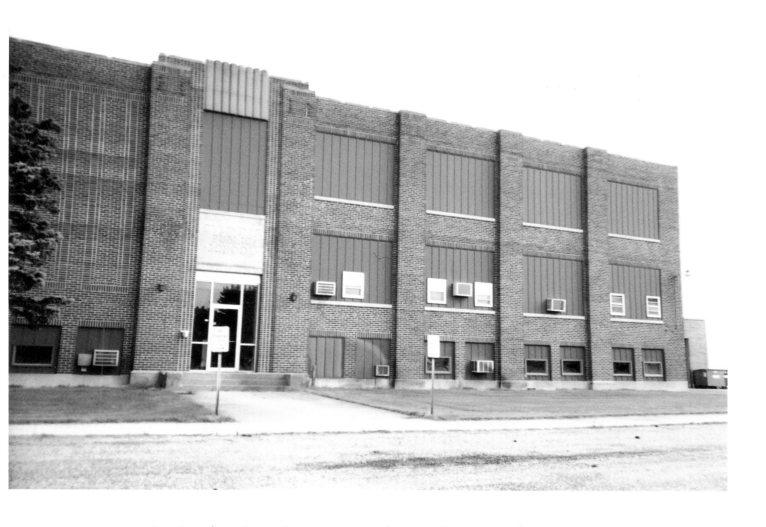

Cylinder | Palo Alto County | Purple/Gold | Cyclones

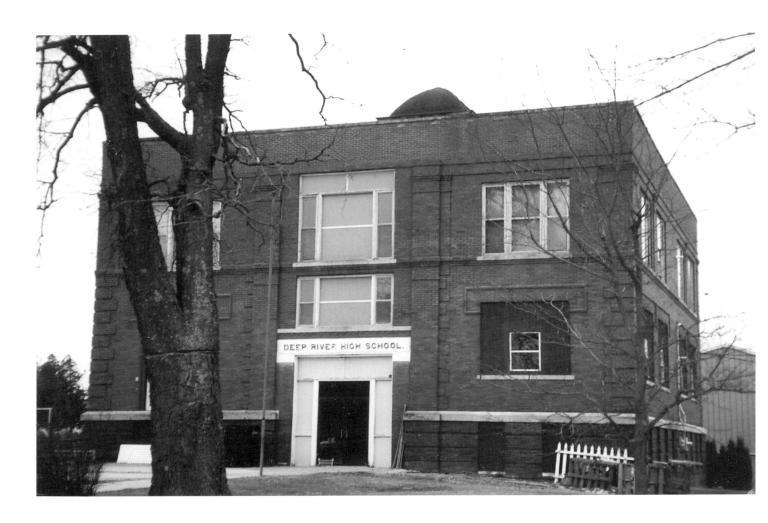

Deep River | Poweshiek County | Red/Black later became Orange/Black | Tigers

Home of Old Schoolhouse Candy and Donut Days.

Janel Grimm, Basketball Hall of Fame, 1993

Girls State Basketball Tournament Semifinalists, 1951

Donnellson | Lee County | Orange/Black | Demons later became Tigers

Max Lynn, Basketball Hall of Fame, 1921

Judy Hodson, Basketball Hall of Fame, 1958

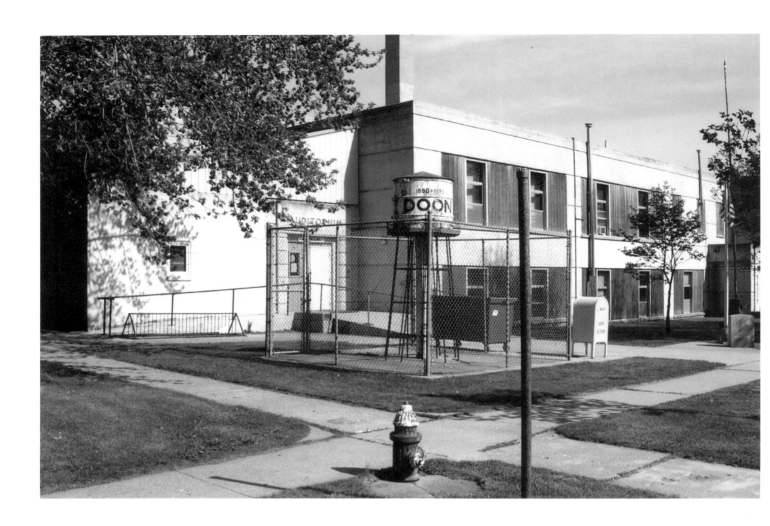

Doon | Lyon County | Blue/Gold | Dragons
Birthplace of Frederick Feikema Manfred, author of Scarlett Plume.

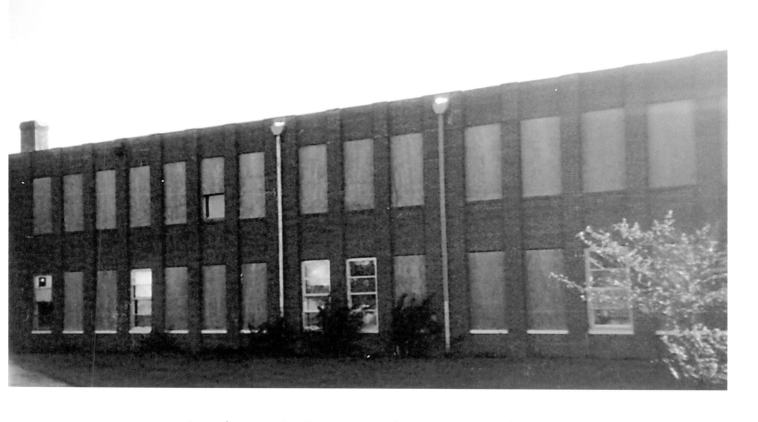

Dunbar | Marshall County | Blue/Gold | Vikings

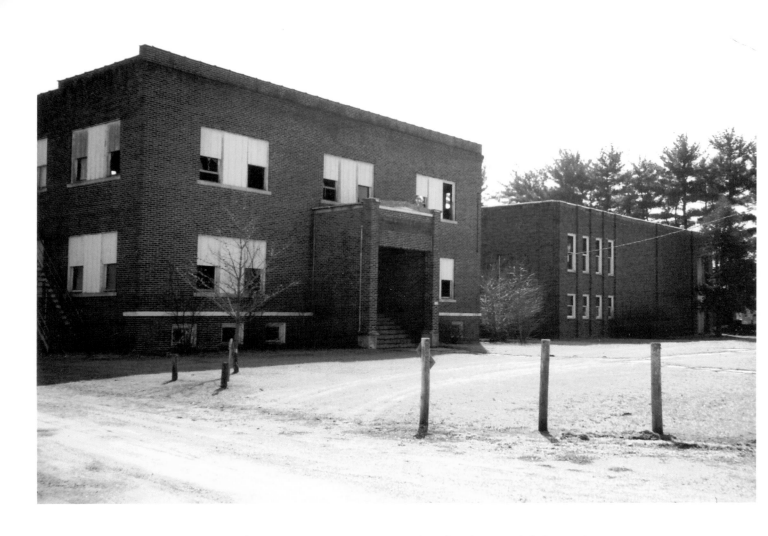

Dundee | Delaware County | Black/Gold | Bobcats

Hometown Heroes

Famous names from Iowa small schools

Hometown Heroes

Famous names from Iowa small schools

Some of the towns and old schools we visited were home to achievers in sports, arts, military, science, and government. For example, Colfax was home to G.B. Lewis, a professional football player for the 1929 Green Bay Packers. Dallas Clark, who attended Livermore, played for the Indianapolis Colts. Robert Gallery, Masonville, played for the Oakland Raiders; Derek Pagel, Plainfield, for the New York Jets; Trev Alberts, Northern University High, for the Indianapolis Colts; and Jeff Criswell, Searsboro, for the Kansas City Chiefs. Additionally, Vice President Henry Wallace attended Orient; Harry Reasoner, journalist and television commentator, Dakota City; Phil Stong, author of *State Fair*, Pittsburg; Buffalo Bill Cody, LeClaire; Johnny Carson, TV personality, Corning and Avoca; George "Superman" Reeves, actor, Woolstock; Andy Williams, singer, Wall Lake; Ashton Kutcher, actor, Homestead; Governor Terry Branstad, Leland; Annabeth Gish, actress, Northern University High; and Robert Waller, author, Rockford. All attended schools that have been lost due to declining enrollment and consolidation.

In Ayrshire, a gentleman told us that the last graduating class was in 1981 and that their gym was known as "the best in the area." Iowa Hall of Famers Helen Corrick

(Keswick '49), Cordelia Coltvet (Gruver), Vivian Fleming (Emerson '58), and Jeanette Engel (Washta '54) no longer have the schools that were the center of their high school careers in girls six-on-six basketball. When our cousins played girls basketball in Moneta in the l950s, we never dreamed that today, driving down the tree-lined road into town, we would see no stores, few houses, and an old school overgrown with weeds. As a gentleman in Hazelton told us, "It [the school] was tore down. When the school goes, the churches do too. It's a shame."

Boxholm, which later became Southeast Webster-Grand, sent their boys basketball team to state in 1932. The LaMoille High School team went to state in 1930 with a record of 22-4, and tiny Melrose sent their boys in 1937. Tracy and Calumet were represented at the state boys basketball tournament along with Marathon, Plover, Martelle, Geneseo, Fertile, Palmer, and many more small schools. The Sharpsburg boys went to state in 1957, and the school closed its doors the next year with four graduating seniors.

The town of Beaconsfield is the home of astronaut Peggy Whitson. Although she graduated from Mt. Ayr High School, the family farm is near Beaconsfield. Beaconsfield is also the home of the first Hy-Vee grocery store. The Mt. Ayr School reorganized in 1958, consolidating with the towns of Beaconsfield, Redding, Delphos, Maloy, Benton, Tingley, and Ellston.

Bussey is the hometown of 1925 graduate Gayle Arlene McClure, M.D., and Cincinnati is the hometown of Iowa State researcher Griffith Buck. Author Frederick Feikema Manfred graduated from Doon High School in northwest Iowa. Richard Longworth, author, was born in Gravity, and John L. Lewis, labor leader of Mine Workers of America, was from Lucas. ◆

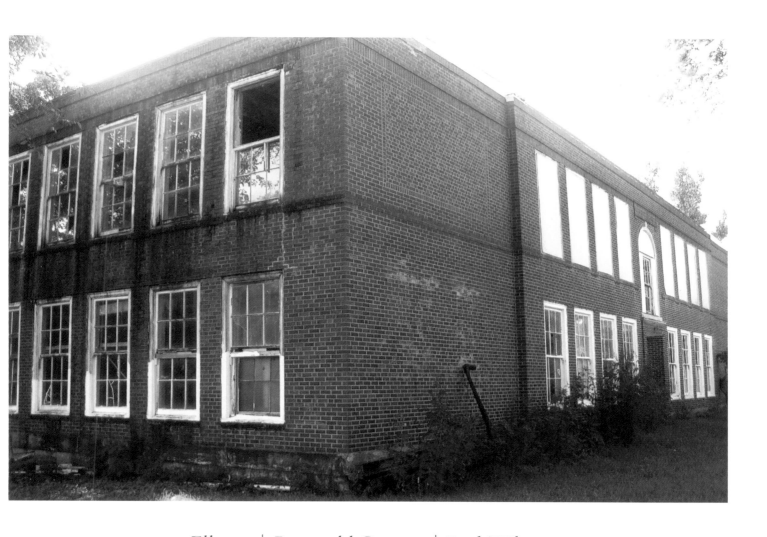

Ellston | Ringgold County | Red/White

Harley Wilhelm, Basketball Hall of Fame, 1919

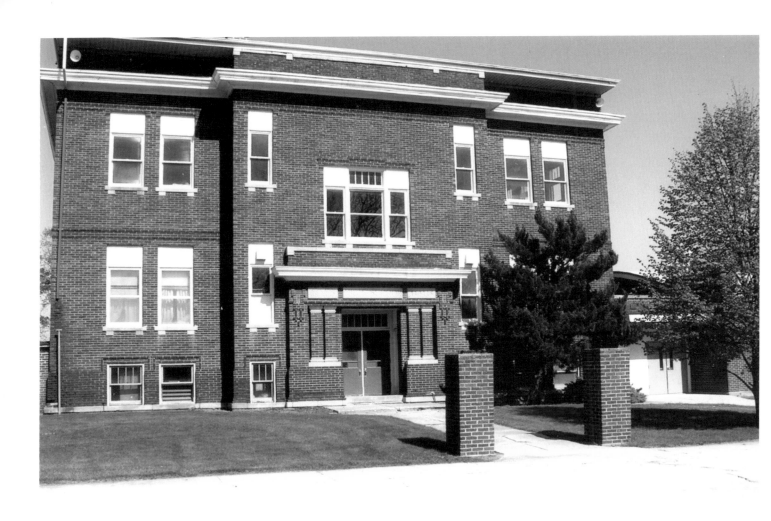

Ellsworth | Hamilton County | Purple/Gold | Eagles

Built in 1916, the Ellsworth High School is now a community building.

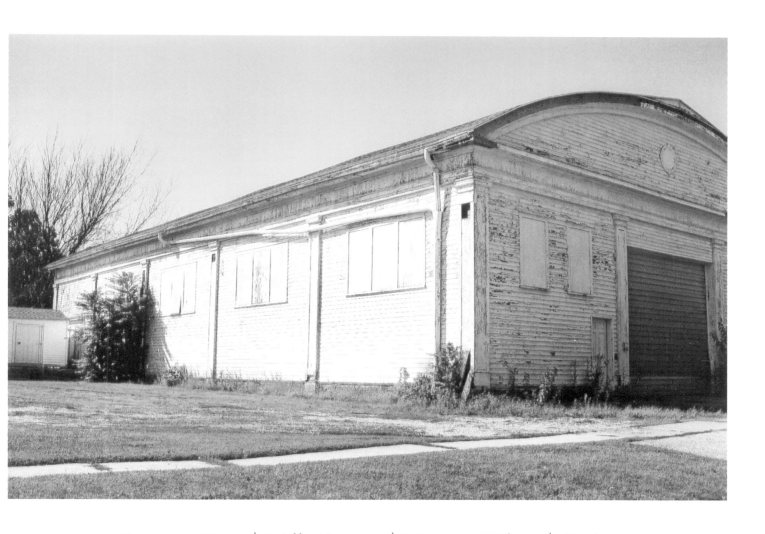

Emerson Gym | Mills County | Maroon/White | Eagles

Vivian Fleming, Girls Basketball Hall of Fame, 1958

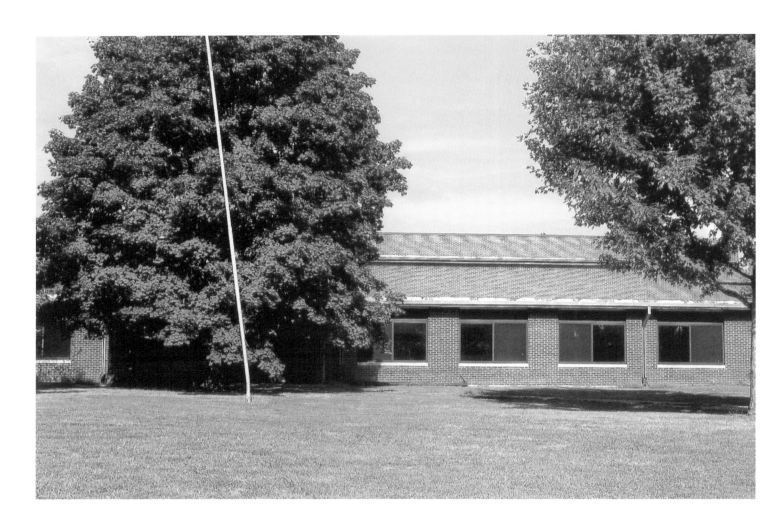

Farmington | Van Buren County | Purple/White | Wildcats

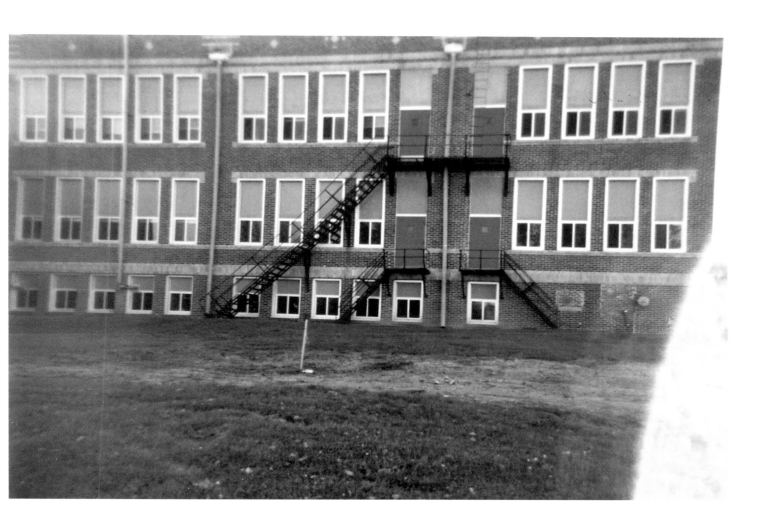

Ferguson | Marshall County | Blue/Gold | Bulldogs

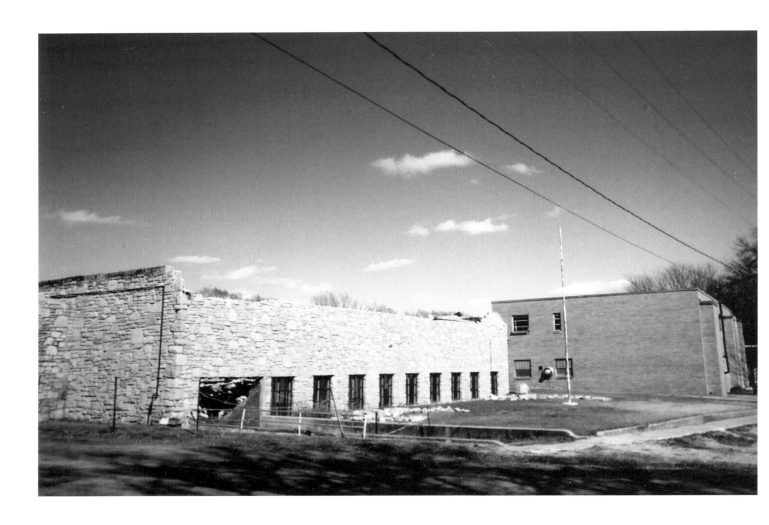

Fertile | Worth County | Red/Black | Indians

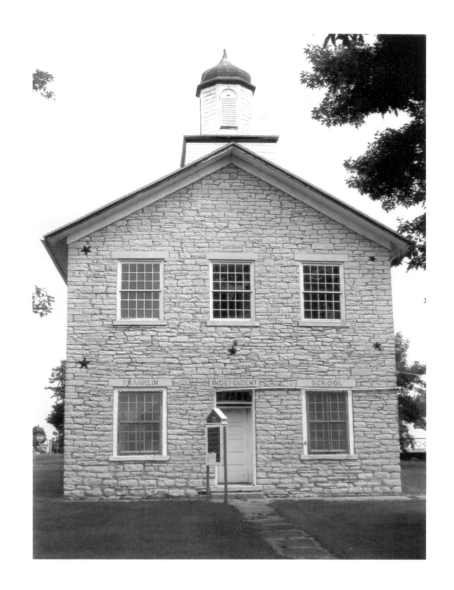

Franklin | Lee County

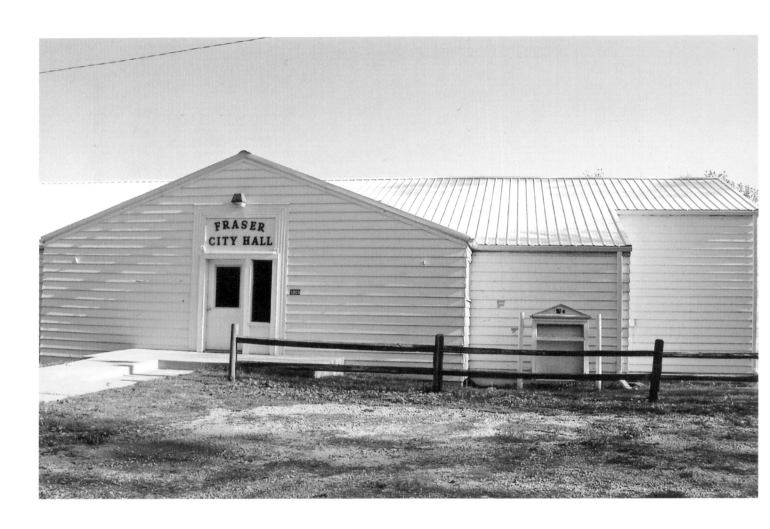

Fraser | Boone County

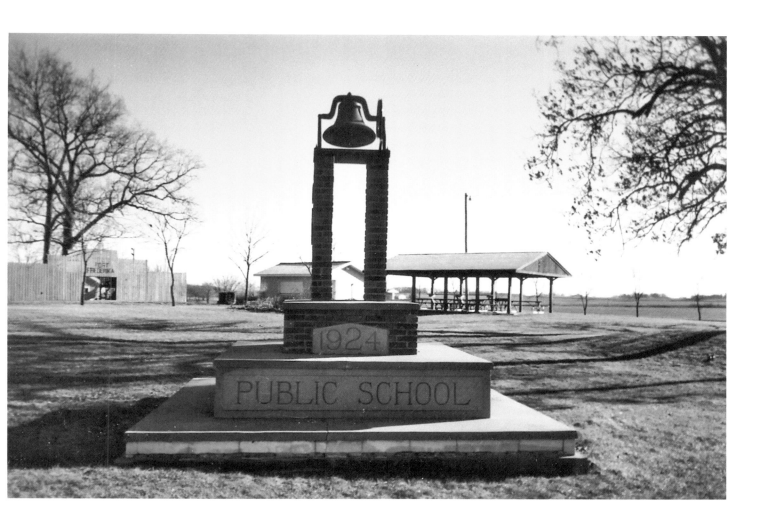

Fredericka | Bremer County | Purple/Gold | Trojans

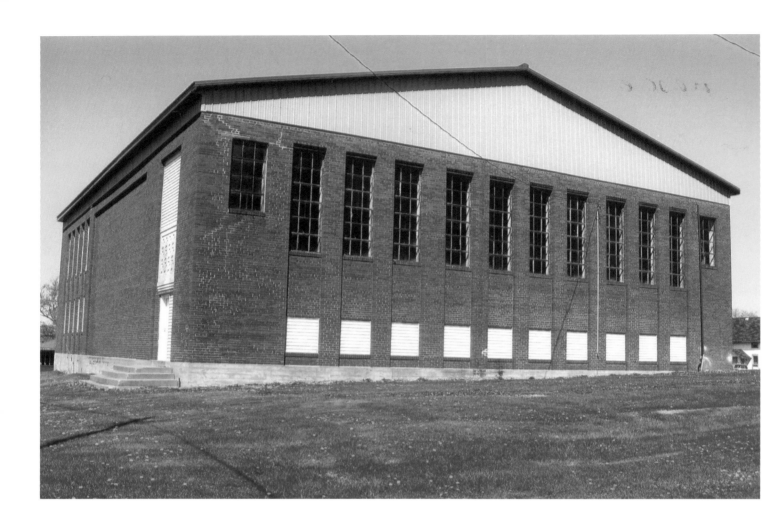

Garrison | Benton County | Red/White | Rockets (Boys)/Rockettes (Girls)

Sylvia Froning, Basketball Hall of Fame, 1957

Girls State Basketball Tournament Runner-Up, 1956

Girls State Basketball Tournament Champions, 1957

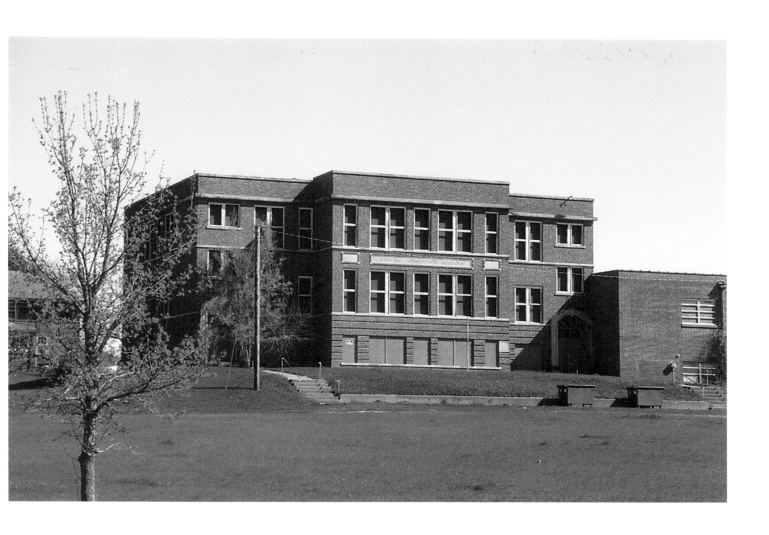

Geneseo | Tama County | Purple/Gold | Wolves

Geneseo High School, with an enrollment of 40 students, was a fan-favorite in the 1945 state basketball tournament, playing much larger schools.

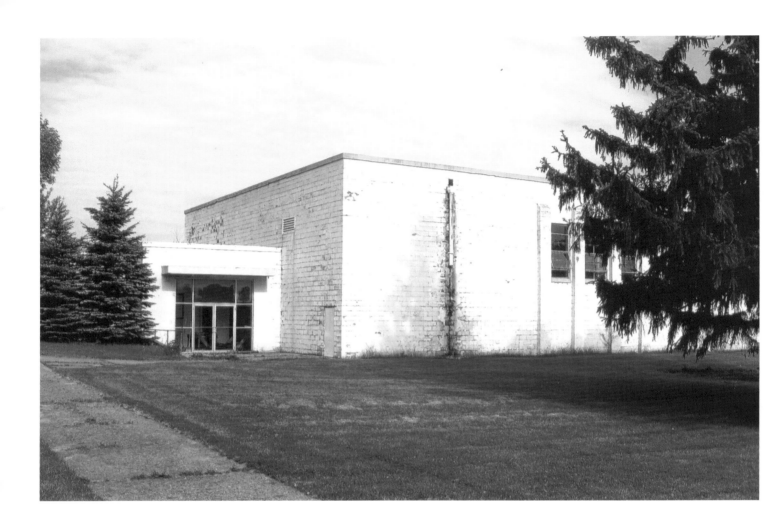

Geneva | Franklin County | Black/Gold | Lions

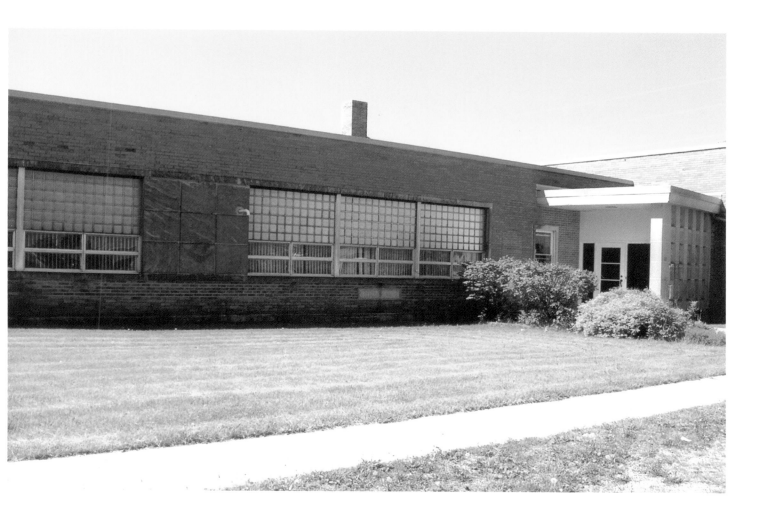

Goodell | Hancock County | Royal Blue/White | Bears

The Goodell High School is now being used as a church.

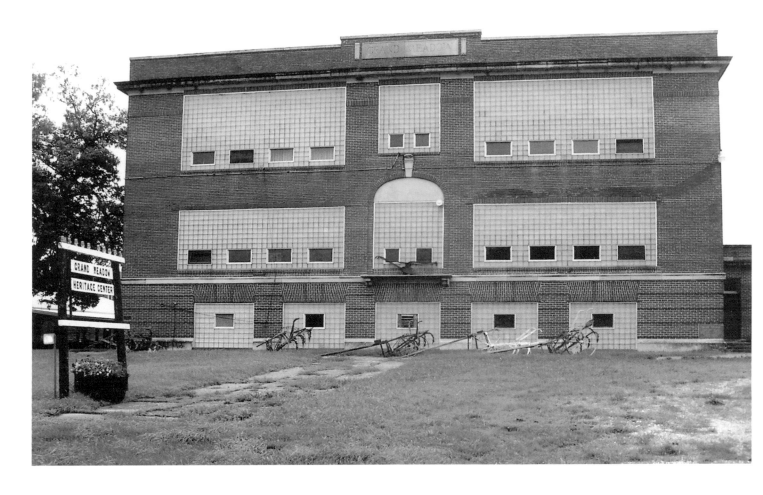

Grand Meadow | Cherokee County | Maroon/Gold | Larks

Grandview | Louisa County | Black/Orange | Greyhounds

Gravity | Taylor County | Orange/Black | Grizzlies

Author Richard Longworth wrote a book in 2001 entitled
Gravity, Iowa and Dordogne, France: A Bucolic Double Portrait.

Gray | Audubon County | Blue/Gray | Greyhounds

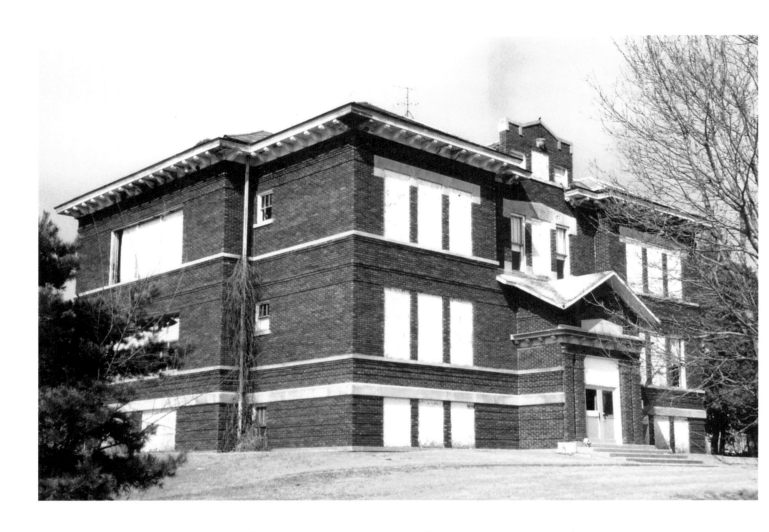

Greeley | Delaware County | Purple/White | Elks

Gruver | Emmet County | Orange/Black | Rockets

Cordelia Coltret, Basketball Hall of Fame,1960

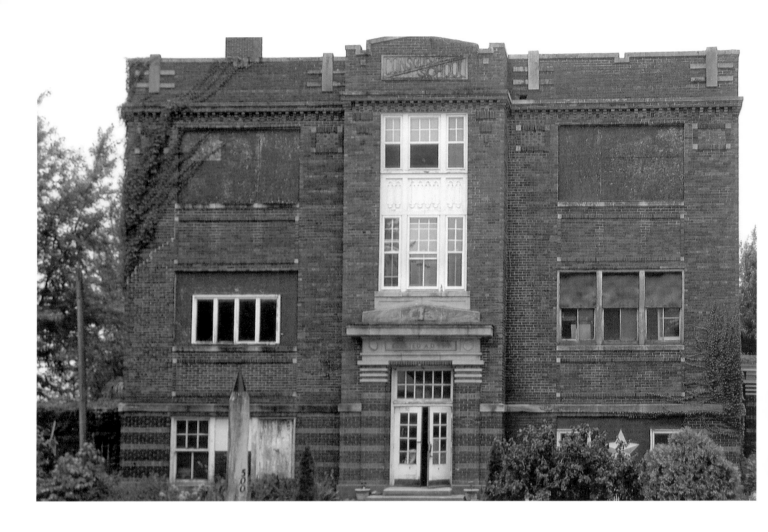

Guernsey | Poweshiek County | Orange/Black | Hawks

Through Rain and Snow

The development of school transportation

Through Rain and Snow
The development of school transportation

Although many Iowa communities had schools in the early 1900s and towns were close to each other, children living on farms had to find a way to get to school. Initially they walked, rode horses, or were taken to school by their parents. In 1913 the Kirkman School was consolidated. According to a plaque outside the school, high school boys drove four horse-drawn hacks, a type of carriage made of timber, to pick up and deliver kids to school. About 50 students were hauled to school every day. In 1914 the horse-drawn hacks delivered their passengers to the schoolhouse every day with the exception of two days when students were only slightly tardy.

Later, horse-drawn buses replaced the hacks. The horse-drawn buses were then replaced with Model T Ford or Chevrolet trucks. In Lake Center the trucks were equipped with an enclosed box with possibly a window and a door in the rear. The

buses were ten feet long and four feet wide. They were cold. Raymond Olson, quoted in a *Sioux City Journal* article, noted, "There were times in the coldest weather that little kids would bring a hot brick wrapped in a sack, and they would put their feet on them on their way to school."[i]

Bus transportation across the state of Iowa became available in almost all districts in the 1920s and 1930s. By 1919, all 48 states in the contiguous United States had laws allowing the use of public funds for transporting children to school. Today in the United States 480,000 buses transport 26 million children to and from school every day. Over half of the country's student population is transported by buses. ◆

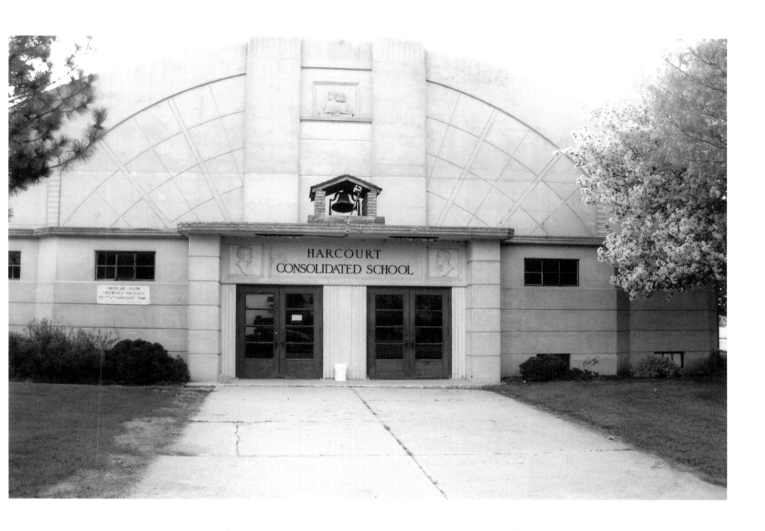

Harcourt | Webster County | Black/Gold | Hornets

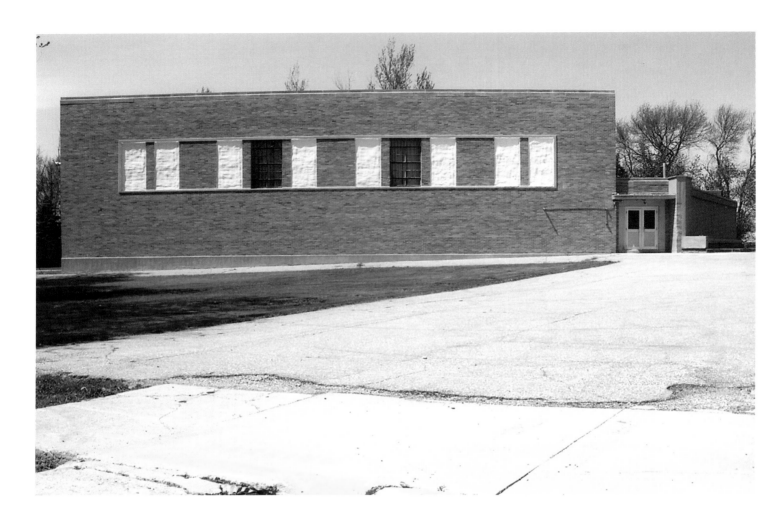

Harris | Osceola County | Purple/White | Panthers

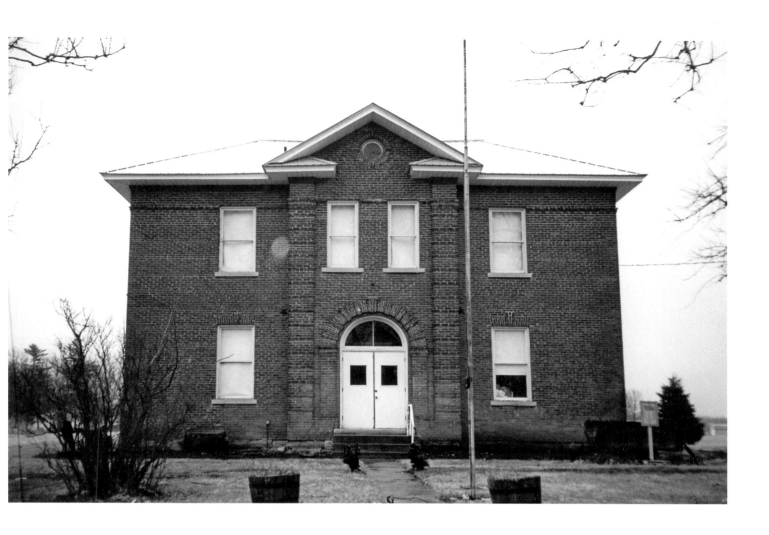

Harvey | Marion County

A memorial has been erected on the Harvey school site, "In Memory of the Deep Coal Miners."

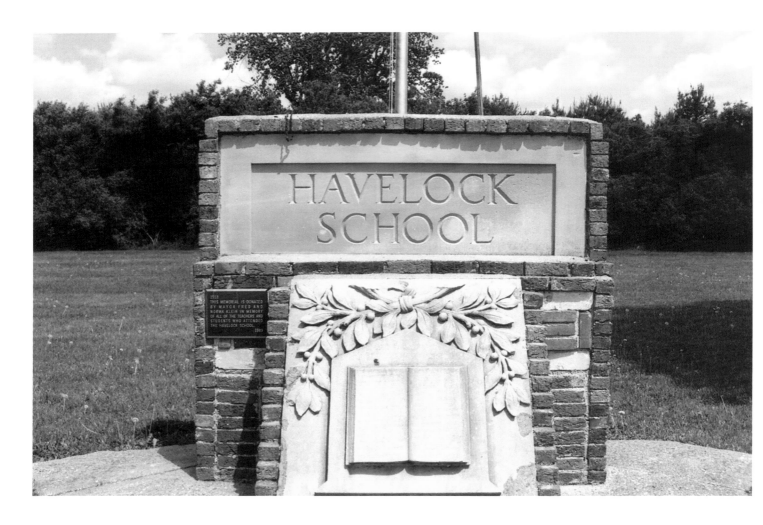

Havelock | Pocahontas County | Blue/White | Eagles

A memorial is dedicated to teachers and students.

Girls State Basketball Tournament Semifinalists, 1942

Girls State Basketball Tournament Runner-Up, 1943

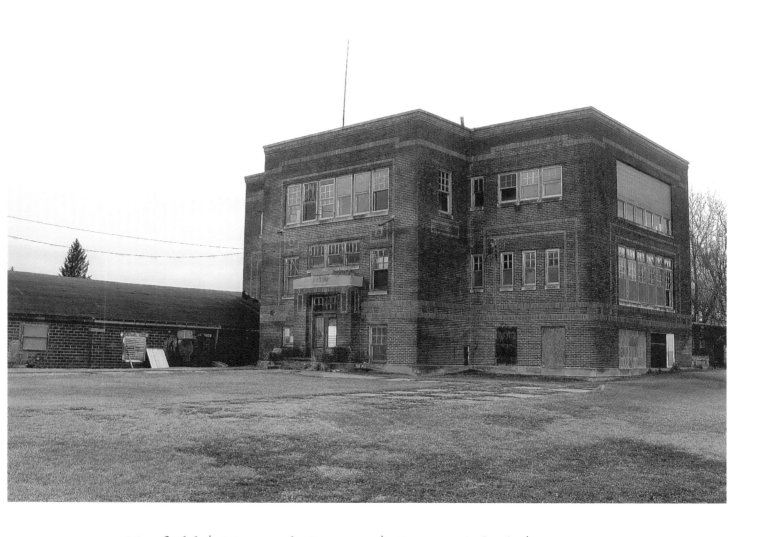

Hayfield | Hancock County | Orange/Black | Hornets
Built in 1916.

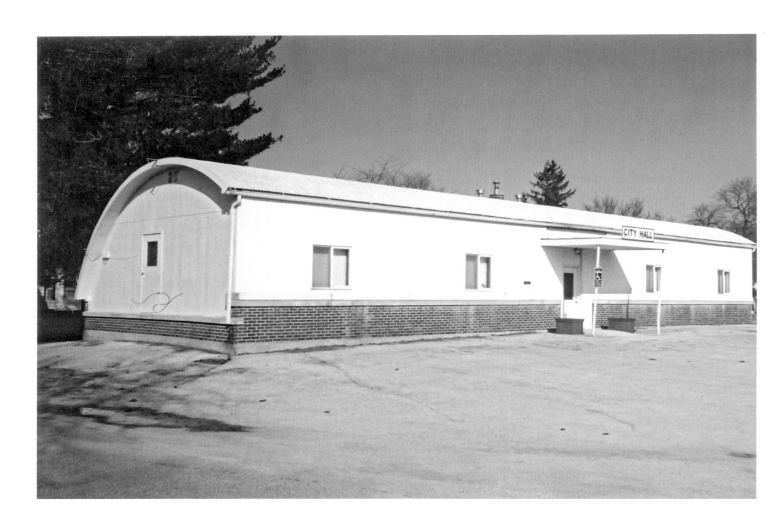

Hazelton | Buchanan County | Orange/Black | Tigers

The Hazelton High School now serves as the city hall. A gentleman commented,
"It [the school] was tore down. When the school goes, the churches do too. It's a shame."

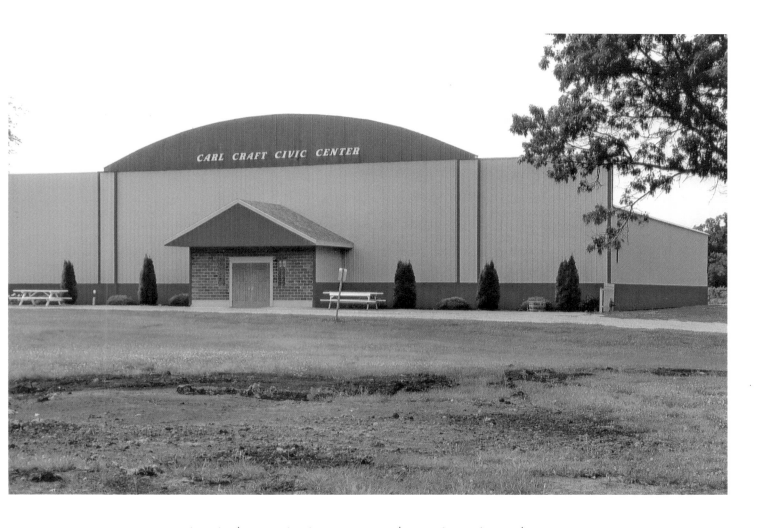

Hedrick | Keokuk County | Red/White | Foxes

Nan Doak, Track and Field Hall of Fame, 1980

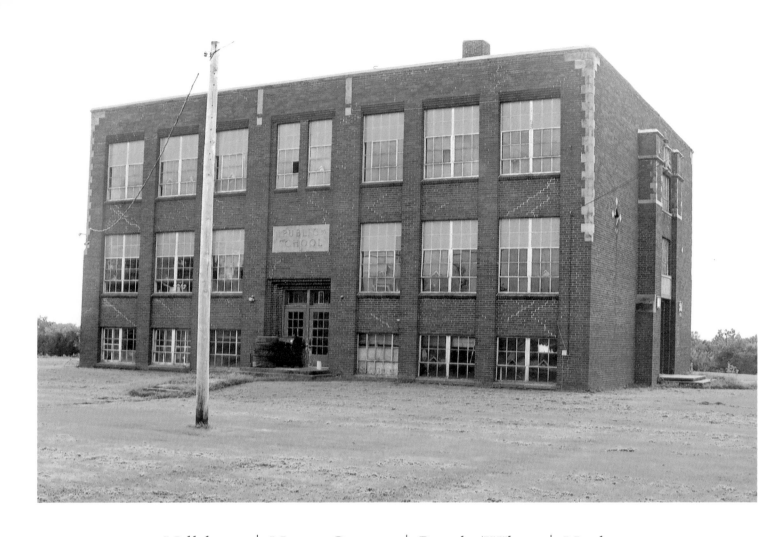

Hillsboro | Henry County | Purple/White | Huskies

Girls State Basketball Tournament, Second Place, 1933, 1935

Mildred Moore, Basketball Hall of Fame, 1935

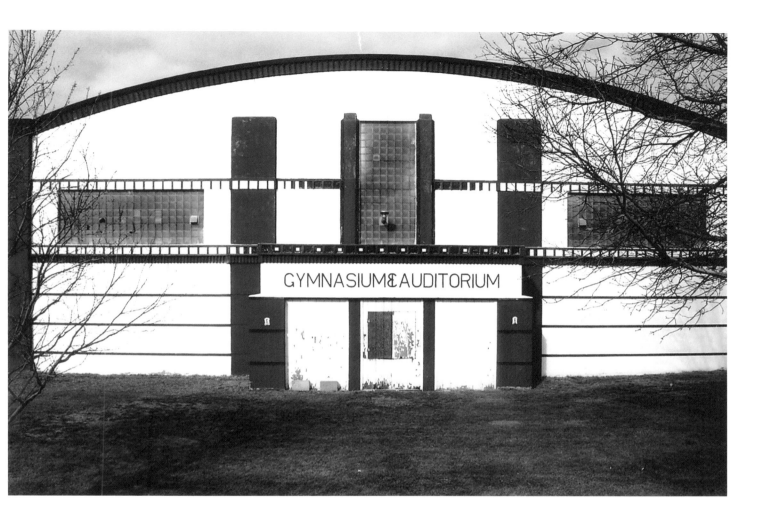

GYMNASIUM & AUDITORIUM

Holly Springs | Woodbury County | Orange/Black | Ramblers later became Hornets

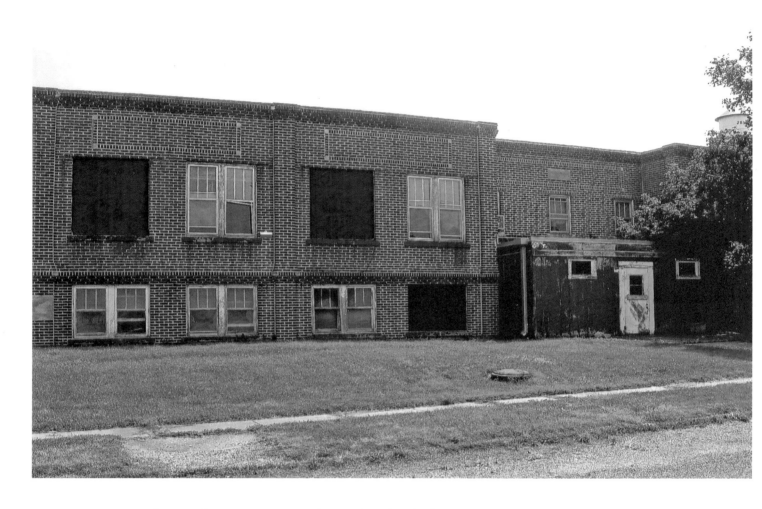

Jamaica | Guthrie County | Red/Black | Wildcats later became Raiders

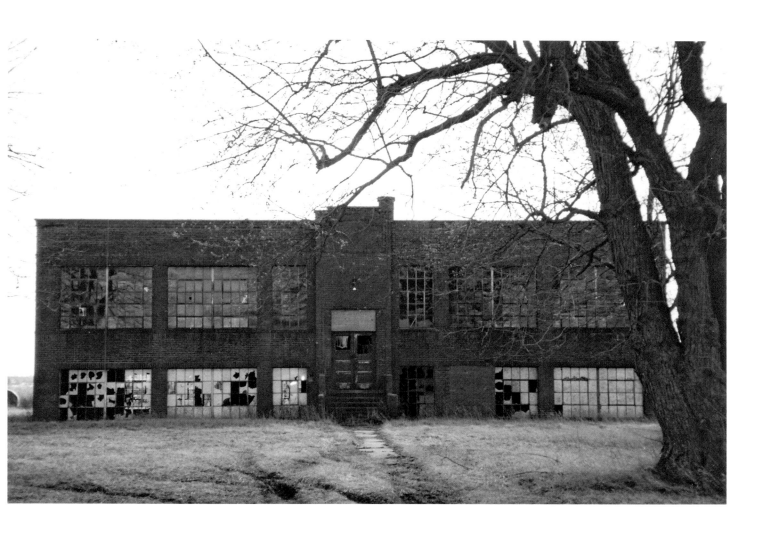

Jerome | Appanoose County

It is said that Jerome never had athletic teams.

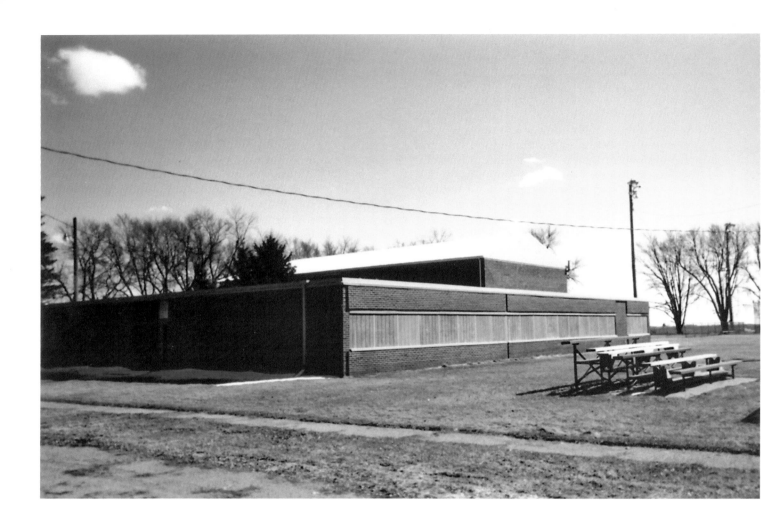

Joice | Worth County | Black/White | J-Hawks

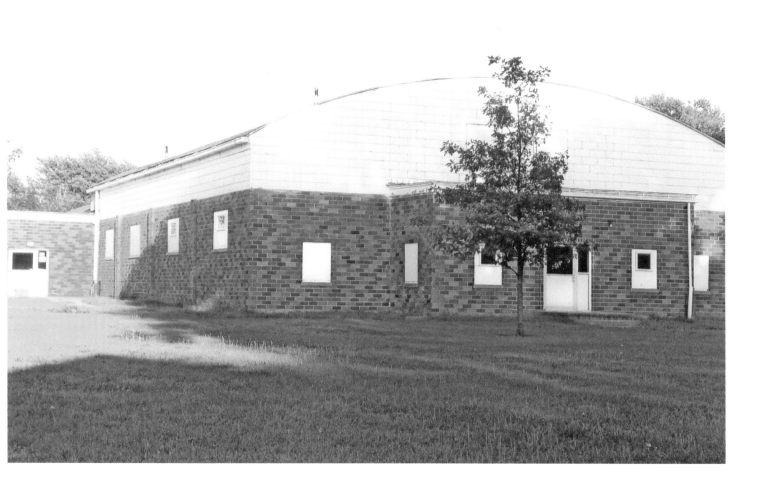

Kellerton | Ringgold County | Purple/Gold | Tigers

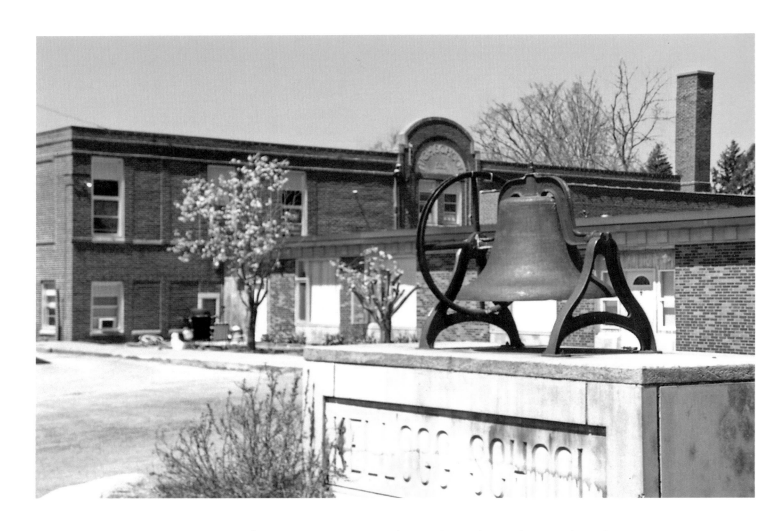

Kellogg | Jasper County | Red/White | Cardinals

The first Kellogg school was built in 1903 and the second school was built in 1923.
Kellogg joined Newton in 1957.

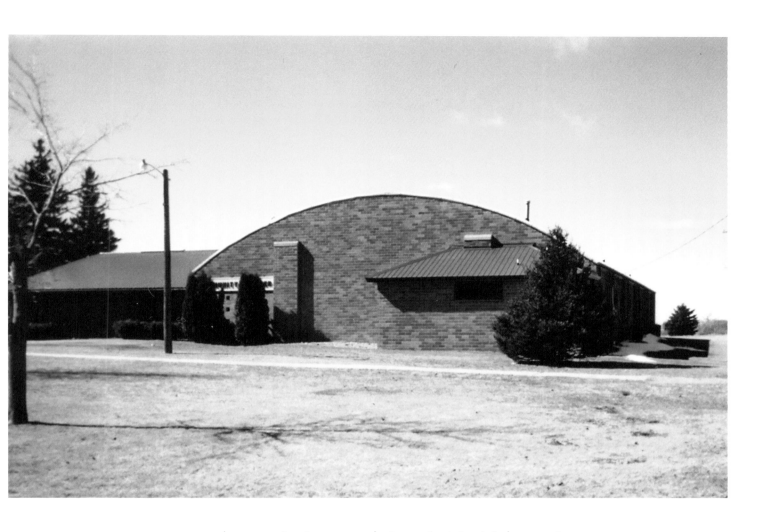

Kensett | Worth County | Purple/Gold | Rockets

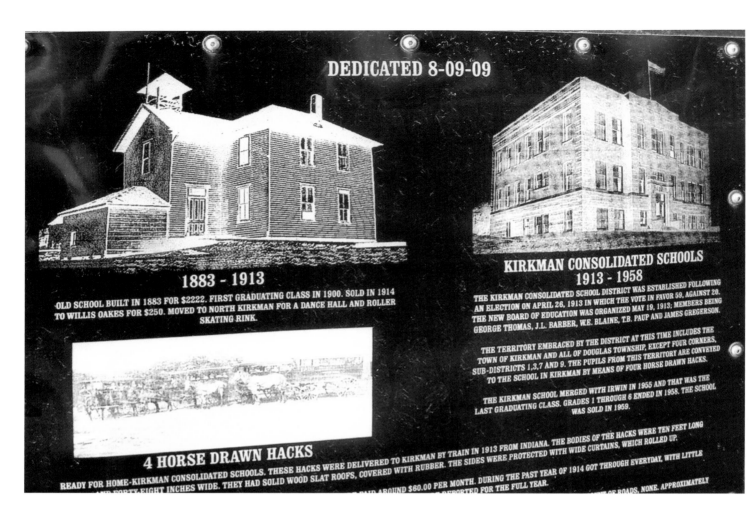

DEDICATED 8-09-09

1883 - 1913
OLD SCHOOL BUILT IN 1883 FOR $2222. FIRST GRADUATING CLASS IN 1900. SOLD IN 1914 TO WILLIS OAKES FOR $250. MOVED TO NORTH KIRKMAN FOR A DANCE HALL AND ROLLER SKATING RINK.

KIRKMAN CONSOLIDATED SCHOOLS
1913 - 1958
THE KIRKMAN CONSOLIDATED SCHOOL DISTRICT WAS ESTABLISHED FOLLOWING AN ELECTION ON APRIL 26, 1913 IN WHICH THE VOTE IN FAVOR 59, AGAINST 20. THE NEW BOARD OF EDUCATION WAS ORGANIZED MAY 19, 1913; MEMBERS BEING GEORGE THOMAS, J.L. BARBER, W.E. BLAINE, T.B. PAUP AND JAMES GREGERSON.

THE TERRITORY EMBRACED BY THE DISTRICT AT THIS TIME INCLUDES THE TOWN OF KIRKMAN AND ALL OF DOUGLAS TOWNSHIP, EXCEPT FOUR CORNERS, SUB-DISTRICTS 1,3,7 AND 9. THE PUPILS FROM THIS TERRITORY ARE CONVETED TO THE SCHOOL IN KIRKMAN BY MEANS OF FOUR HORSE DRAWN HACKS.

THE KIRKMAN SCHOOL MERGED WITH IRWIN IN 1955 AND THAT WAS THE LAST GRADUATING CLASS. GRADES 1 THROUGH 6 ENDED IN 1958. THE SCHOOL WAS SOLD IN 1959.

4 HORSE DRAWN HACKS
READY FOR HOME-KIRKMAN CONSOLIDATED SCHOOLS. THESE HACKS WERE DELIVERED TO KIRKMAN BY TRAIN IN 1913 FROM INDIANA. THE BODIES OF THE HACKS WERE TEN FEET LONG AND FORTY-EIGHT INCHES WIDE. THEY HAD SOLID WOOD SLAT ROOFS, COVERED WITH RUBBER. THE SIDES WERE PROTECTED WITH WIDE CURTAINS, WHICH ROLLED UP. PAID AROUND $60.00 PER MONTH. DURING THE PAST YEAR OF 1914 GOT THROUGH EVERYDAY, WITH LITTLE REPORTED FOR THE FULL YEAR. OF ROADS, NONE. APPROXIMATELY

Kirkman | Shelby County | Black/Red | Wildcats

Former news commentator Lowell Thomas lived in Kirkman as a boy.

Klemme | Hancock County | Green/White | Shamrocks

The Pride of the Town

Sports, music, and other student activities

The Pride of the Town

Sports, music, and other student activities

From the early years of rural Iowa to today, student activities have been woven into the social fabric of small towns. People attend student activities even after their children have graduated, as the school is a meeting place for families and friends. There are many in Iowa's communities who can clearly recall and spin a tale about critical games or extraordinary fine arts performances.

Baseball was one of the earliest sports in America. The game emerged in the 1840s and became America's game, later known as America's pastime, after the Civil War. It was no surprise that baseball became an Iowa high school sport. Girls softball followed shortly after.

Interscholastic football and basketball competitions began in the 1880s and 1890s in Iowa high schools. The Iowa High School Athletic Association (IHSAA) organized in 1904. The initial cost of school membership in the association was $2.50. The first IHSAA member schools in 1904 were:

- Grinnell
- Central High School-Sioux City
- Charles City
- Harlan
- North High School-Des Moines
- East High School-Des Moines
- Dubuque
- Cherokee
- Red Oak
- Ottumwa
- Ida Grove
- Iowa City
- New Hampton
- Stuart[ii]

Until 1926, boys and girls sports were included in the IHSAA. At that time, the Iowa Girls High School Athletic Union (IGHSAU) was formed. In the early years, football, boys and girls basketball, baseball, girls softball, and boys track were offered

to students. Later girls volleyball, girls track, boys and girls cross country, wrestling, boys and girls golf, boys and girls tennis, and boys and girls swimming were added as student sports. In recent years, boys and girls bowling and shooting teams have emerged in Iowa's schools.[iii]

State tournaments are now held in all sports, adding to community excitement. Rivalries in small schools have been intense and have contributed to school community lore. Stories are still told in Holstein about critical girls basketball games coached by Russ Kraai. People lined up early for rivalry tournament games and the gym reached capacity long before games started. That was and is typical in many communities. Mascots and school colors are held dear and revered. Once a scarlet and white Tracy Bobcat, always a Tracy Bobcat—though the school may be long closed.

There are residents of Calumet who can still replay games and accurately recite scores of when Calumet went to the state boys basketball tournament in five consecutive years—1957, '58, '59, '60, and '61. They can tell you about beating Ames and Davenport in the tournament in 1961. Delmar Dau and Dennis Runge are household

names. Likewise, sports fans in Union and Whitten can tell you about Denise Long, 1968-69 Girls Basketball Hall of Famer, and give a quarter-by-quarter account of the state championship game with the Everly Cattlefeeders and Jeanette Olson. Or how about the Melrose Shamrocks, the smallest school ever to win a single class boys basketball title in 1937? The 1937 Shamrocks, who were 33-0, were recognized by the Des Moines Register in 2012 as one of the ten best state tournament teams in Iowa high school basketball history. Who in northwest Iowa can forget the longest basketball game in Iowa history played between Lytton and Crestland, February 2, 1982? As the story goes, Arnie Koeppen played nine overtimes on a broken ankle. Tim Helmbrecht hit two free throws to give Lytton the 96-94 victory. It is the fourth longest high school basketball game in U. S. history. Or how about the lowest scoring girls basketball game between Melvin and Sibley in 1979? The district tournament game was tied 0-0 at the end of regulation. Melvin won 4-2 in four overtimes.

It is unlikely anyone in Palmer has forgotten the three boys state basketball championships from 1986-88 and the 103-game winning streak. Those around Rembrandt, the smallest school in the state in 1979, remember Keith Stroup's 61 points in a basketball game against Meriden in 1960 and recall games pitched by Softball Hall of Famer Valerie Haraldson. What Cheer is the home of the late Ed Thomas, who

had an illustrious football coaching career at Parkersburg and Aplington-Parkersburg, coaching four high school players who later played in the National Football League. Ed was the NFL High School Coach of the Year in 2005. Similar stories can be recounted across the state and are a part of the culture of many Iowa communities. So many Iowa schools have so many stories to tell.

Sixteen years after the Iowa High School Athletic Association was formed, Rockford Superintendent G.T. Bennett contacted all schools in Iowa that had six or more teachers. His purpose was to suggest a statewide music contest series for the following spring. A year later, in the spring of 1921, regional contests were held. The Iowa Musical Activities Association was formed in November 1921. This was the beginning of orchestra and vocal competitions in Iowa high schools. The first state high school music festival was held in Iowa City in 1926. The name of the Iowa Musical Activities Association was later changed to the Iowa High School Music Association in 1929.[iv]

Nineteen thirty-one saw the emergence of marching band competitions. State contests for marching bands were moved to the fall of 1939 with 72 participating schools. By 1941 there were 641 members in the Iowa High School Music

Association. The All-State Music Festival, Large Group Contest/Festival, Solo/ Small Ensemble Festivals, All-State Chorus, Piano Festival, and Show Choir/Jazz Band Festivals were organized in the years that followed and schools eagerly engaged their students.[v]

Speech and debate were also available to students in Iowa's schools, and students began entering in state events. The Iowa High School Declamatory Association was established in 1887. The first state declamatory final was held in the Opera House in State Center. In 1943 the Iowa Interscholastic Speech Association was formed. In the early 1950s the name was changed to the Iowa High School Speech Association.[vi] Drama, theater, dinner theater, and musical productions further expanded school activities for students and became additional sources of school and community pride.

It is clear in Iowa's history that the epicenter of social activity in small rural communities was the school and student activities. Perhaps in no other facet of community life has so much happened, so much been told, and so much remembered as in events surrounding school and student accomplishments. ◆

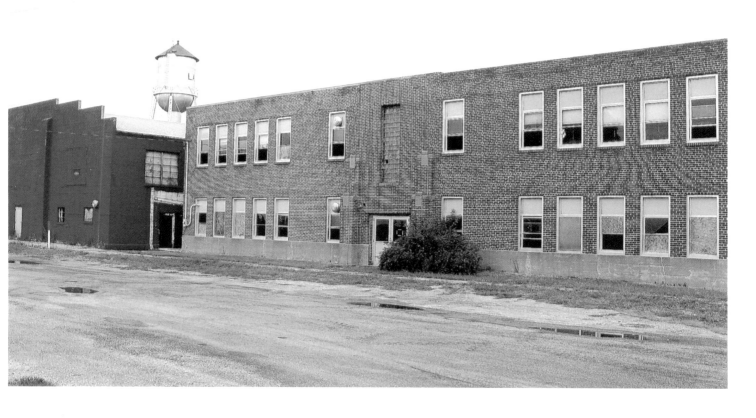

Ladora | Iowa County | Blue/White later became Scarlet/Black | Panthers

Birthplace of Mildred Benson, author of the Nancy Drew mysteries.

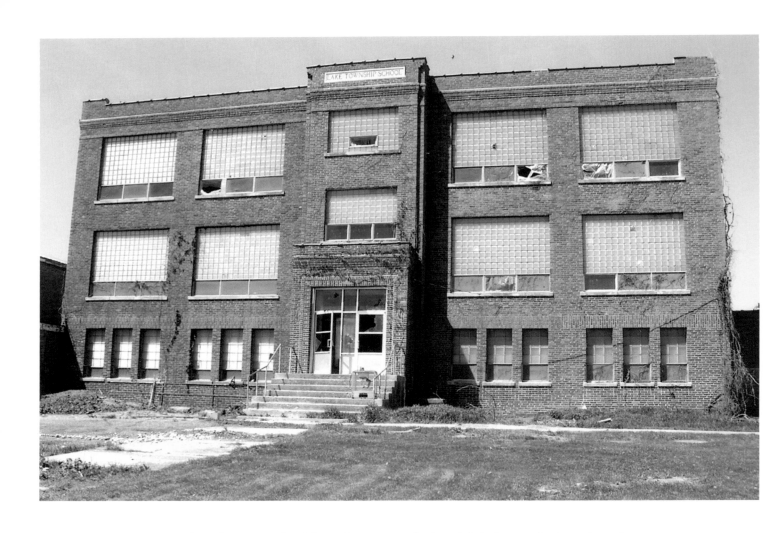

Lake Center | Clay County | Red/White | Cardinals

Lake Center was the first consolidated school in the state of Iowa.

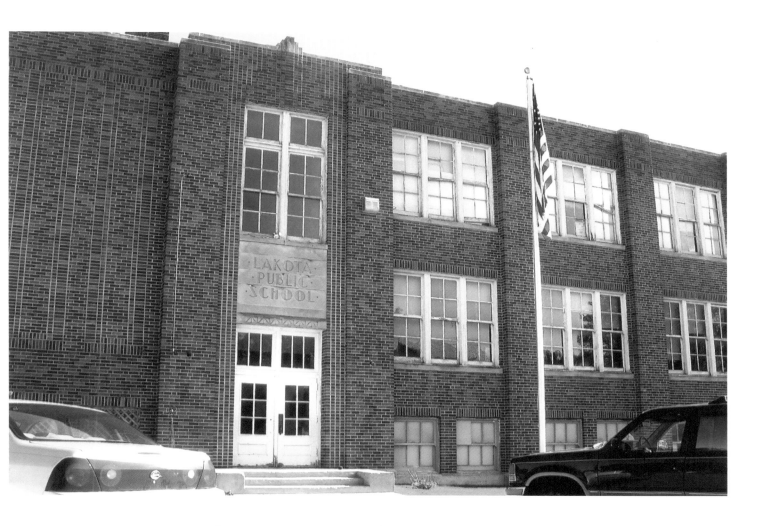

Lakota | Kossuth County | Purple/White | Eagles

The Lakota school now serves as apartments and a banquet center.
Lakota is said to be the site of the first open enrollment in Iowa.

LaMoille | Marshall County | Orange/Black | Panthers

Played in first 16-Team Boys State Basketball Tournament, 1930

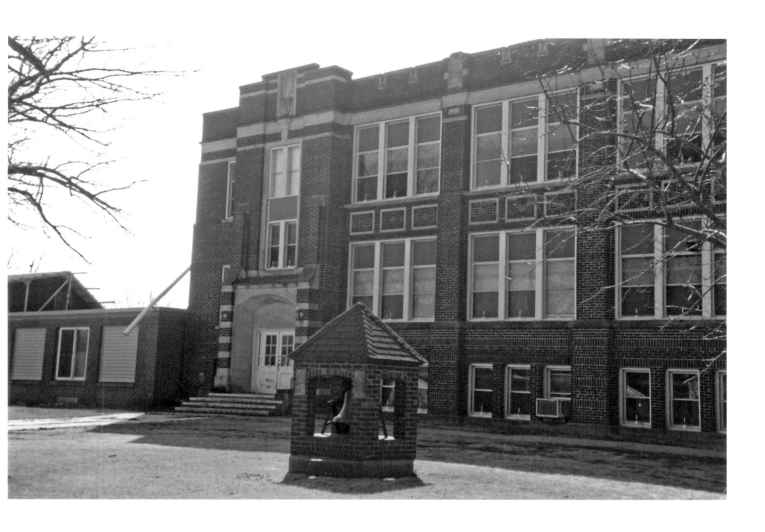

Lamont | Buchanan County | Orange/Black later became Black/Gold | Bulldogs

The Lamont school is now home to a sign company.

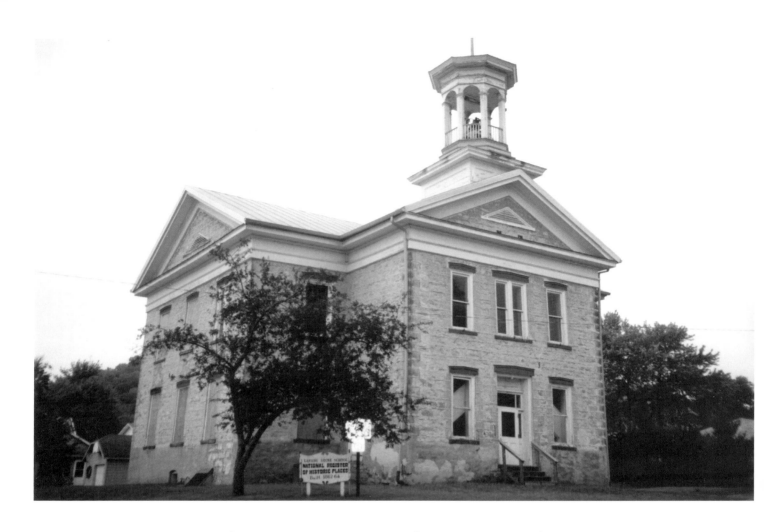

Lansing | Allamakee County | Red/White | Cardinals

The Lansing school is listed on the National Register of Historic Places. The school was built in 1863.

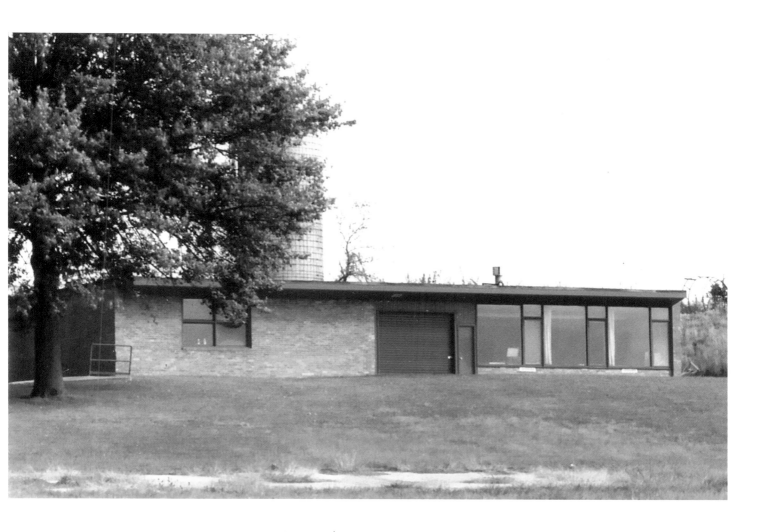

Leighton | Mahaska County

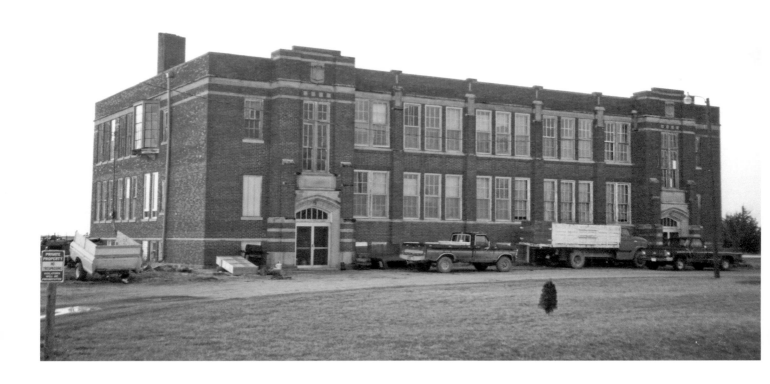

LeRoy | Decatur County | Black/Orange

In the 2000 census, LeRoy was the second smallest populated incorporated city in Iowa.
It now shares the title of the smallest populated incorporated city with Beaconsfield.

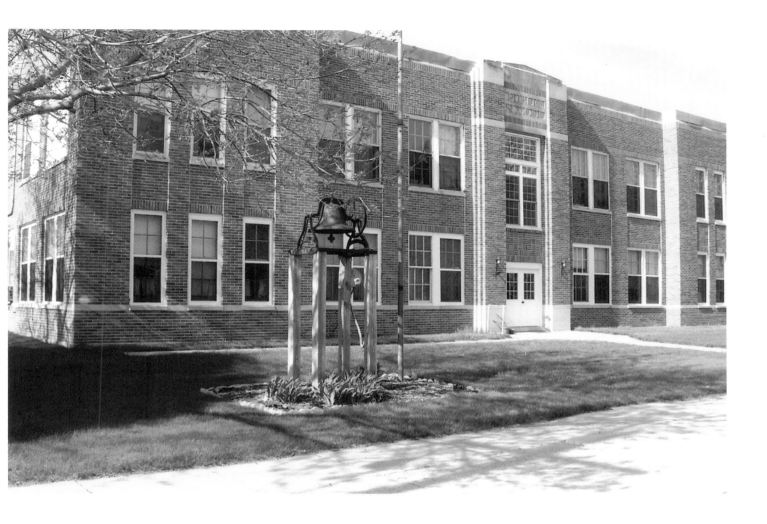

Lester | Lyon County | Blue/Yellow | Goldfinches

Originally called Hastings, the name was changed to Lester after Lester Cleveland, a 13-year-old boy who died in the blizzard of 1888. Lester became a school district in 1895.

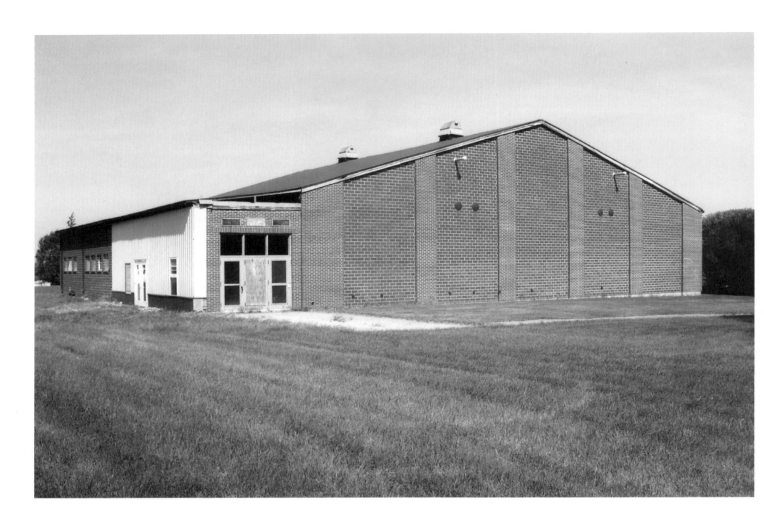

Linn Grove | Buena Vista County | Blue/Gold | Tigers later became Bulldogs

Lohrville | Calhoun County | Red/White/Black | Blackhawks

Kelli Riedesel, Girls Track and Field Hall of Fame, 1988

Lorimor | Union County | Old Gold/Black | Indians

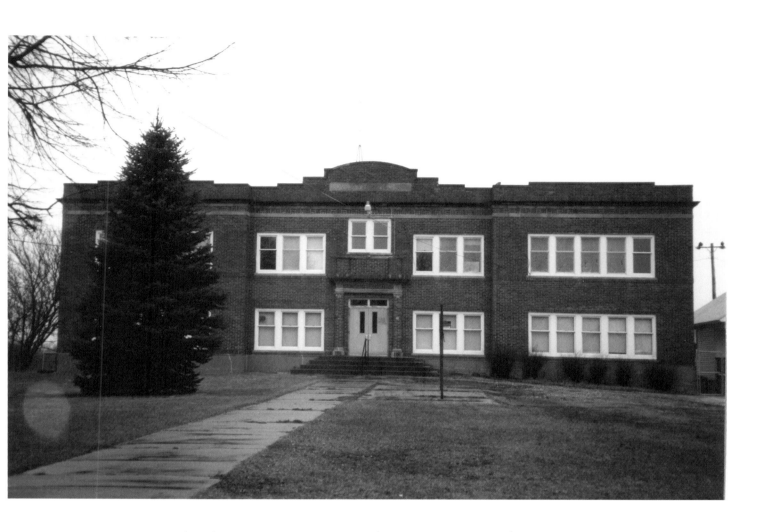

Lovilia | Monroe County | Purple/Gold | Comets

"The coal mining center of Iowa."

Lucas | Lucas County | Red/Gold

Home of the Big Hill Coal Mine, where John Lewis, United Mine Workers of America, found his first job.
Home of George Bennard, composer of "The Old Rugged Cross."
Thomas Williams was the school principal at age 18 in 1885.

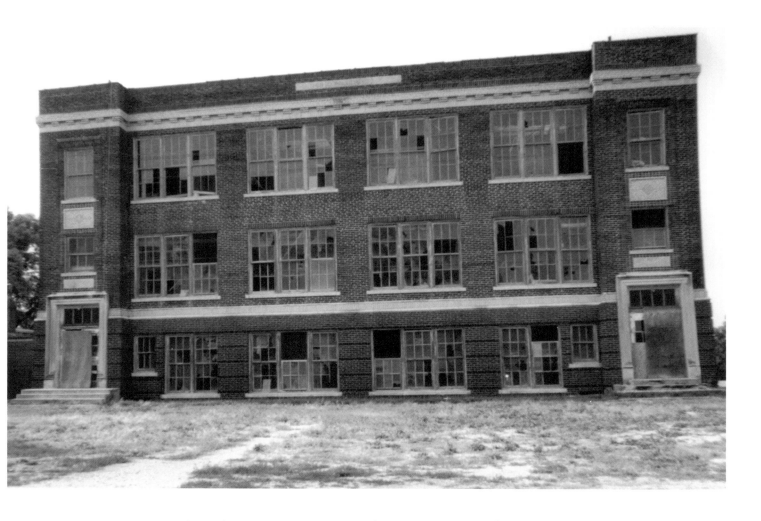

Luther | Boone County | Red/White | Rockets

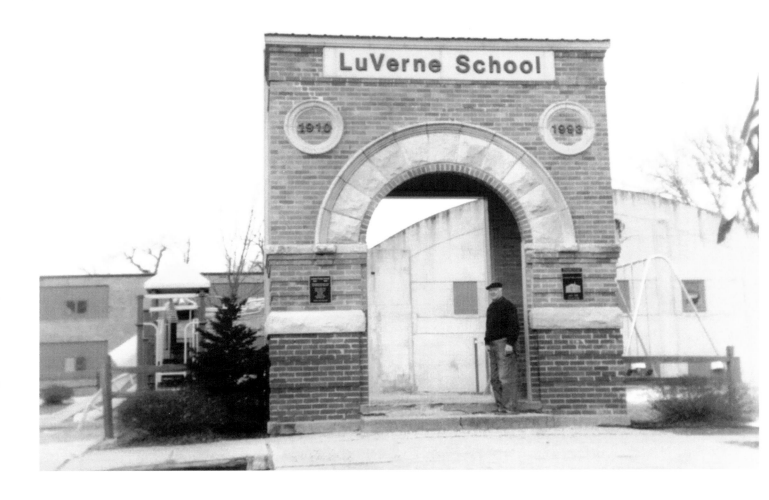

LuVerne | Kossuth County | Purple/White | Lions

Boys State Basketball Tournament Runner-Up, 1921

Class C Boys State Track and Field Champions, 1960

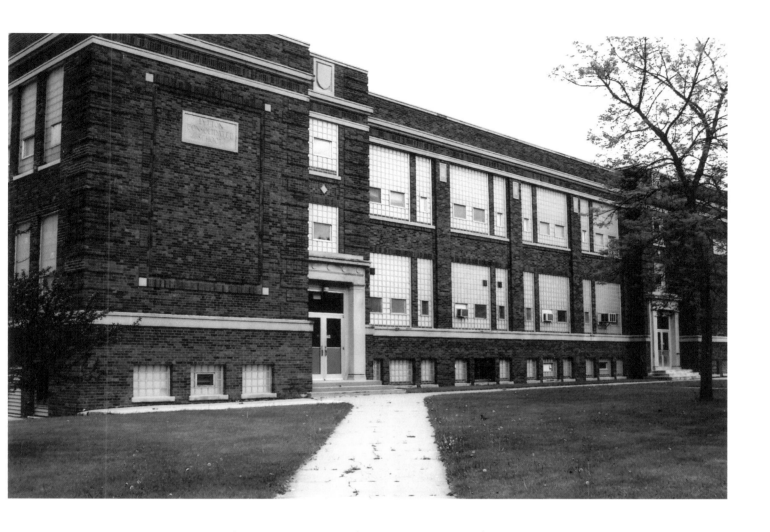

Lytton | Sac County | Black/Gold | Bulldogs

Lytton and Crestland of Early played the longest boys basketball game in Iowa history February 2, 1982. The game went to nine overtimes.

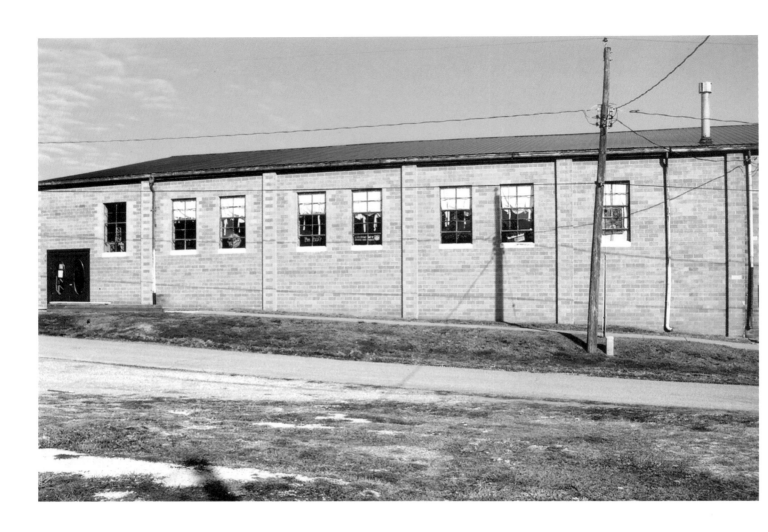

Magnolia | Harrison County | Green/White | Wildcats

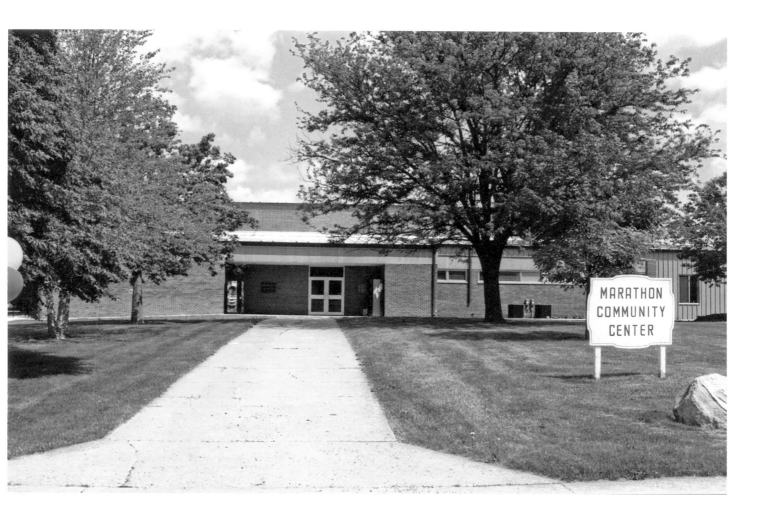

Marathon | Buena Vista County | Maroon/White | Minettes (Girls)/Minutemen (Boys)

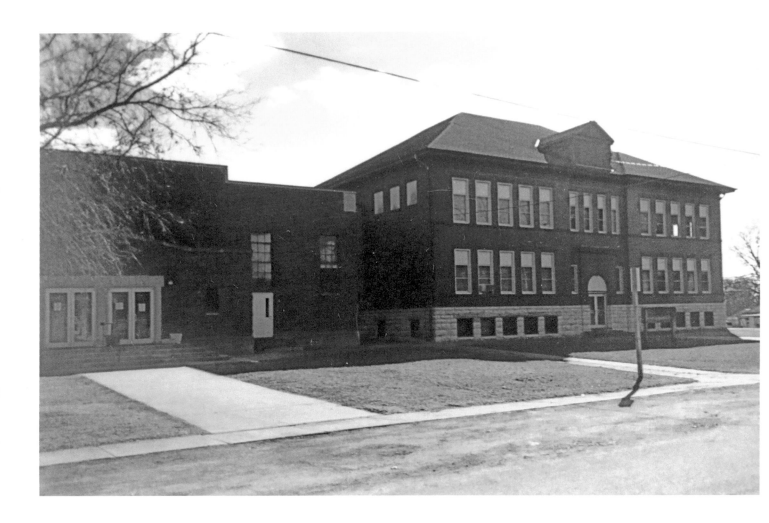

Marble Rock | Floyd County | Red/White | Rockets

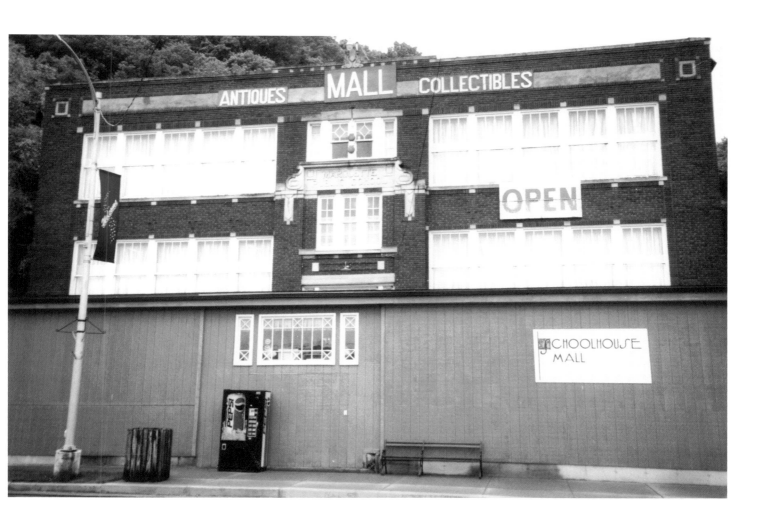

Marquette | Clayton County | Purple/Gold | Railroaders

Marquette High School is a thriving antique mall today.

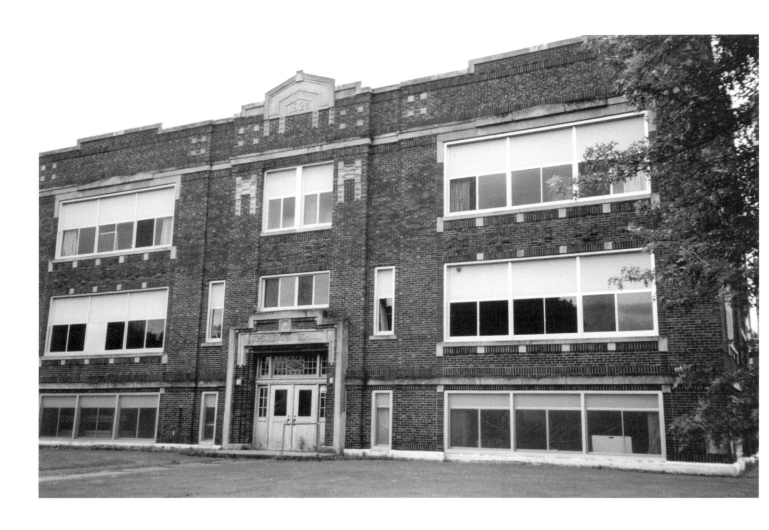

Martelle | Jones County | Blue/Gold | Golden Eagles

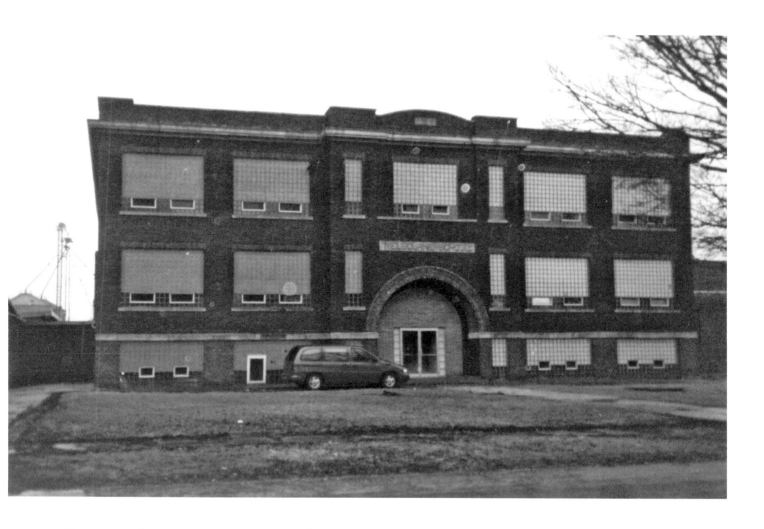

Melbourne | Marshall County | Purple/Gold | Wildcats later became Tigers

Melrose | Monroe County | Green/White | Shamrocks

The town is known as Little Ireland. The boys basketball team won the state basketball tournament in 1937, making the Shamrocks the smallest school ever to win a single class state basketball title in Iowa. The 1937 team was 33-0 and the first undefeated boys basketball team in Iowa history.

Basketball Hall of Famers: Walt Connor, 1937; Jim Thyne, 1939; Donald Knowles, 1940

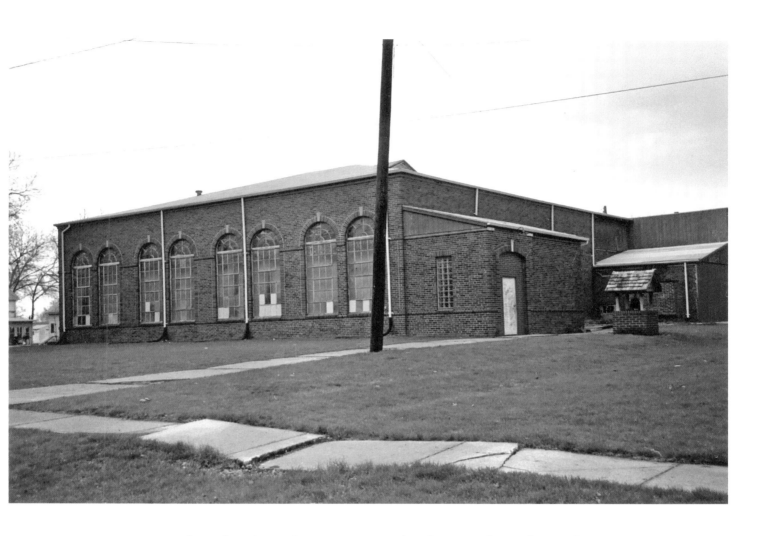

Meriden | Cherokee County | Blue/White | Eagles

Millerton | Wayne County | Green/White | Waves

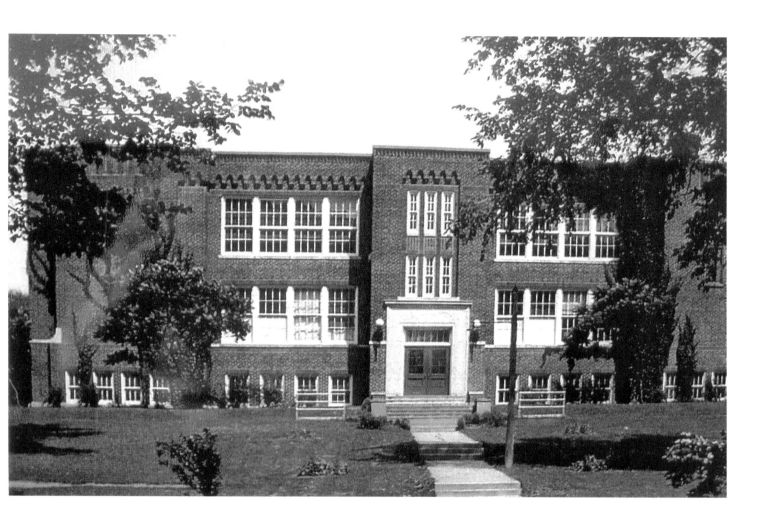

Milton | Van Buren County | Red/Black | Red Devils

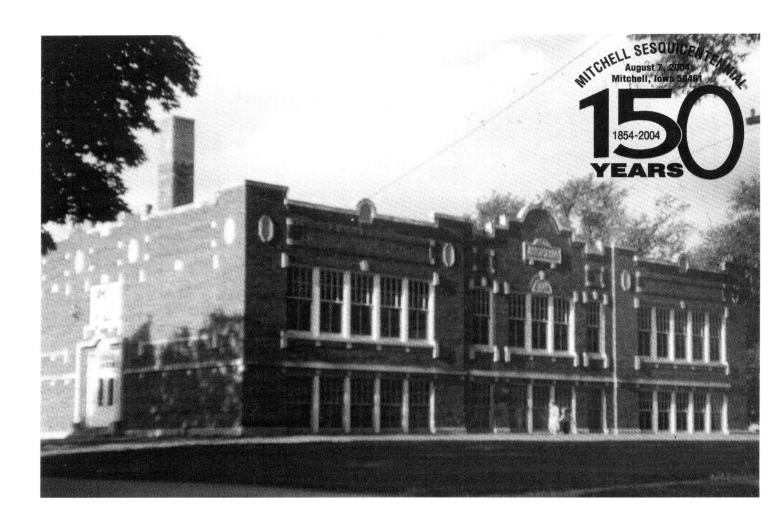

Mitchell | Mitchell County | Orange/Black

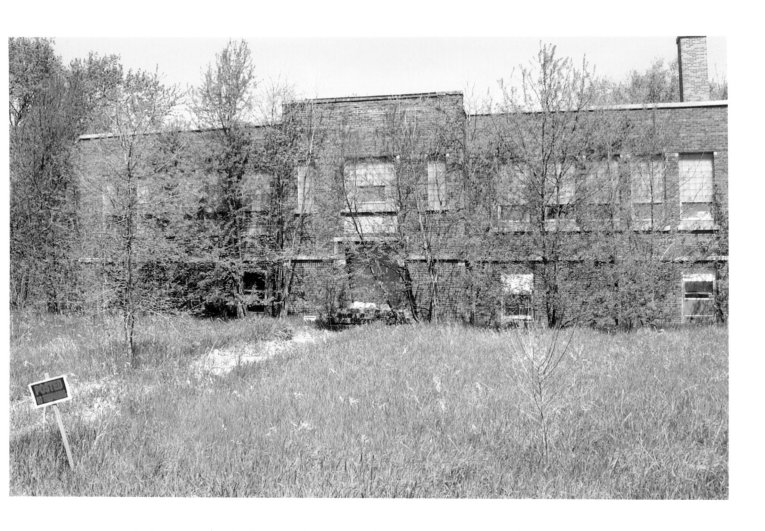

Moneta | O'Brien County | Orange/Black | Bulldogs

*Moneta is the home of Vicki Myron, author of the series on
Dewey, the cat who made his home in the Spencer Library.*

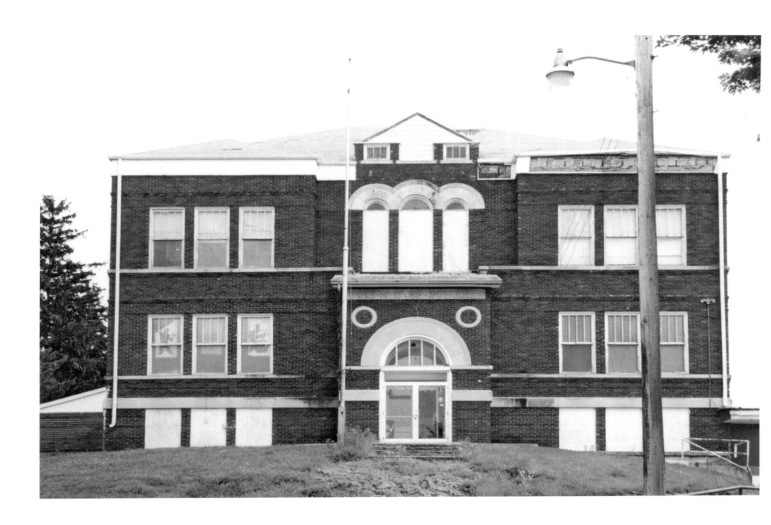

Monmouth | Jackson County | Purple/Gold | Mohawks

Consolidated with Center Junction, Onslow, and Wyoming to form Midland in 1962.

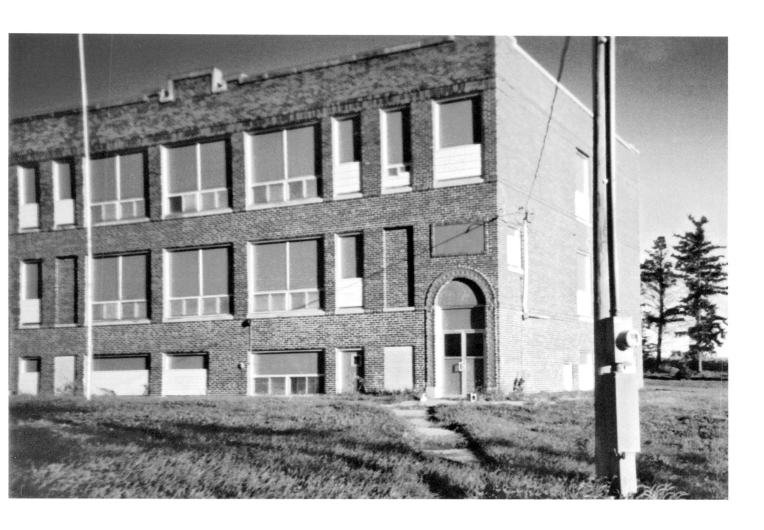

Montour | Tama County | Red/Black | Cardinals

Played in the 1943 Boys State Basketball Tournament when qualifiers were reduced to eight teams due to rationing in WWII.

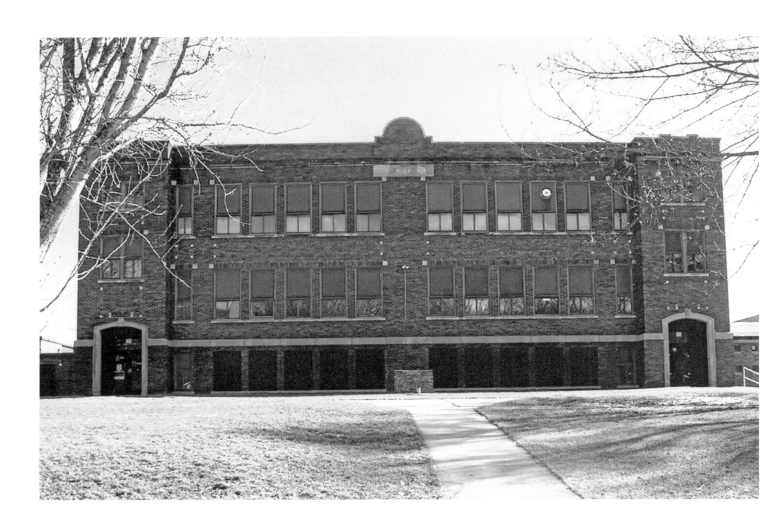

Moorhead | Monona County | Old Gold/Black | Vikings

In the heart of Loess Hills.

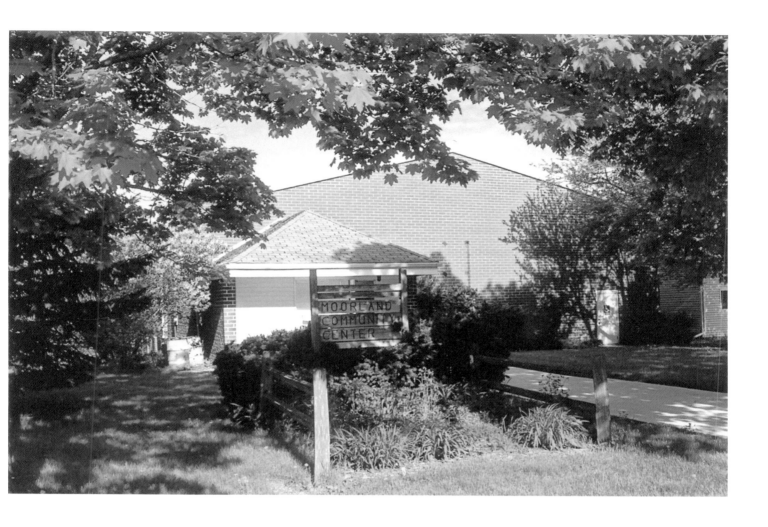

Moorland | Webster County | Purple/Gold | Mohawks

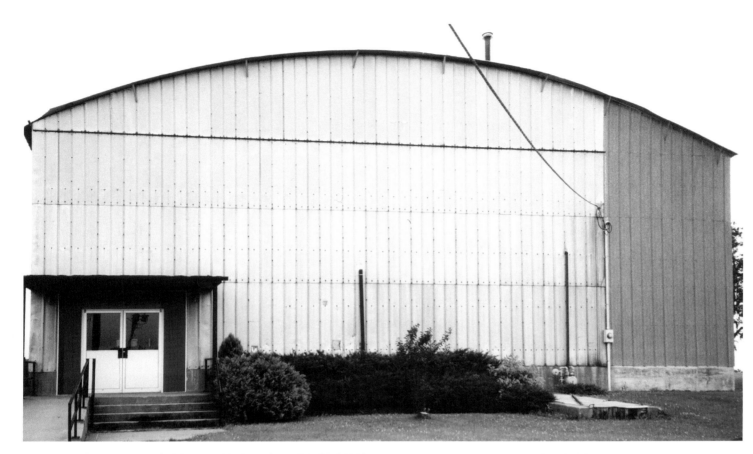

Morley | Jones County | Orange/Black | Tigers

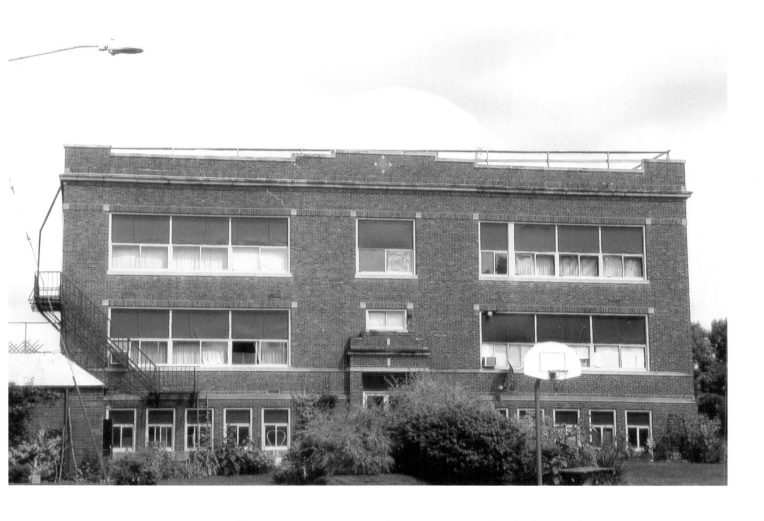

Mt. Union | Henry County | Orange/Black | Eagles

Mosquitoes and Minute Men

The diversity of school colors and mascots

Mosquitoes and Minute Men

The diversity of school colors and mascots

As athletic and fine arts opportunities for students grew, so did the pride in school colors and school mascots. Students not only were proud of their performances, they were equally proud of performing for their school symbols. The Ashton blue and white Bombers, the green and white Beaver Beavers, Doon blue and gold Dragons, Farragut blue and white Admirals (boys) and Adettes (girls), Fox Valley green and white Trotters, Grand Meadow maroon and gold Larks, Marathon red and white Minute Men (boys) and Minuettes (girls), Panama Public Mosquitoes, Sheffield Clay Diggers, Rockford blue and white RoHawks, Tingley Toppers, Zion purple and gold Zephers, and Zwingle Zippers were just a few of the unique and prized mascots and colors throughout Iowa.

The Owasa School District had no mascot, which was highly unusual in Iowa schools. On occasion the mascots changed. Volga started out as the Boatmen and later became the Bluejays. The Williams boys were the Corn Huskers and the girls the Red Birds. Williamson had red and white colors initially and then red and black. The Wiota mascot was the Little Giants in the 1940s, became the Blue Racers in the 1950s, and then the Panthers in the 1960s. Depending on who you listened to, Gravity High School was the Bears or the Grizzlies.[vii] ◆

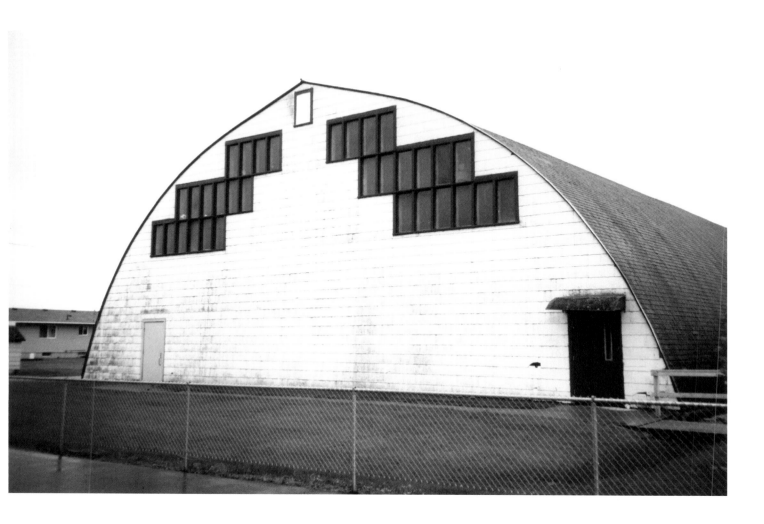

New Albin | Allamakee County | Purple/Gold | Eagles

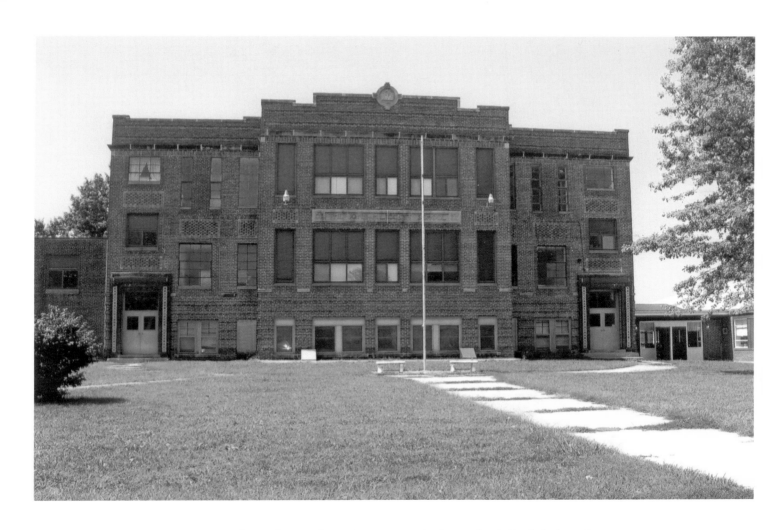

New Market | Taylor County | Purple/Gold | Miners

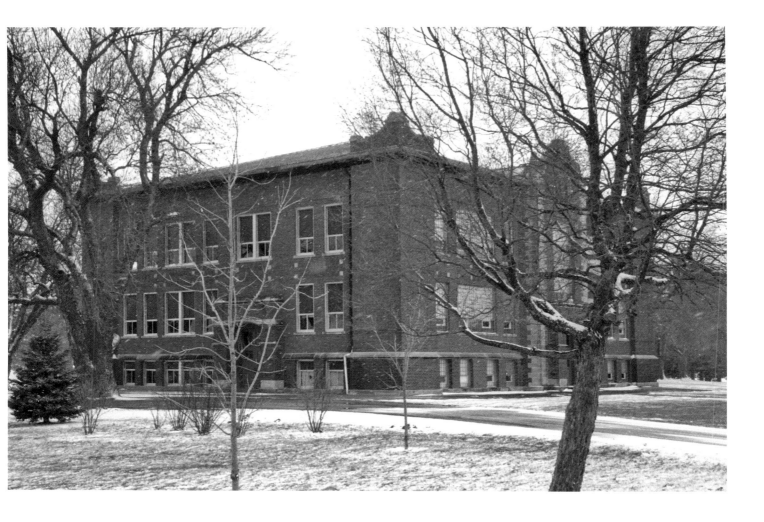

New Providence | Hardin County | Blue/White | Indians

The school was built in 1936 as a Works Progress Administration project. It is famous for the Roundhouse Gym, which is on the Historic Register . Omelet Day is held here in April.

Girls State Basketball Tournament, Second Place, 1946

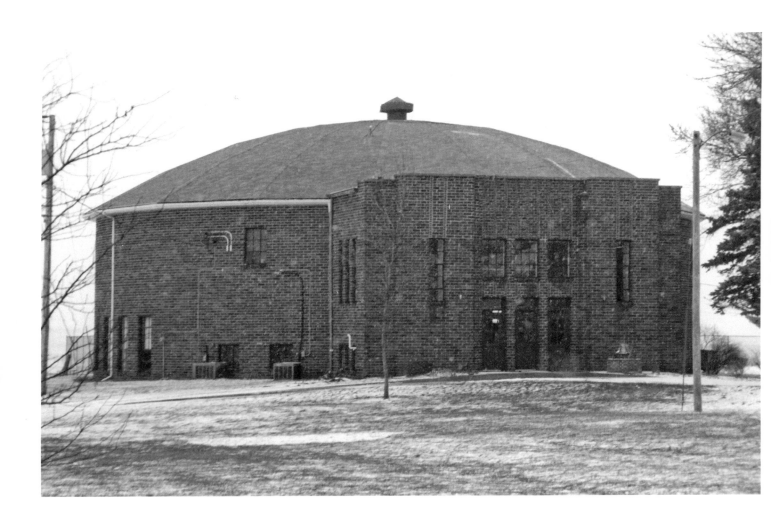

New Providence Roundhouse Gym

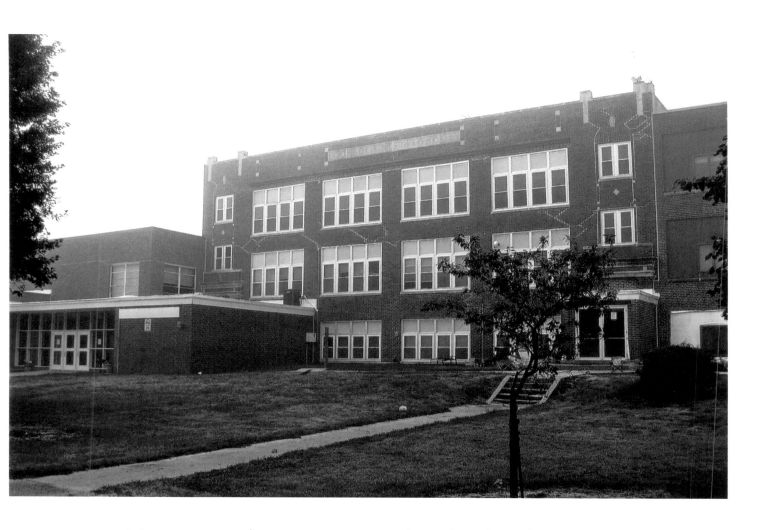

New Virginia | Warren County | Red/White | Rockets

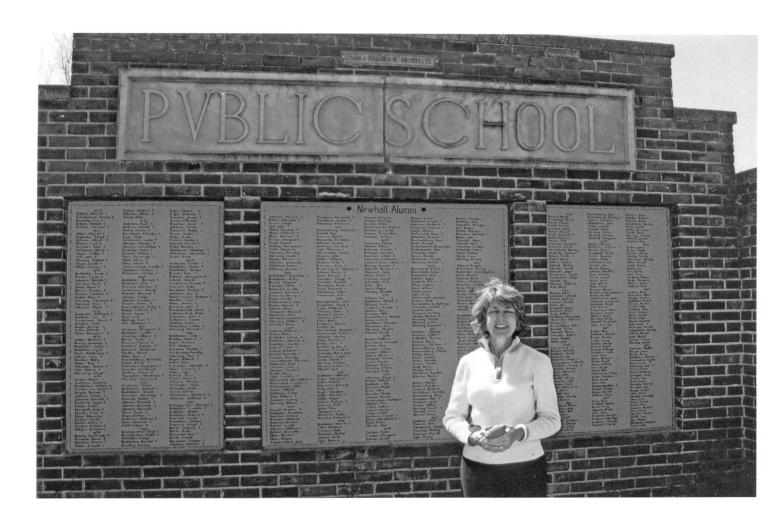

Newhall | Benton County | Purple/Gold, Black/Gold in '60s | Panthers

A memorial has been erected with bricks from the school.

Luella Gardeman, Girls State Basketball Hall of Fame, 1929

Girls State Basketball Champions, 1927

Newkirk | Sioux County | Red/White | Red Raiders

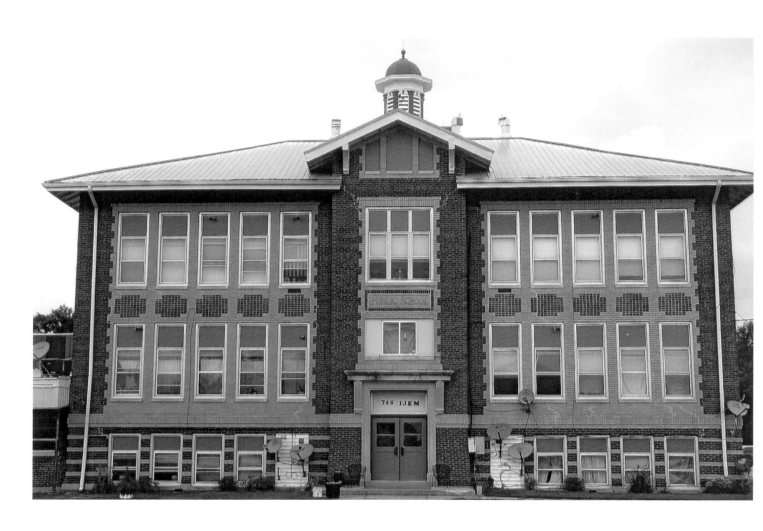

Nichols | Muscatine County | Maroon/White | Little Nicks

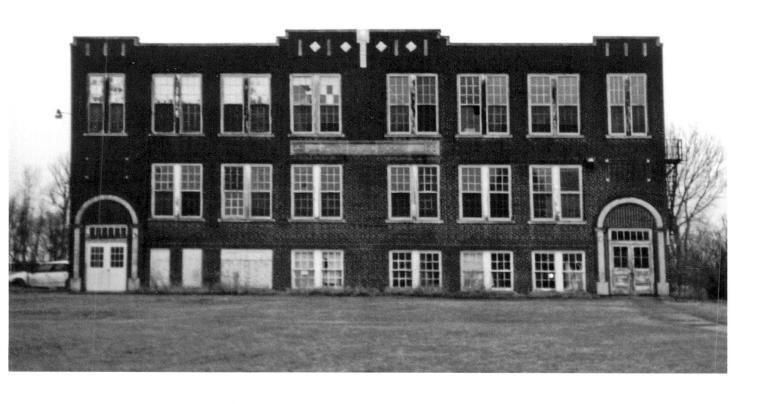

Nodaway | Taylor County | Red/White | Cardinals

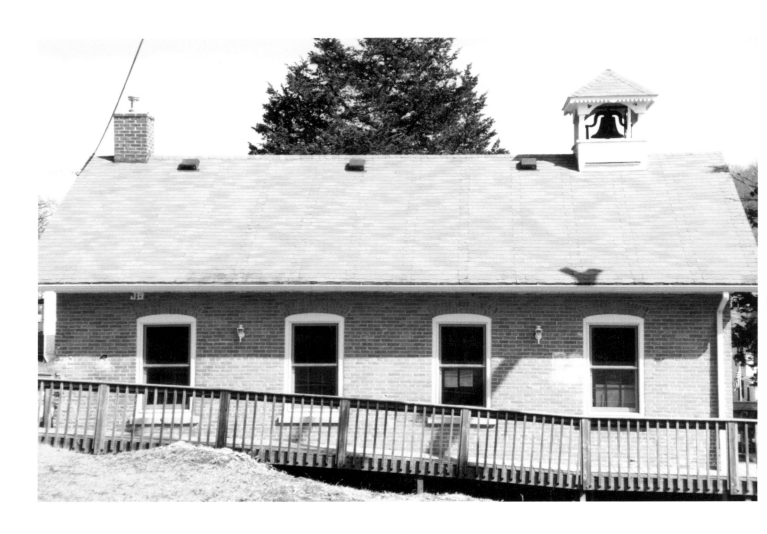

North Buena Vista | Clayton County

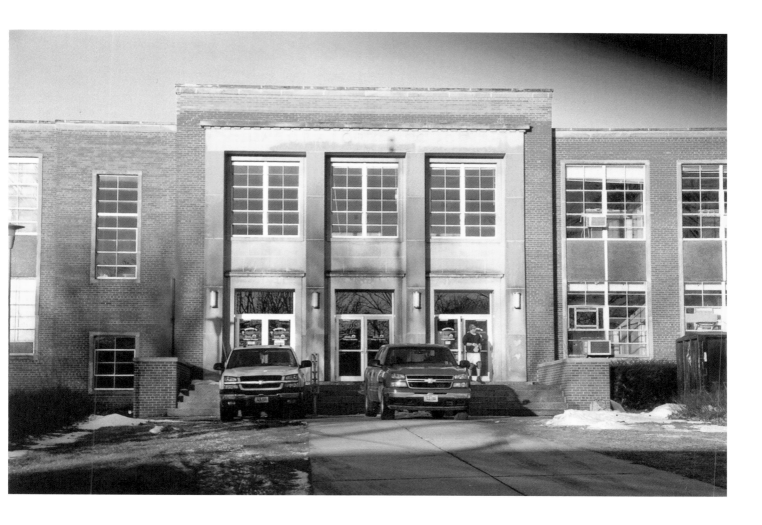

Northern University High School | Black Hawk County | Orange/Black | Little Panthers

Boys State Basketball Tournament, Second Place, 1989

Boys State Basketball Tournament Champions, 2008

Boys State Track Tournament Champions, 1986, 1987, 1988, 1990, 1991, 1998

4 X 200 Relay Winners in 1991 Drake Relays

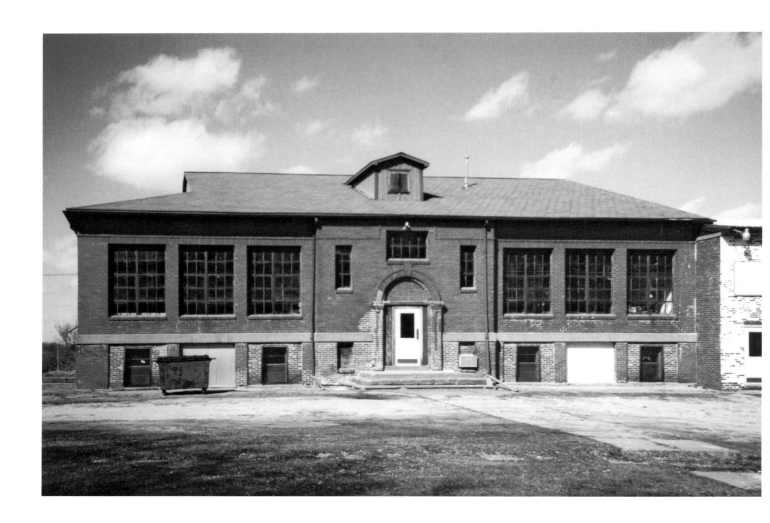

Numa | Appanoose County | Red/White | Miners

Girls State Basketball Tournament Champions, 1941

Girls State Basketball Tournament Runner-Up, 1947

Eleanor Lira, Basketball Hall of Fame, 1940

Eva Tometich, Basketball Hall of Fame, 1941

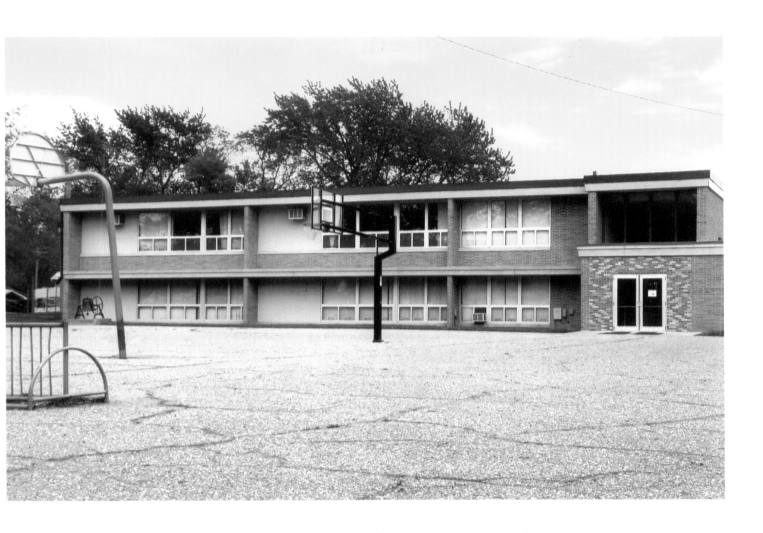

Ocheyedan | Osceola County | Orange/Black | Mounders

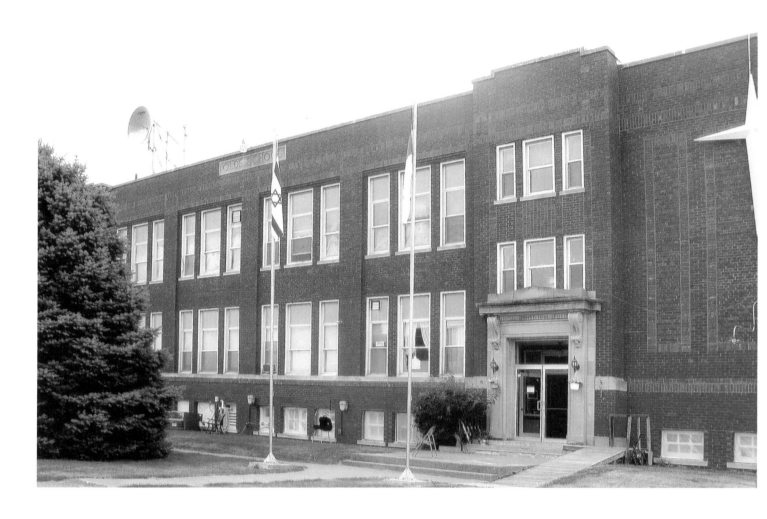

Olds | Henry County | Black/Gold | Raiders

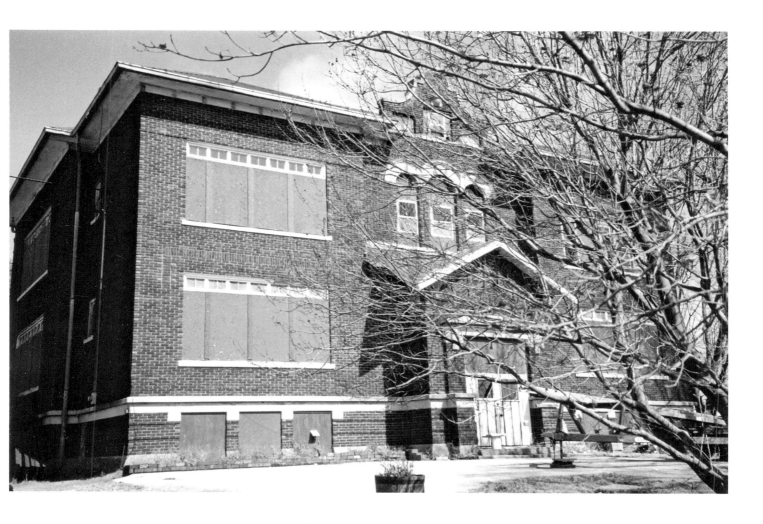

Oneida | Delaware County | Red/White | Indians later became Braves

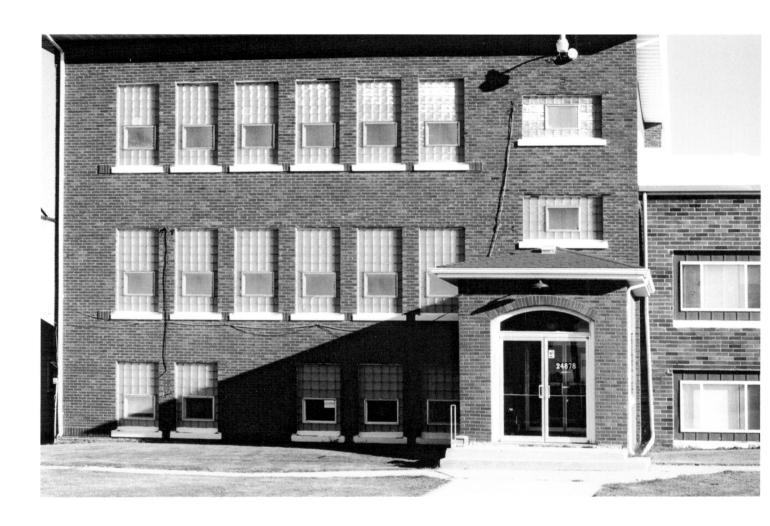

Oran | Fayette County | Purple/Gold | Panthers

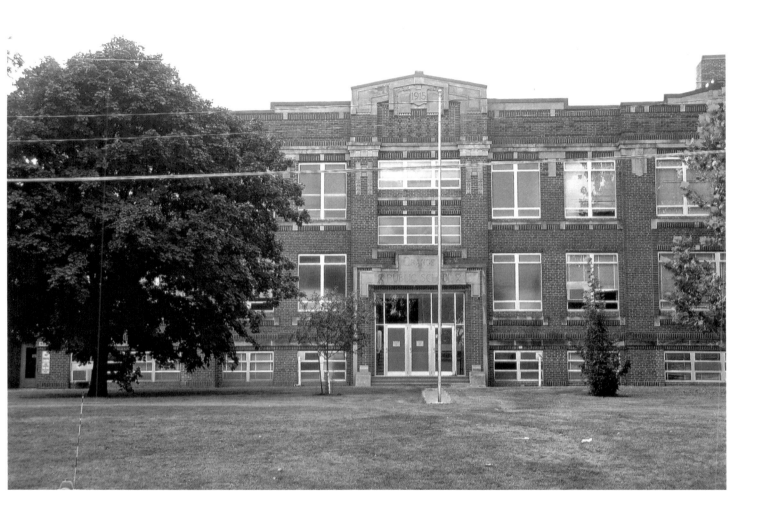

Orange Township | Black Hawk County | Orange/Black | Tigers

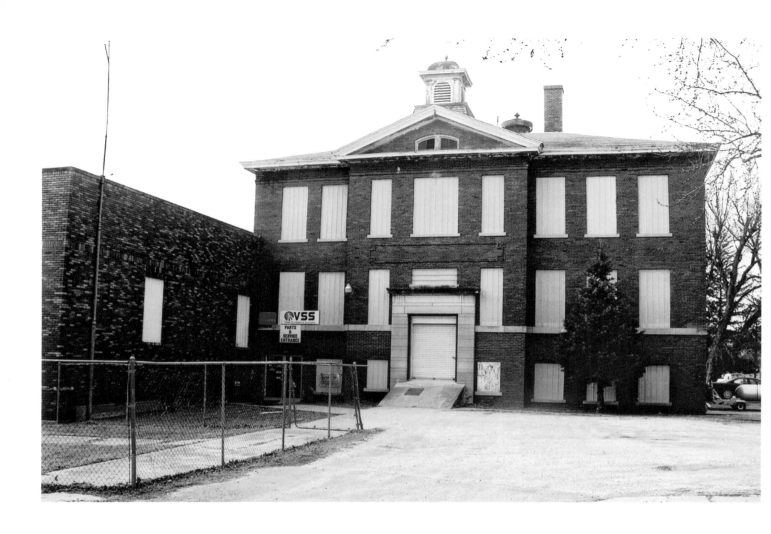

Oto | Woodbury County | Purple/Gold | Bulldogs

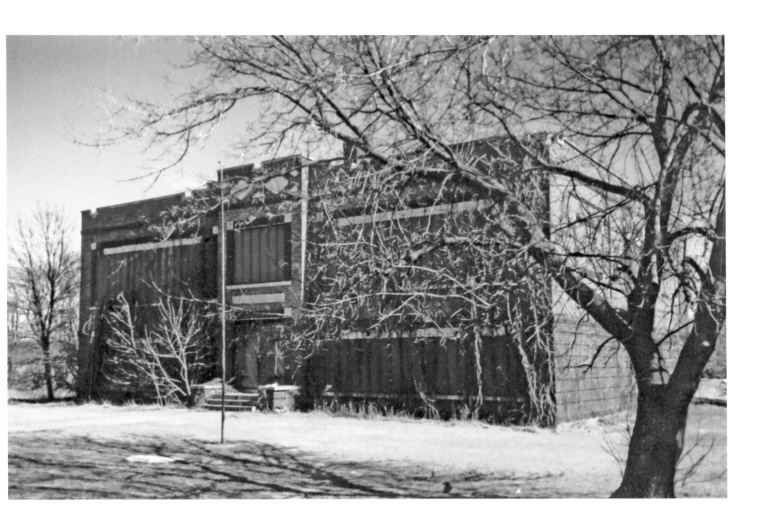

Otranto | Mitchell County

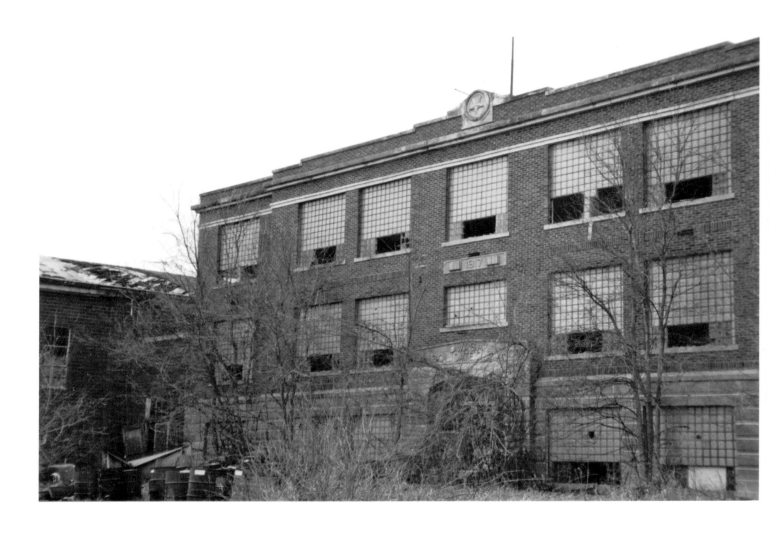

Owasa | Hardin County | Old Gold/Maroon | Eagles

Fashion on the Field

The evolution of athletic uniforms

Fashion on the Field
The evolution of athletic uniforms

It is difficult to talk about school colors without also delving into the history of athletic uniforms in the early days. For many years athletic teams wore no special clothing. When boys basketball teams did start wearing uniforms, they were generally shorts that came to mid-leg and sleeveless jerseys. Most were made of wool and were very hot. Long socks also were a part of some of the boys' uniforms.

The two sports that saw the greatest evolution in uniforms were football and girls basketball. The changes in girls basketball uniforms could be described as "from bloomers, bows and middie blouses to just like one of the boys."[viii] In the 1920s, girls wore bloomers, bows around their necks, and, in some cases, bows in their hair. There were uniforms that had sailor insignias on the blouses with a number on the insignia indicating the place of the girl on the team. It was important and appropriate at that time that bare skin not be shown. Blouses were long sleeved and long socks extended from the bottom of the bloomers to the ankle.

Perhaps the girls basketball uniforms reflected the conservative nature of the early game. The court was divided into thirds with each team having two guards, two forwards, and two centers. The rules on dribbling changed from no dribbles allowed

in 1910 to one dribble acceptable in 1913 and then three dribbles in 1918. Early rules stated that the player could hold the ball only three seconds before passing. There was limited running or jumping, and a player could not grab or touch the ball when in the opposing player's hands. Doing so was considered unladylike.

In the late 1930s, the basketball court was divided in half instead of thirds and three guards and three forwards made up each six-player team. The uniforms also changed, with skirts being common. Today, boys and girls basketball uniforms are similar.

Football surfaced as a sport in the 1800s, and uniforms underwent significant transformations over the years. Early games resulted in frequent injuries because players, like those in rugby, did not wear any protective equipment. It was not uncommon for players to try to create some protection using padding stuffed into their clothing around their shoulders, knees, and hips. Unfortunately, there were no helmets and head injuries were common, adding to the brutality of the sport. In an effort to reduce slipping and sliding during the game, players came up with novel ideas for gaining traction. Regular leather shoes were transformed into football shoes by nailing or otherwise attaching a roughly fashioned cleat.

Some Iowa high schools played football in 1890 but most of the teams were club teams. In 1905 the Iowa High School Athletic Association banned schools from playing football but lifted the ban in 1908. Helmets were a required part of the football uniform in 1935. When helmets were first provided to players, they were made of leather with no face masks. They provided minimal protection. Plastic face masks made their debut in 1954. Six years later, tooth and mouth guards were required. Concern for head injuries and concussions resulted in advanced technology to ensure helmets gave the greatest protection possible. It should be noted that before 1960 less than half of the Iowa High School Athletic Association member schools played football.[ix] ◆

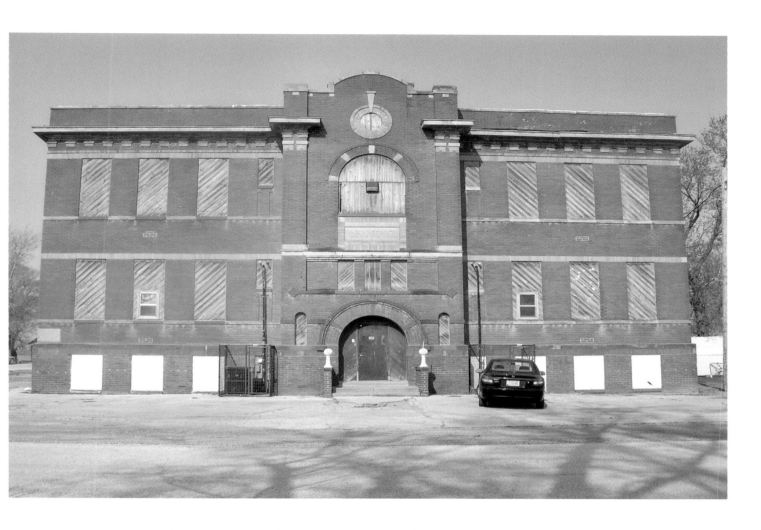

Pacific Junction | Mills County | Black/Gold | Eagles

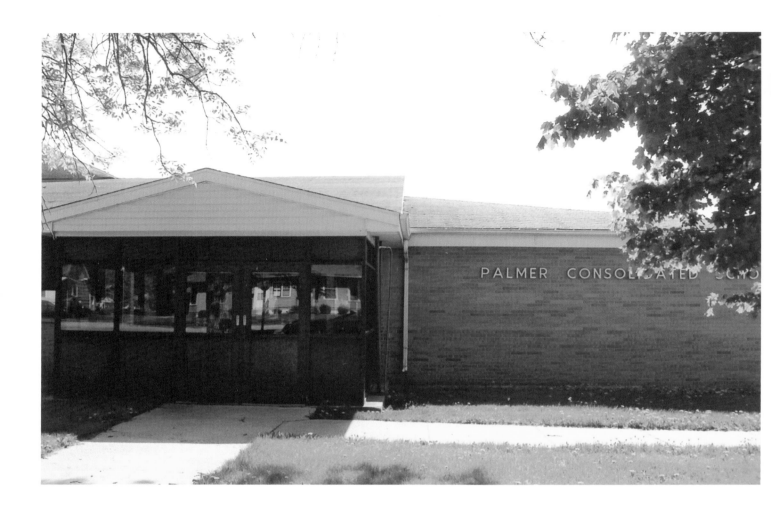

Palmer | Pocahontas County | Purple/Gold | Panthers

The 1987 team averaged more points than any Iowa boys high school basketball team.

Boys Basketball State Champions, 1986 to 1988

Basketball Hall of Famers: Norm Wiemers, 1977; Bill Francis, 1983;
Troy Skinner, 1988; Brian Pearson, 1988

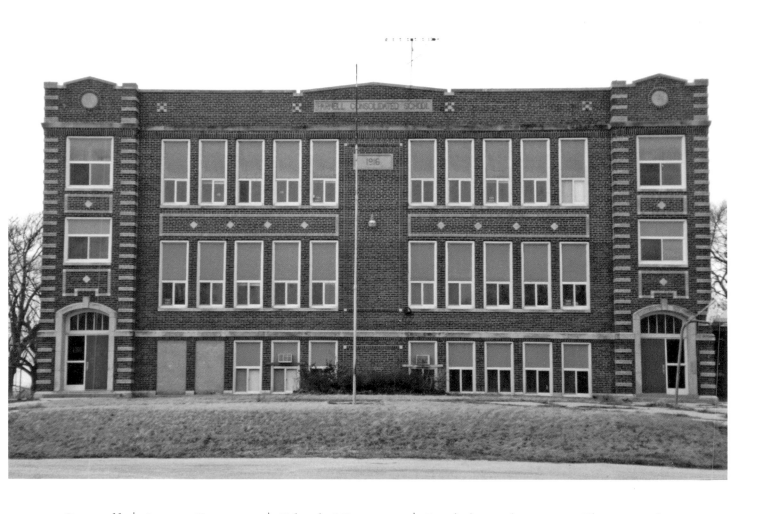

Parnell | Iowa County | Black/Orange | Irish later became Shamrocks

Parnell used Catholic nuns as public school instructors.
Patsy Gharrity from Parnell played major league baseball.

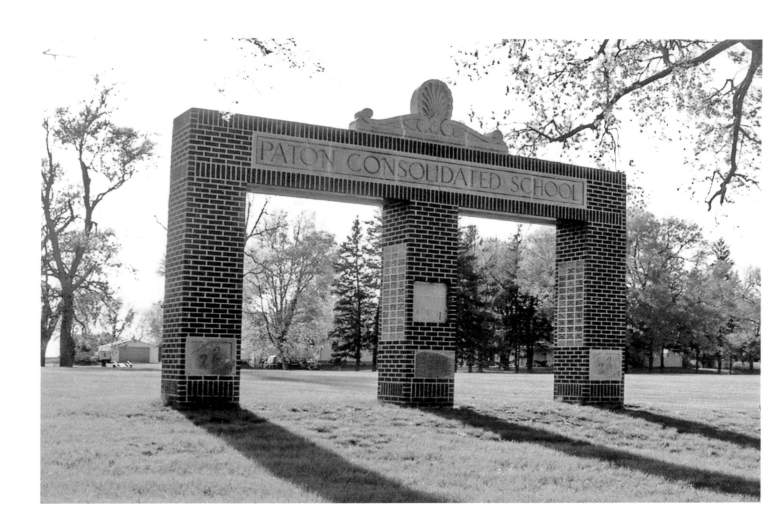

Paton | Greene County | Red/Black | Panthers

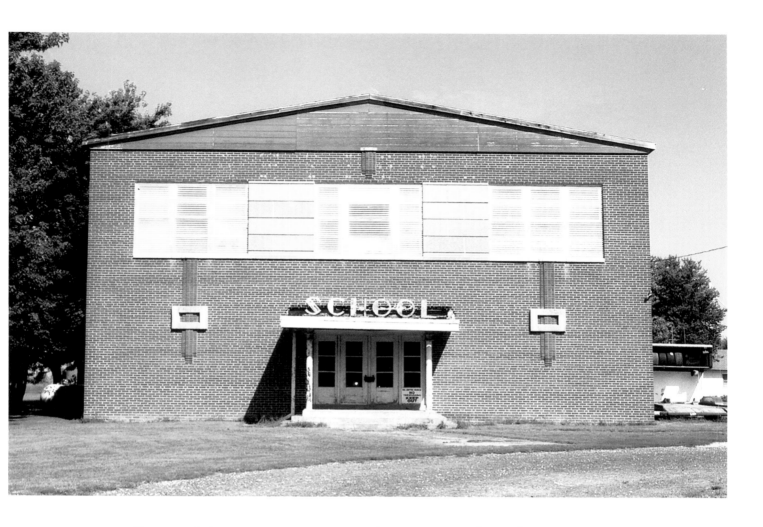

Percival | Fremont County | Green/White | Hornets

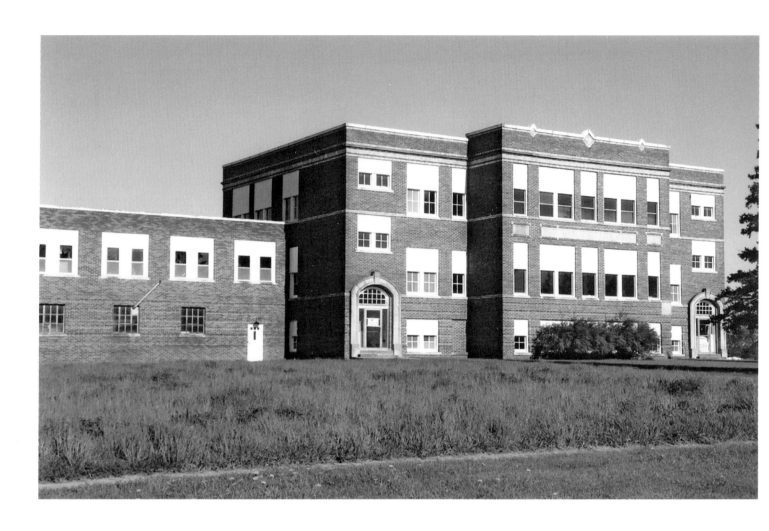

Pilot Mound | Boone County | Black/Gold | Eagles

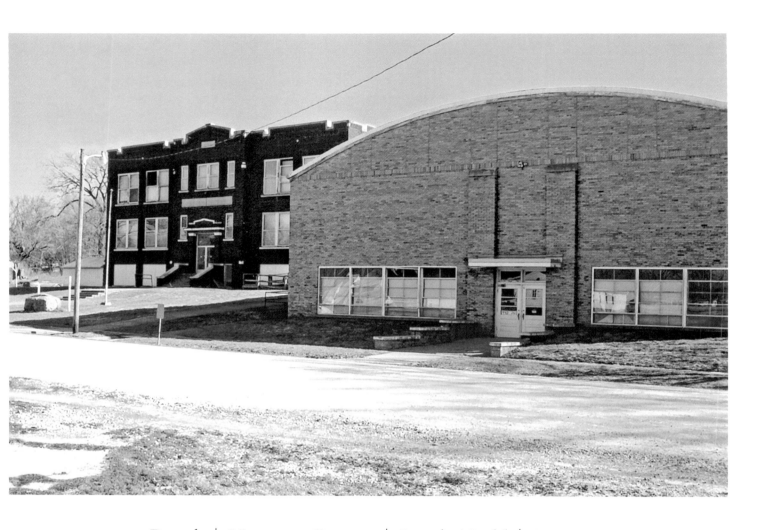

Pisgah | Harrison County | Purple/Gold | Pirates

Pisgah is the home of "Dave's Old Home Filler Up and Keep on Truckin' Café."

Phyllis Bothwell, Basketball Hall of Fame, 1960

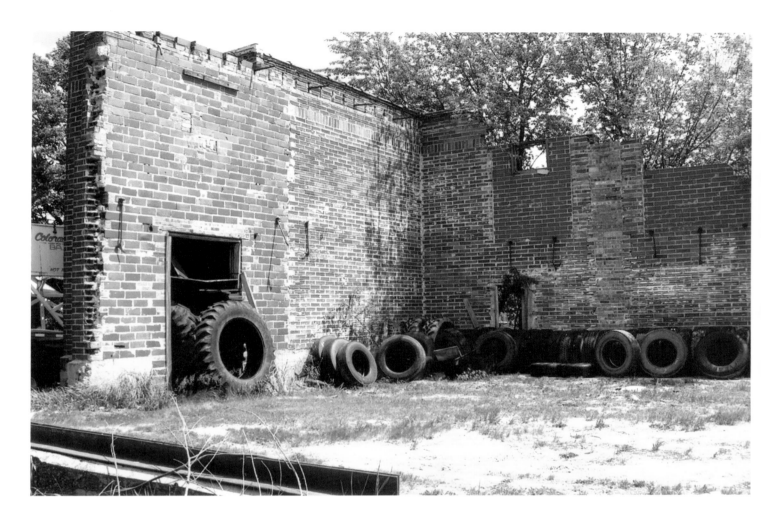

Plover | Pocahontas County | Purple/White | Panthers

A gentleman commented, "I have no place to go for my school reunion" in response to the crumbling building.

Myrtle Fisher, Basketball Hall of Fame, 1933

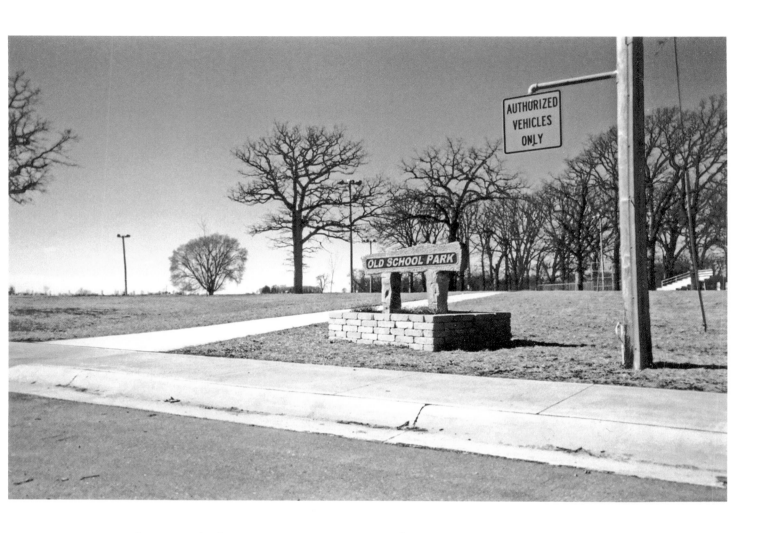

Plymouth | Van Buren County | Green/White | Pirates

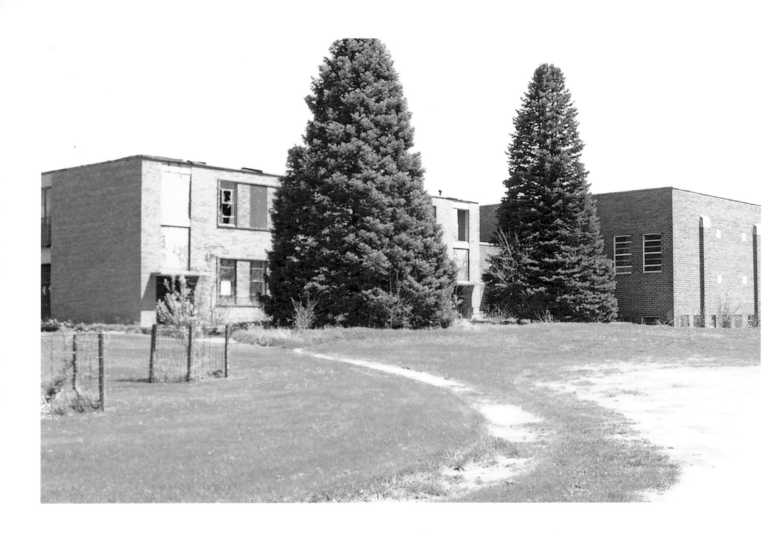

Popejoy | Franklin County | Purple/Gold | Pirates

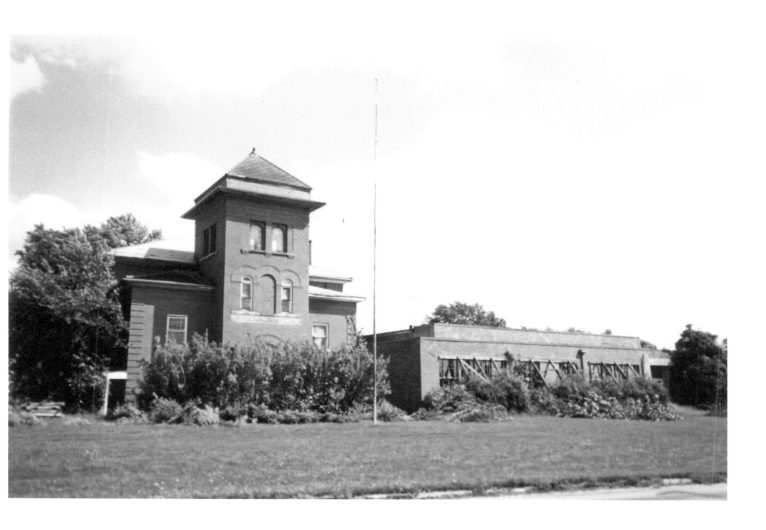

Pulaski | Davis County | Royal Blue/White | Blue Hawks

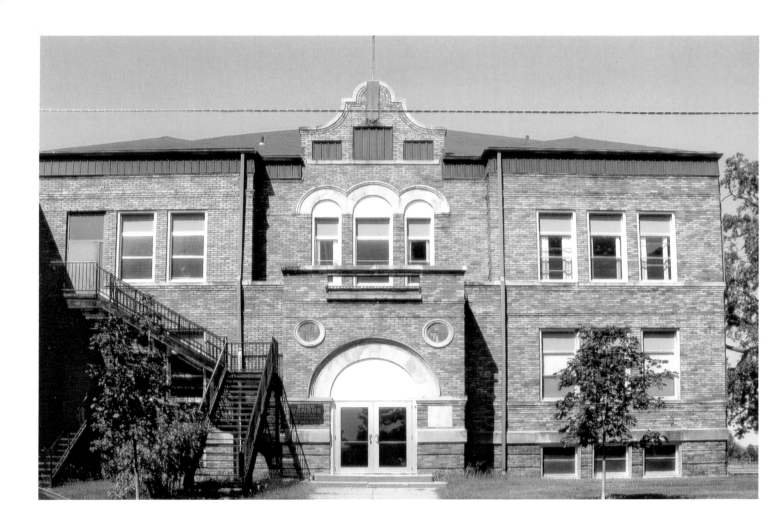

Quasqueton | Buchanan County | Red/Black | Indians

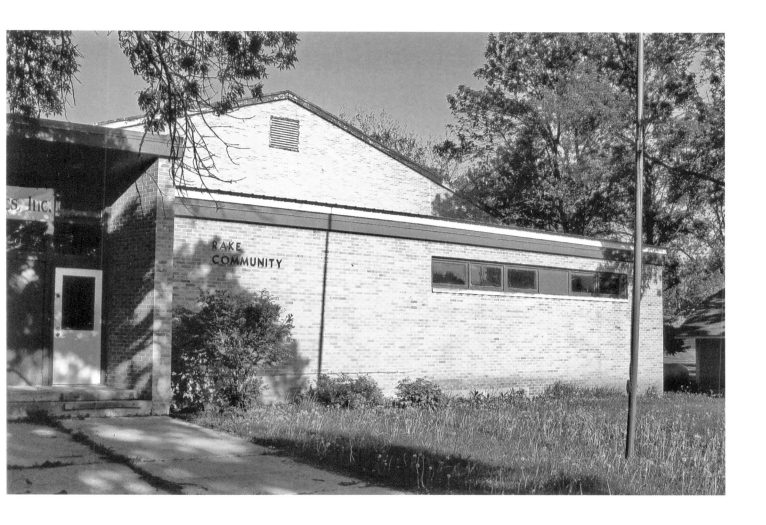

Rake | Winnebago County | Red/White | Tigers

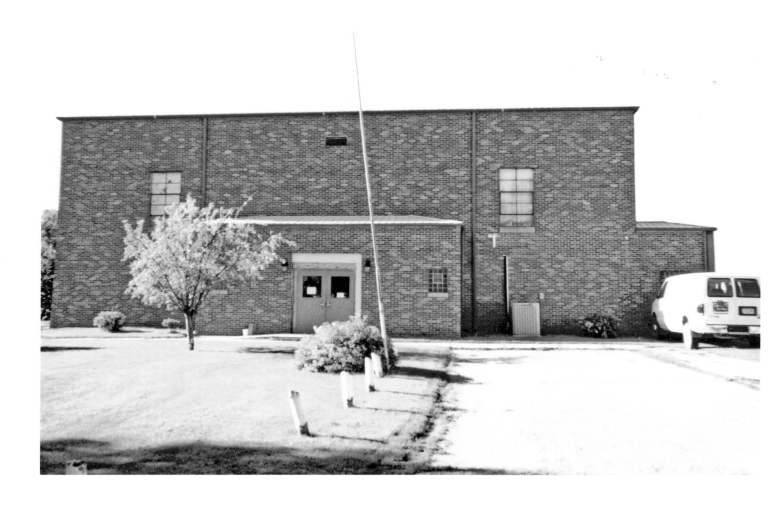

Randall | Hamilton County | Blue/Gold | Rams

Charlotte Weltha, Basketball Hall of Fame, 1940

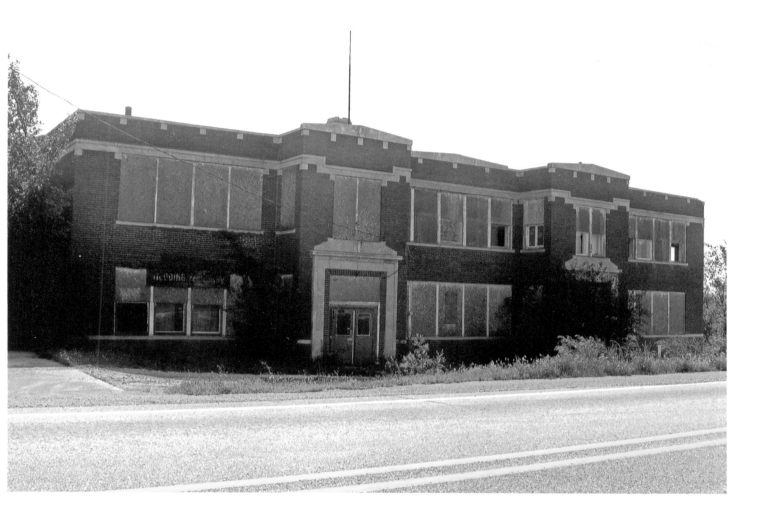

Redding | Ringgold County | Blue/Gold | Panthers

In the 1930s the home economics class prepared hot lunch for students.
Then the Parent Teacher Association (PTA) ran the hot lunch program.

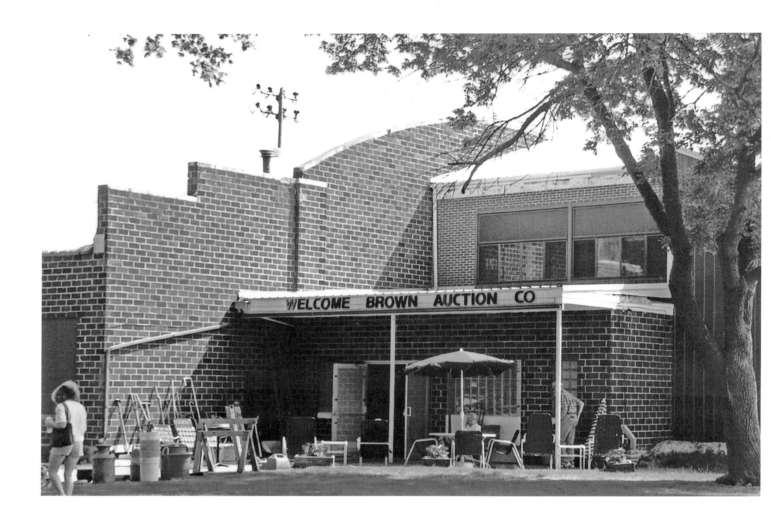

Rembrandt | Buena Vista County | Purple/Gold | Raiders

Keith Stroup scored 61 points in a boys basketball game against Meriden in 1960.
In 1979, Rembrandt was the smallest school district in Iowa.

Valerie Haraldson, Softball Hall of Fame, 1970

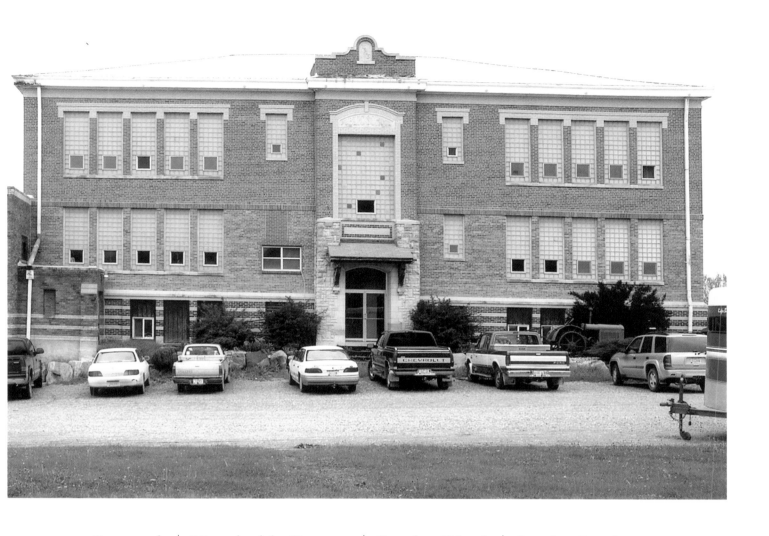

Renwick | Humboldt County | Scarlet/Black | Scarlet Raiders

Because of snow-blocked roads, the 1929 Renwick High School boys basketball team took a train to LuVerne, then another train to Britt to win the sectional tournament.

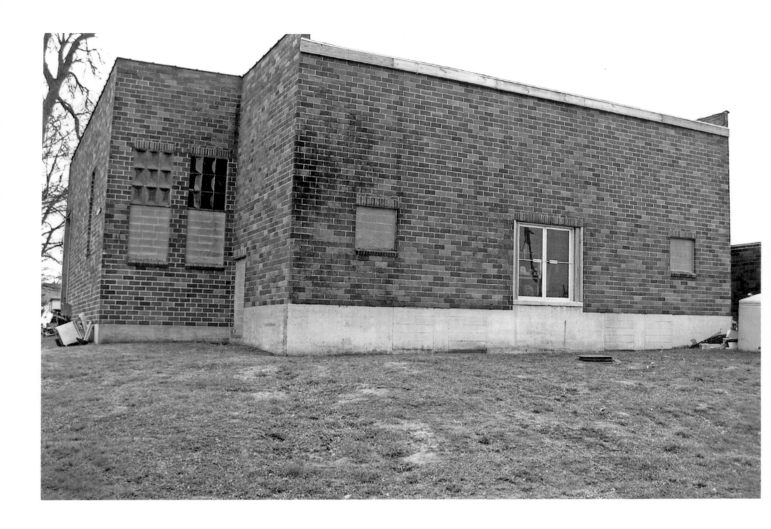

Rhodes | Marshall County | Purple/Gold | Rockets

Jeanette Haas, Basketball Hall of Fame, 1940

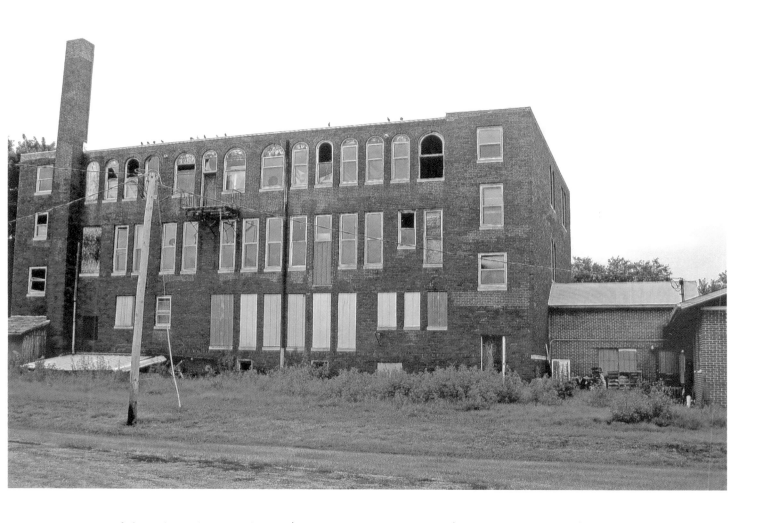

Richland Independent | Keokuk County | Blue/White | Tigers

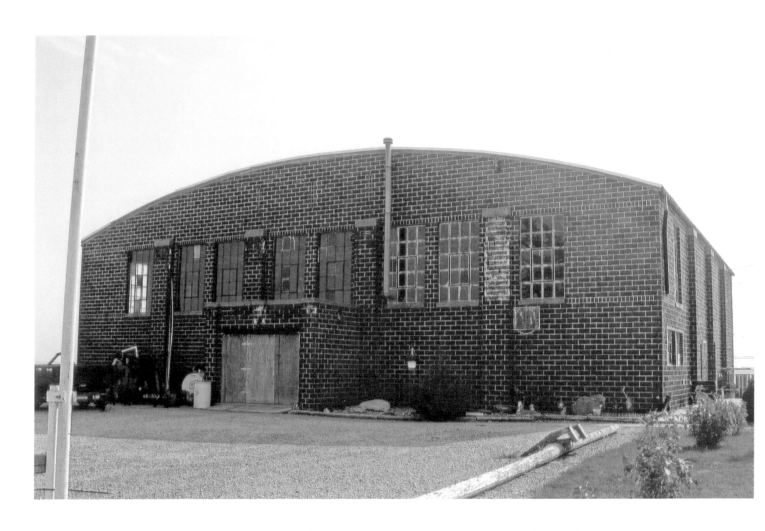

Richland Township | Adair County | Red/White | Raiders

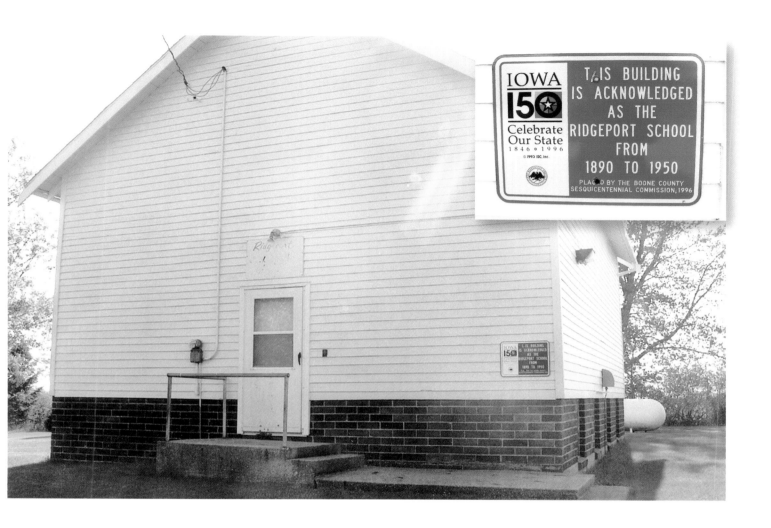

Ridgeport | Boone County

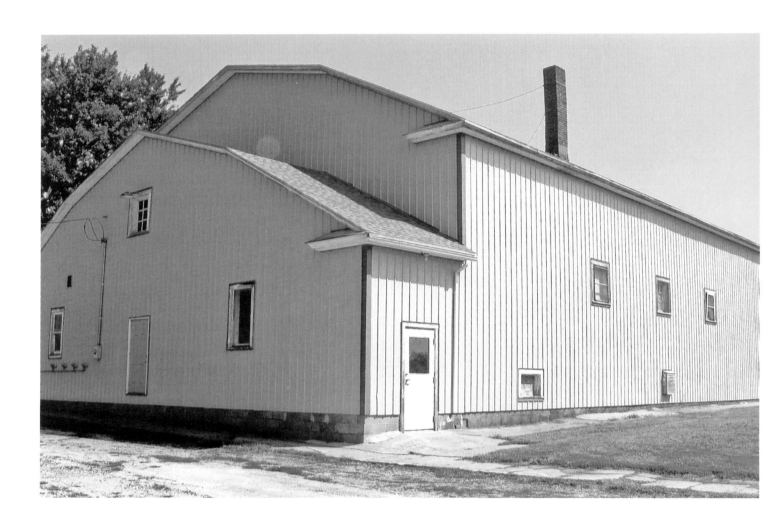

Riverton | Fremont County | Orange/Black | Panthers

Rock Falls | Cerro Gordo County | Red/Black | Wildcats

Rockford | Floyd County | Purple/White | RoHawks

Marty Pump, Softball Hall of Fame, 1980

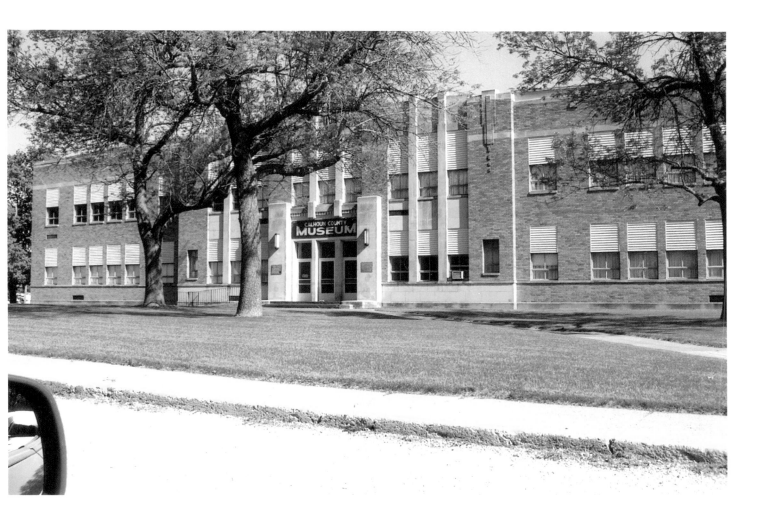

Rockwell City | Calhoun County | Royal Blue/White | Wildcats

The Rockwell school is now a museum.

Girls State Basketball Tournament Semifinalists, 1959, 1968

Linda Lory, Basketball Hall of Fame, 1961

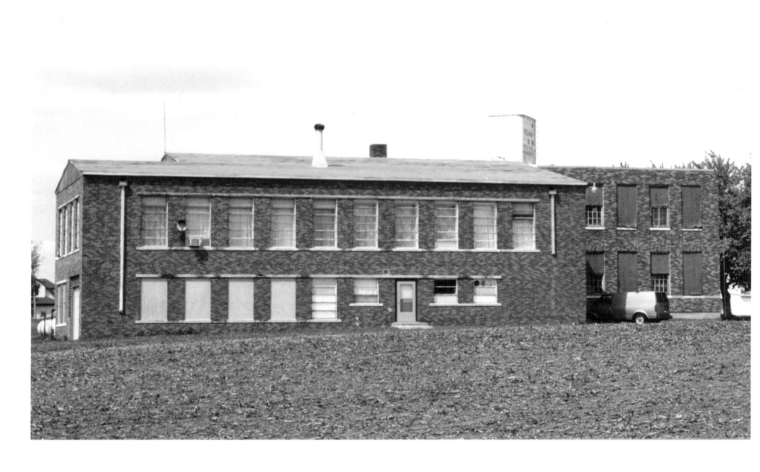

Rodman | Palo Alto County | Red/White | Cardinals

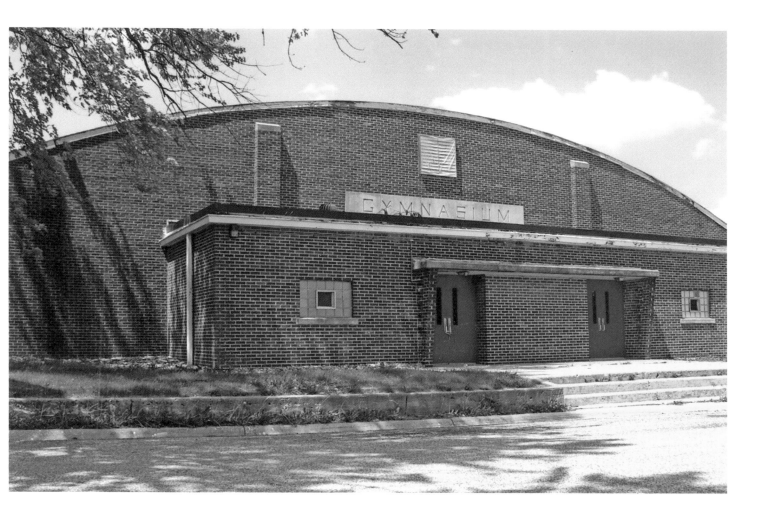

Rolfe | Pocahontas County | Red/Gold | Rams

Rolfe is the birthplace of Virgil Hancher, thirteenth president of the University of Iowa.

Boys State Basketball Tournament Runner-Up, 1938

Al Budolfson, Basketball Hall of Fame, 1938

Sara Beckford, Track and Field Hall of Fame, 1968

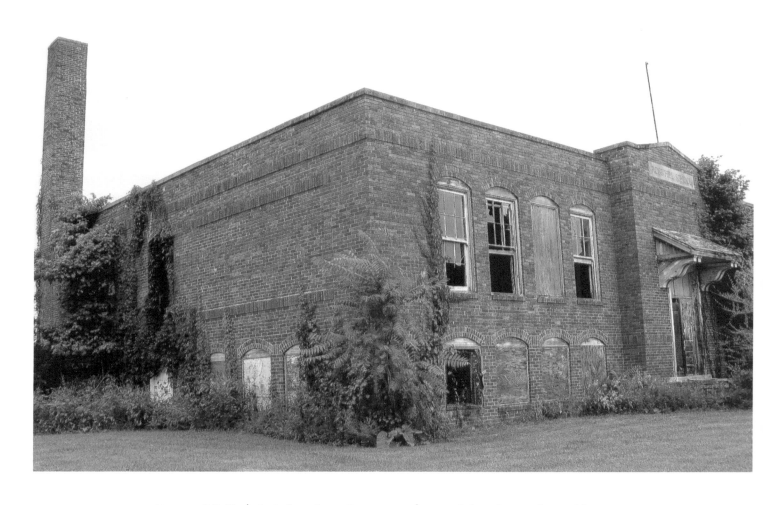

Rose Hill | Mahaska County | Red/White | Hill Men

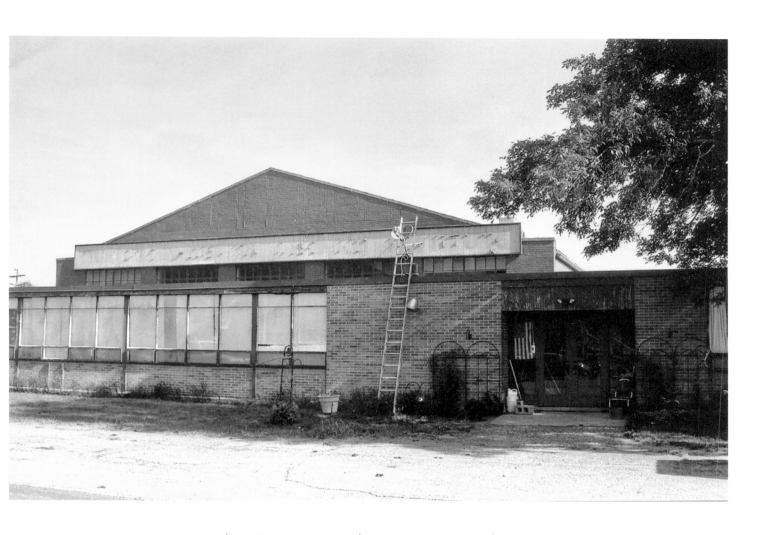

Rossie | Clay County | Purple/Gold | Dragons

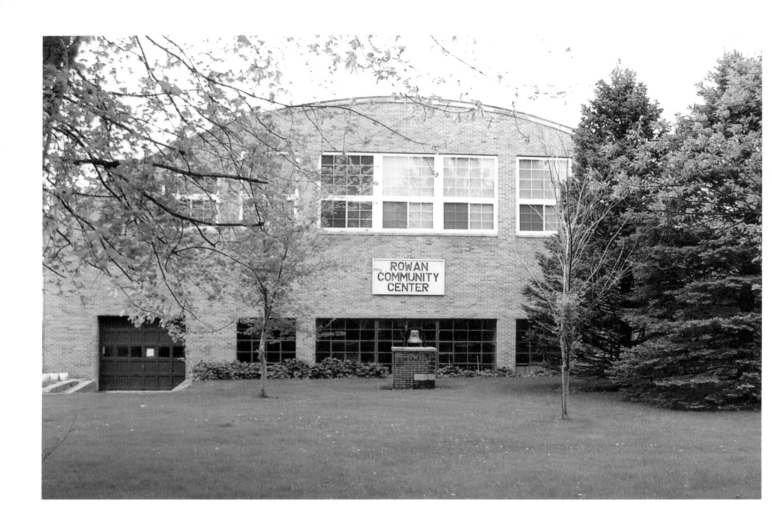

Rowan | Wright County | Trojans

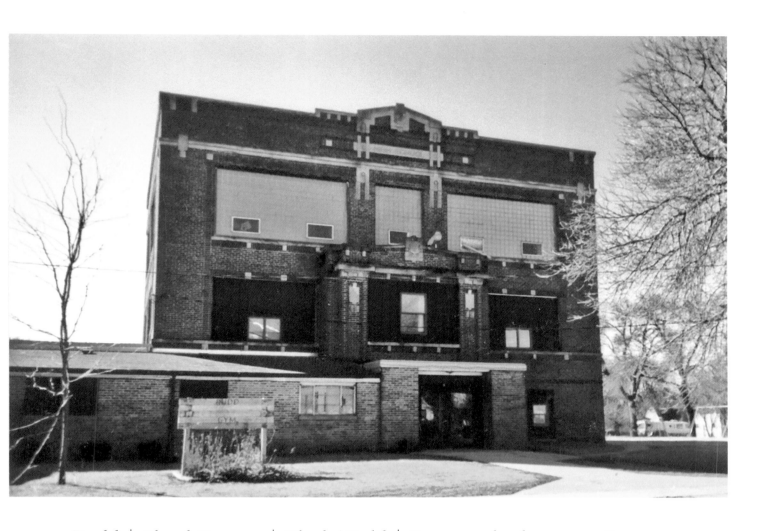

Rudd | Floyd County | Black/Gold | Rangers also known as Ravens

Home of "Doc" Frevert, 1933 NCAA National Wrestling Champion.
"Doc" wrestled for Iowa State University.

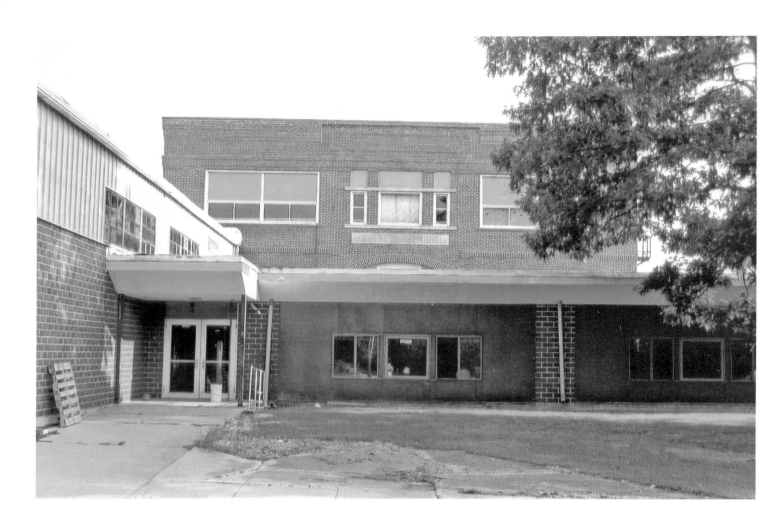

Russell | Lucas County | Blue/White | Bluebirds later became Trojans

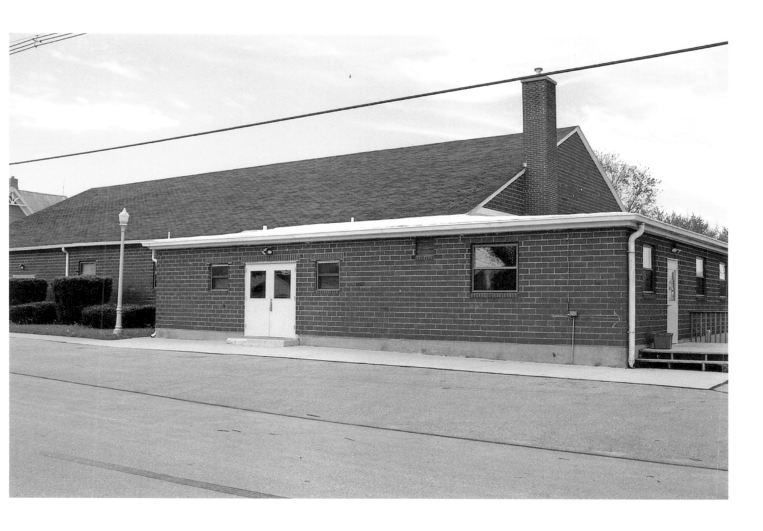

Ryan | Delaware County | Green/White | Fighting Irish

Preparing to Educate

Teaching requirements and certifications

Preparing to Educate
Teaching requirements and certifications

The first teachers in Iowa were primarily men. When many of the men went to fight in the Civil War, women replaced them in their teaching positions. After the war, women continued because pay was low and teaching was one of the few jobs open to them.[x]

Initially in Iowa schools, as in schools across the nation, there were no certification requirements to be a teacher. In the 1800s, having an interest in and a minimal knowledge of reading, math, and history qualified a person to teach children. It was not unusual for those with an eighth-grade education to be teaching younger children. Later some earned certification at their high schools or were prepared through correspondence courses.

Although the early requirements for teaching were minimal, teachers often had a set of rules to follow. The following Rules for Teachers in 1872 reflected common guidelines:

- Teachers each day will fill lamps, clean chimneys.
- Each teacher will bring a bucket of water and a scuttle of coal for the day's session.

- Make your pens carefully. You may whittle the nibs to the individual taste of the pupils.
- Men teachers may take one evening each week for courting purposes, or two evenings if they go to church regularly.
- After ten hours in school, the teachers may spend the remaining time reading the Bible or other good books.
- Women teachers who marry or engage in unseemly conduct will be dismissed.
- Every teacher should lay aside from each pay a goodly sum of his earnings for his benefit during his declining years so that he will not become a burden to society.
- Any teacher who smokes, uses liquor in any form, frequents pool or public halls, or gets shaved in a barber shop will give good reason to suspect his worth, intention, integrity and honesty.
- The teacher who performs his labor faithfully and without fault for five years will be given an increase of twenty-five cents per week in his pay, providing the Board of Education approves. (Source unknown)

As the population grew, there was an ever-increasing need for teachers in Iowa's one-room schoolhouses emerging across the state. The first elementary school in

Iowa was built in Lee County in 1830 and the first high school in Iowa was started in the 1850s. High schools did not become prevalent until the early 1900s.[xi] Many have credited Iowa with the impetus for the high school movement in the United States. By 1910, what we now think of as secondary schools or high schools were serving students across the state of Iowa.[xii]

The need for greater teacher preparation became evident as education opportunities expanded across Iowa. Established to train teachers for Iowa's public schools, the Normal School was founded in Cedar Falls in 1876. In the fall of that year, 27 aspiring educators took teacher preparation classes for three, six, or twelve weeks.[xiii] The Normal School became Iowa State Teachers College in 1909.

With the passing of time, the requirements for receiving an Iowa teaching license increased and preparation programs expanded. Growing expectations were reflected in a 1930s Iowa State school law which stated, "The board [of educational examiners] may issue certificates and state diplomas to such teachers as are found

upon examination to possess a good moral character, thorough scholarship, and knowledge of didactics, with successful experience in teaching."[xiv] The two-year course of study became one of the early teacher certifications.

For nearly three-fourths of the twentieth century, Iowa had some elementary school teachers who had two-year degrees. As early as the 1930s, secondary teachers were awarded certificates upon completion of a four-year course of study. By the late 1970s, all Iowa teachers were required to have a four-year degree. ◆

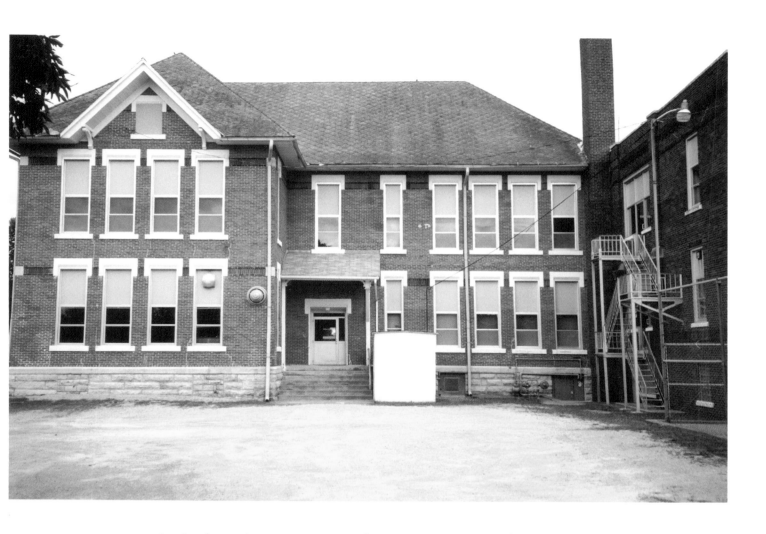

Sabula | Jackson County | Orange/Black | Panthers

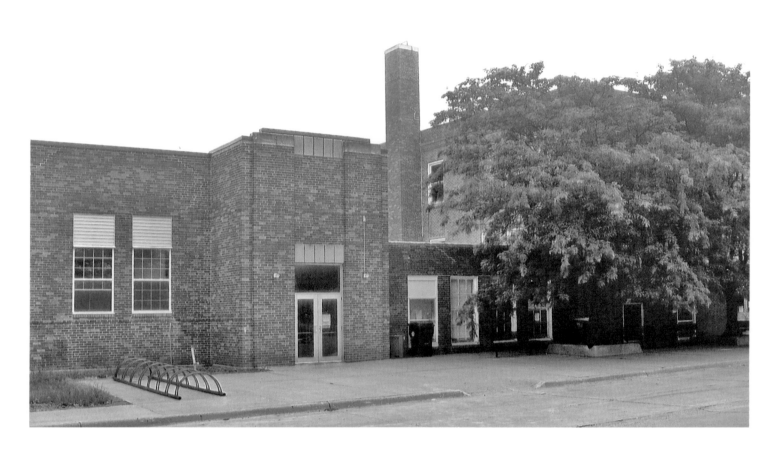

St. Charles | Madison County | Blue/Gold | Tigers were Chargers for a time

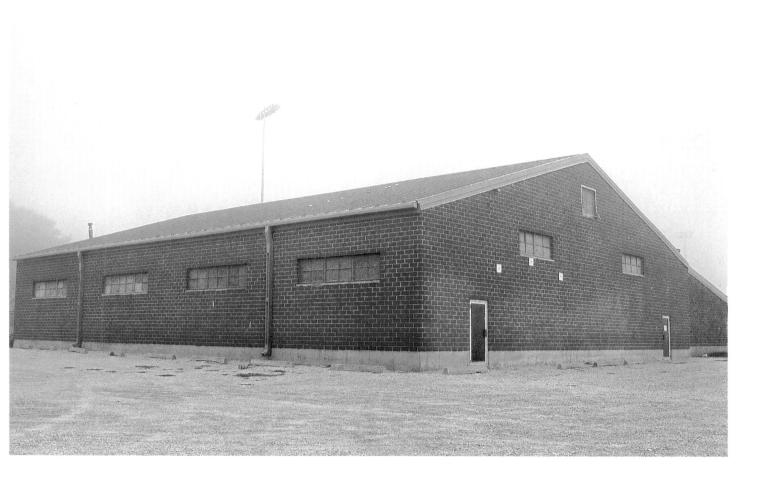

St. Mary's | Warren County | Orange/Black | Panthers

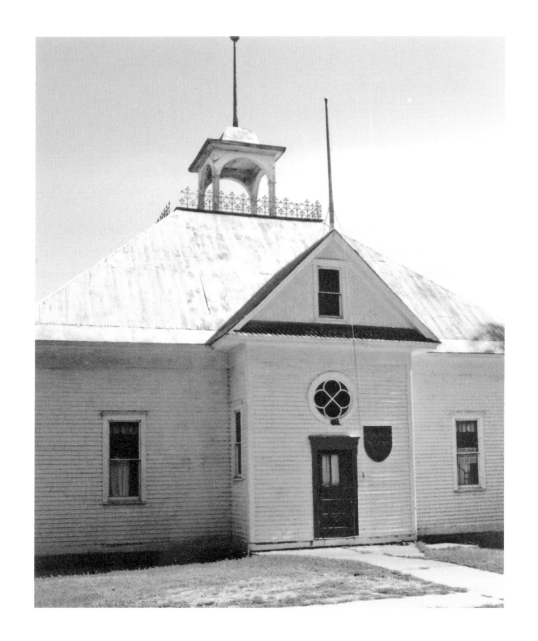

St. Olaf | Clayton County

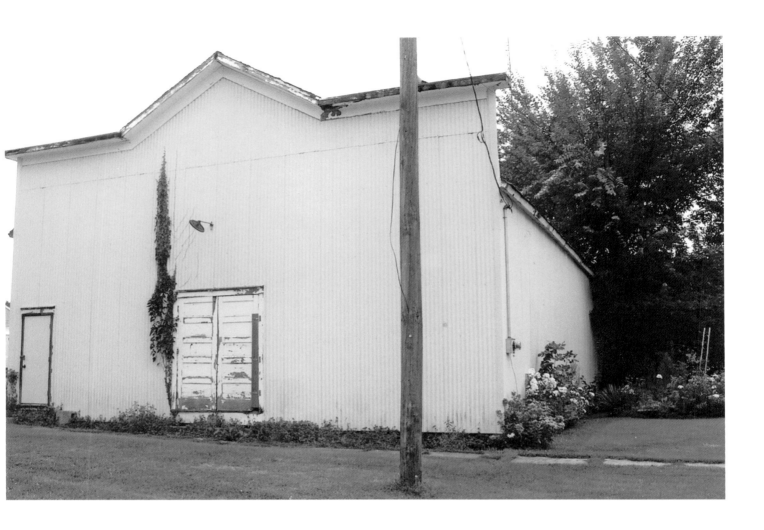

Salem | Henry County | Red/Black | Seahawks

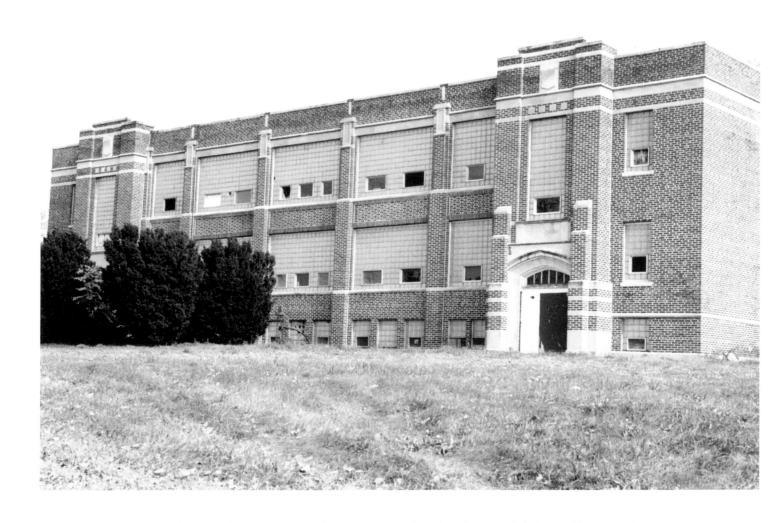

Searsboro | Poweshiek County | Black/Gold | Yellowjackets

Home of Jeff Criswell, NFL lineman.

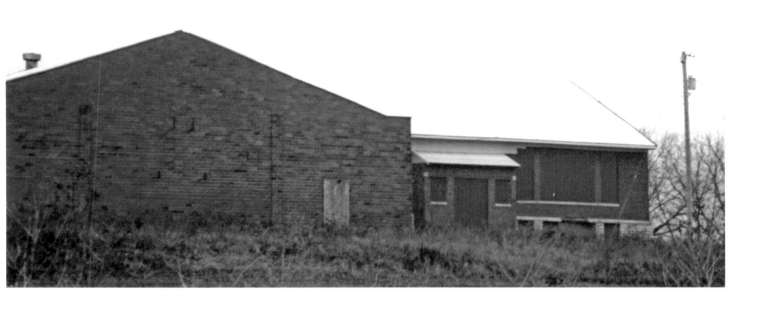

Selma | Van Buren County | Orange/Black | Indians

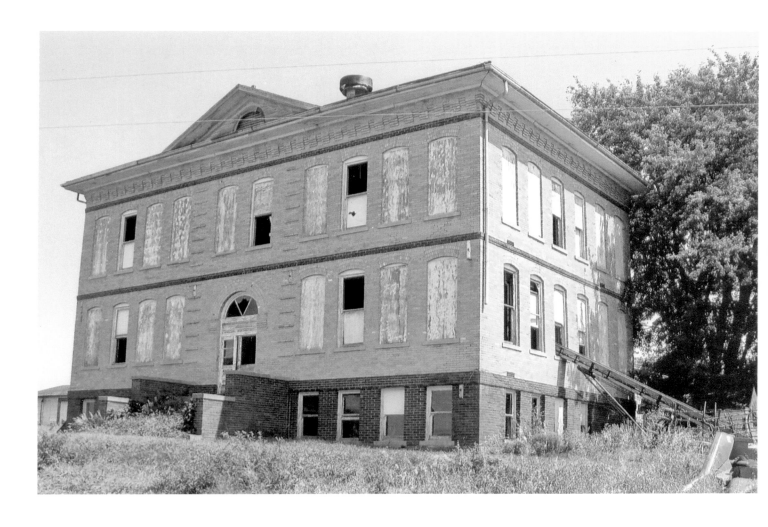

Sharpsburg | Taylor County | Red/White | Cardinals

The last class of four students graduated in 1958.

Played in Boys State Basketball Tournament, 1956

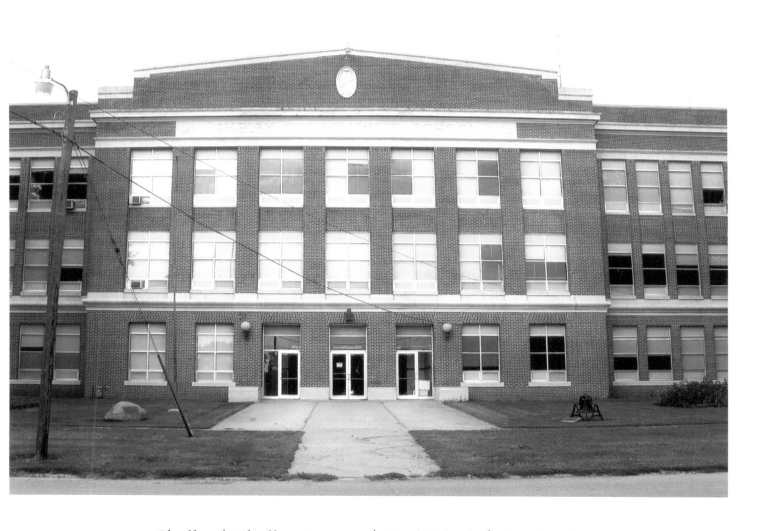

Shelby | Shelby County | Red/Black | Cardinals

Shueyville | Johnson County

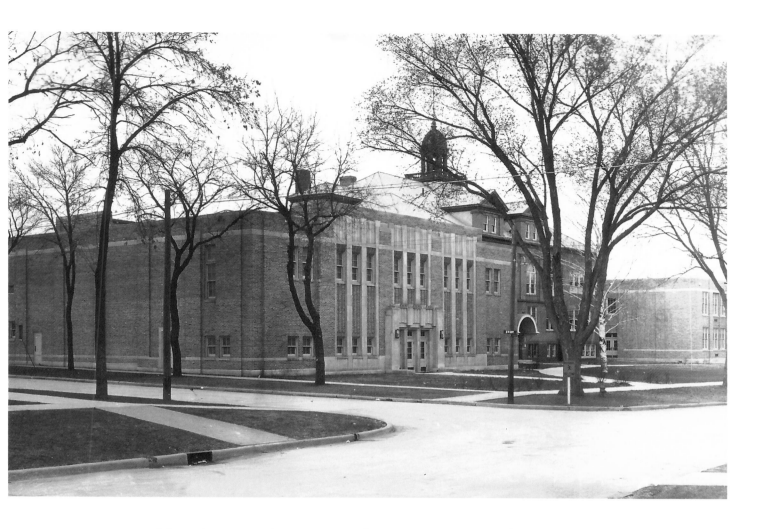

Sibley | Osceola County | Orange/Black | Generals

The Sibley High School burned to the ground in the 1970s.

Boys State Basketball Tournament Consolation Winners, 1958

2A State Football Champions, 1979

Girls State Basketball Tournament Champions, 1986, 1996

Girls State Basketball Tournament Runner-Up, 1995

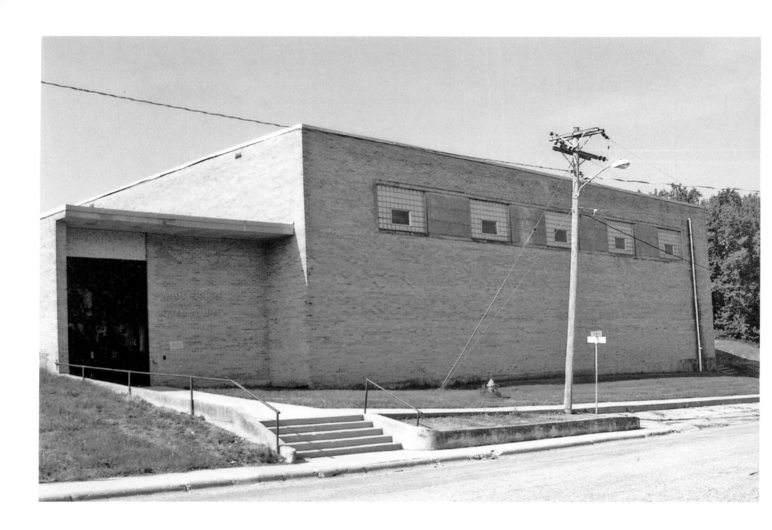

Sioux Rapids | Clay County | Red/Black | Indians

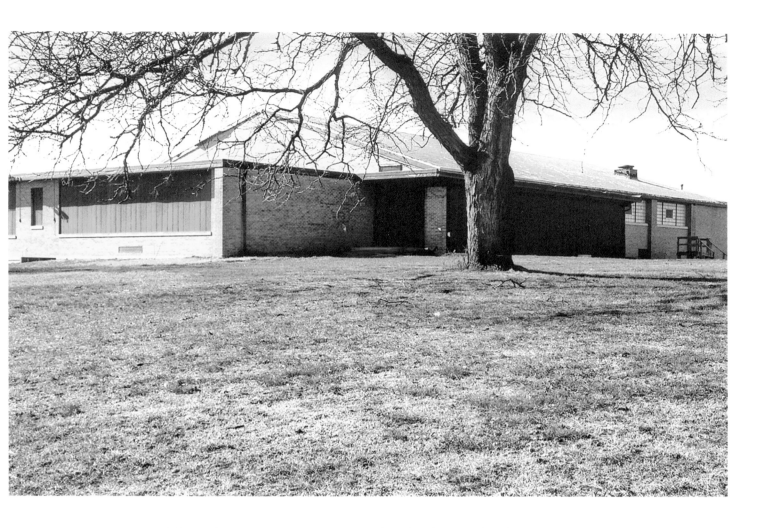

Soldier | Monona County | Black/Gold | Bulldogs

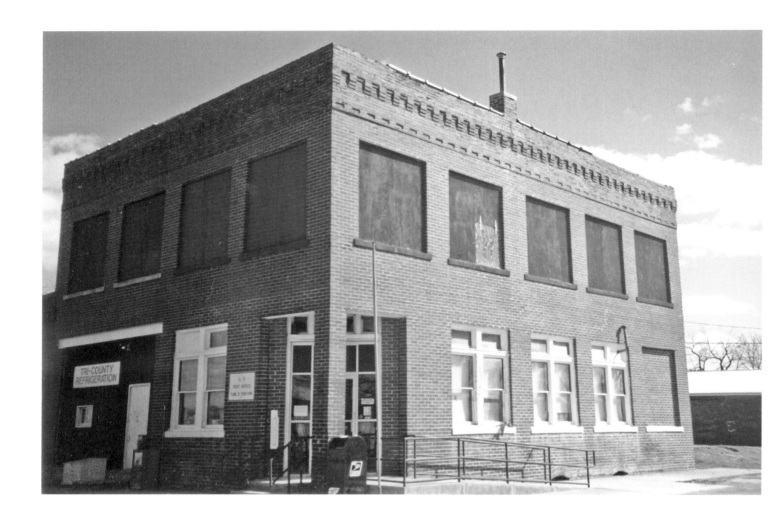

Stanley | Buchanan County | Maroon/Gold | Wildcats

Stanley had the largest bus fleet in Iowa at one time.
The Stanley school houses the post office today.

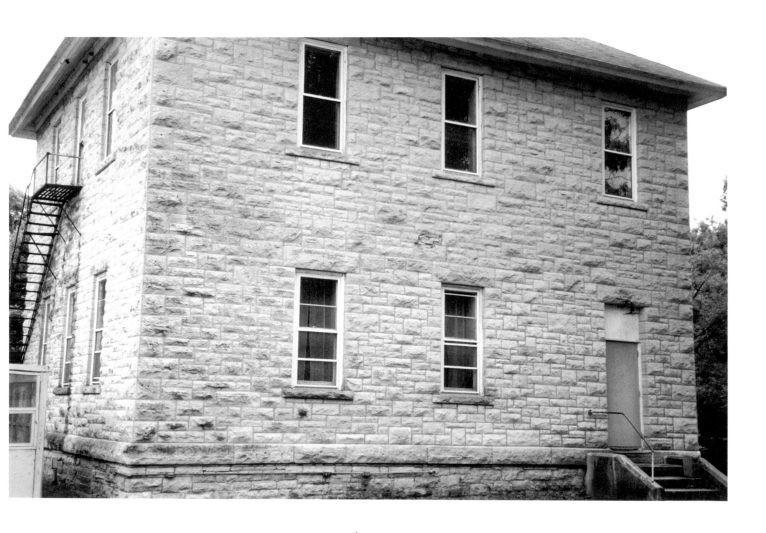

Stone City | Jones County

Stone City High School was closed in 1947.

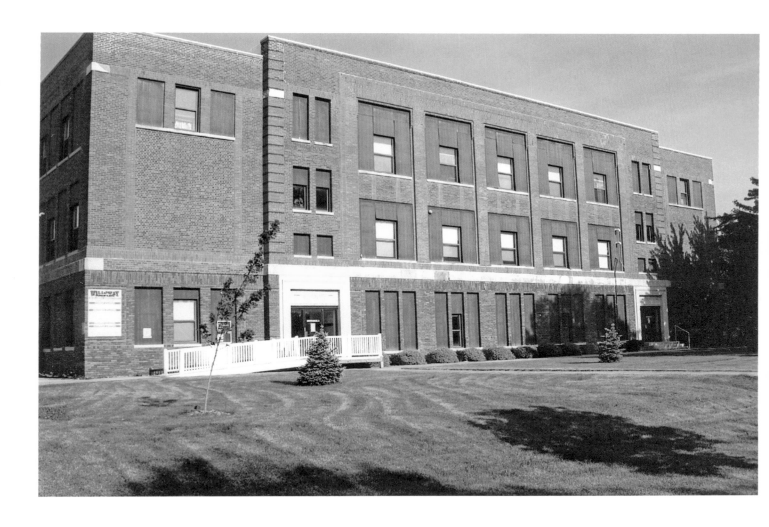

Sutherland | O'Brien County | Orange/Black | Tigers

State Football Class A Champions, 1983

Boys State Track and Field Runner-Up, 1983

Jim Ahrens, Basketball Hall of Fame, 1958

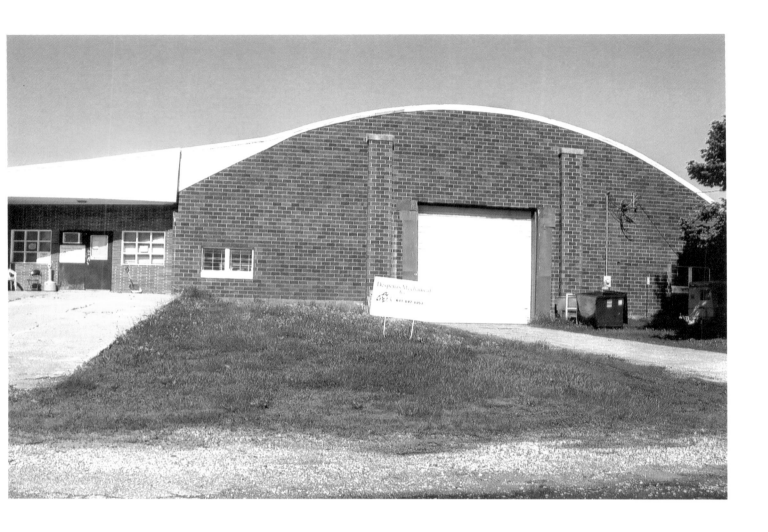

Swaledale | Cerro Gordo County | Red/White | Cardinals

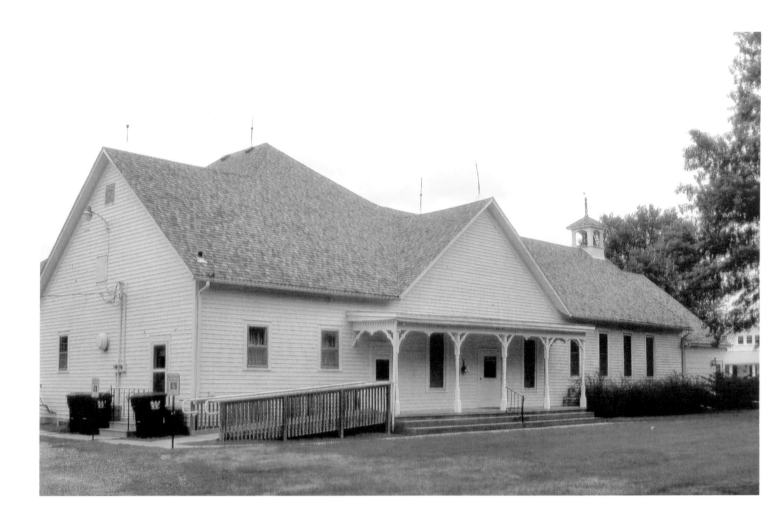

Swedesburg | Henry County

Swedesburg was an all-girls residential high school academy.
The school is now a parish hall.

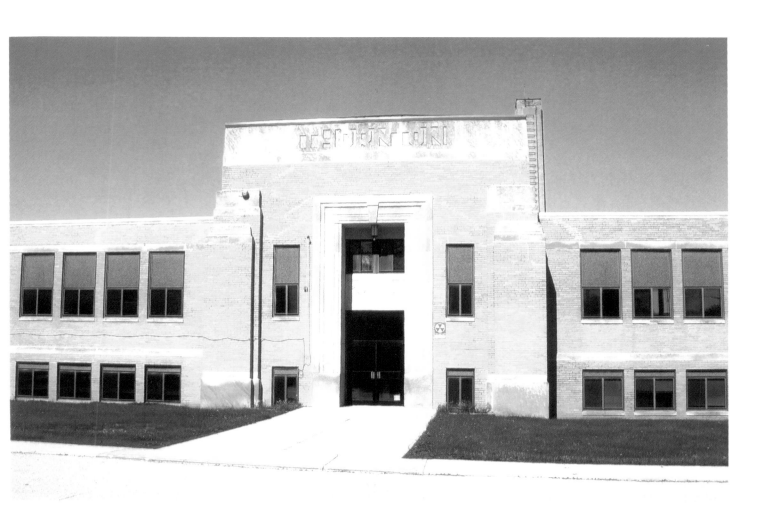

Thornton | Cerro Gordo County | Purple/Gold | Thunderbolts

Betty Floy, Softball Hall of Fame, 1959

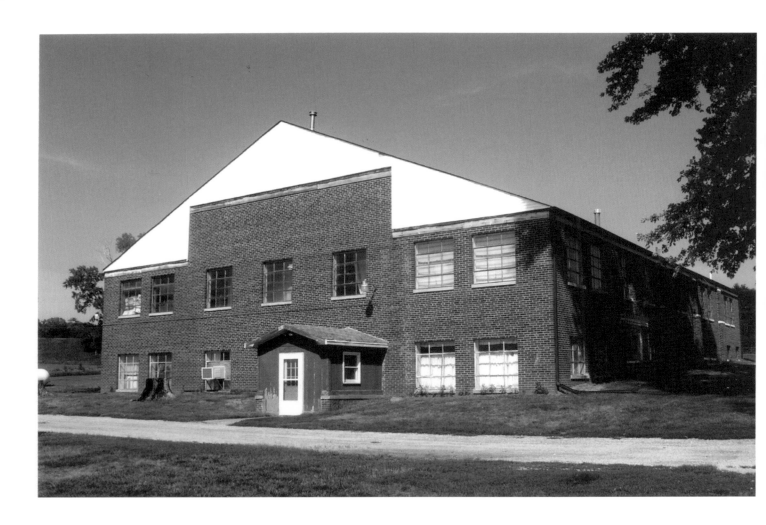

Thurman | Fremont County | Red/White | Cardinals

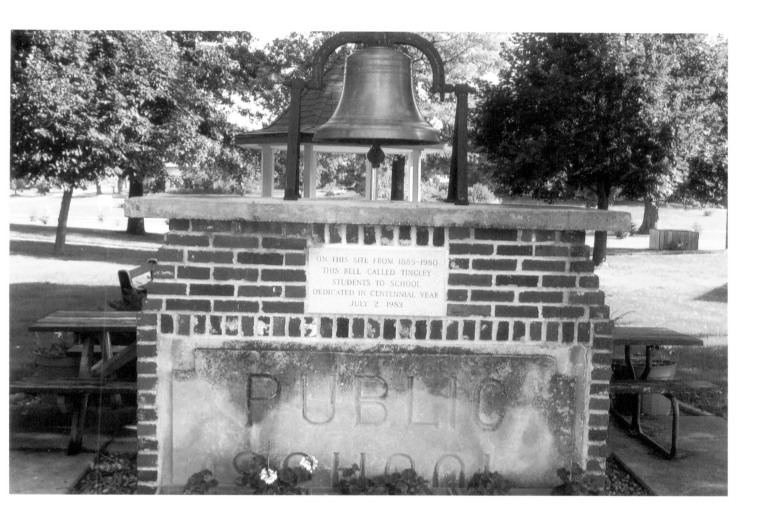

Tingley | Ringgold County | Orange/Black | Nomads/Toppers

Tingley is the home of College Football Hall of Fame coach Daniel McGugin.
He was head coach at Vanderbilt. McGugin's overall coaching record was 197-55.

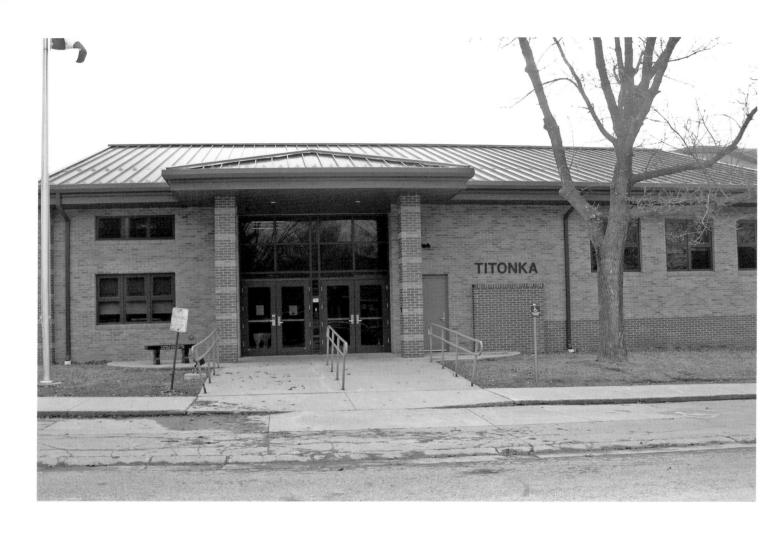

Titonka | Kossuth County | Red/White | Indians

Class C Boys State Track and Field Runner-Up, 1981

Class 1A Girls State Track and Field Champions, 1982

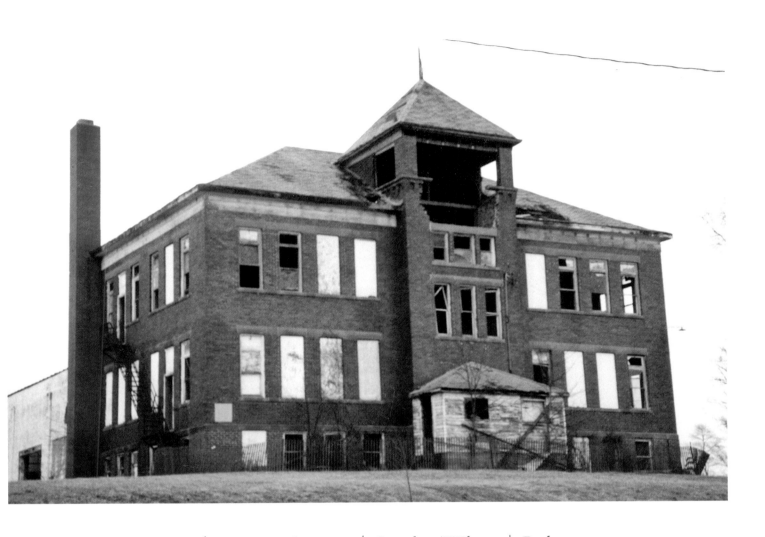

Tracy | Marion County | Scarlet/White | Bobcats

Class B Boys State Basketball Runner-Up, 1956

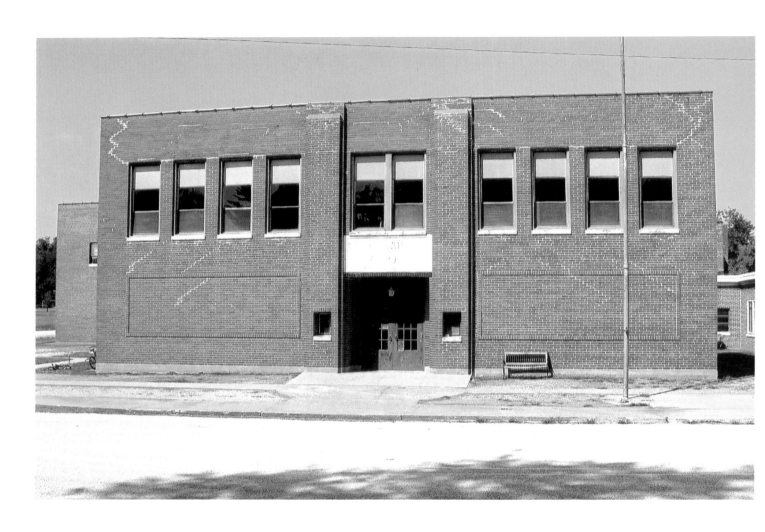

Troy Mills | Linn County | Blue/White | Trojans

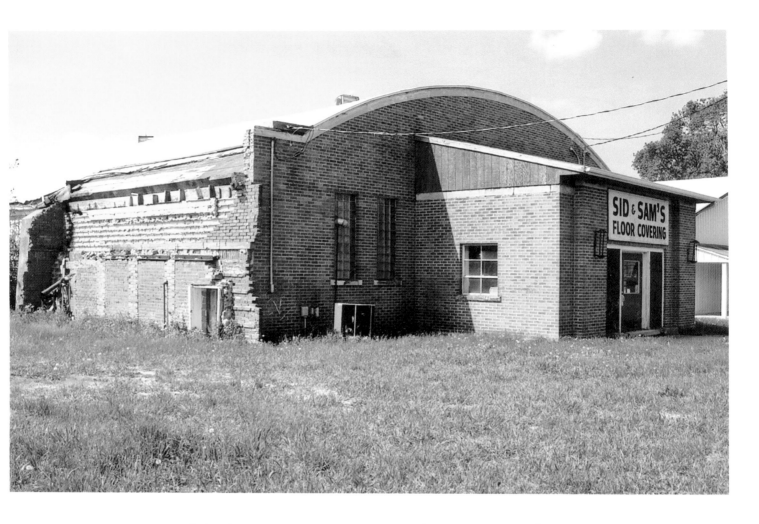

Truesdale | Buena Vista County | Red/Black | Tigers

The Truesdale gym held the first round of the Buena Vista County Boys Basketball Tournament in 1954.

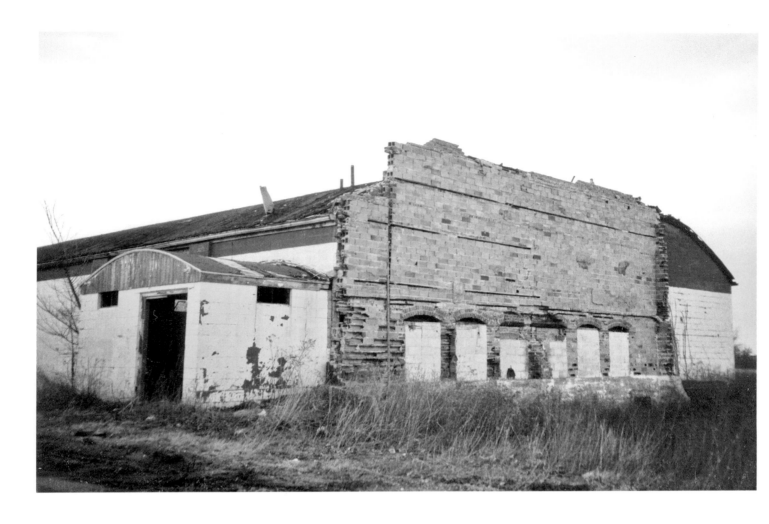

Van Wert | Decatur County | Red/White/Black | Wildcats

In 1922, the per-pupil cost in the Van Wert School District was $12.00.
Today, the per-pupil cost in all Iowa school districts is over $6,000.

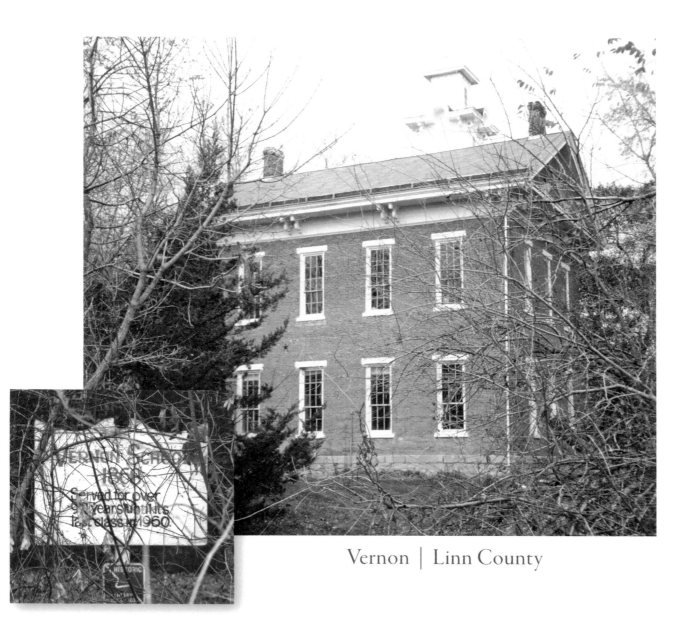

Vernon | Linn County

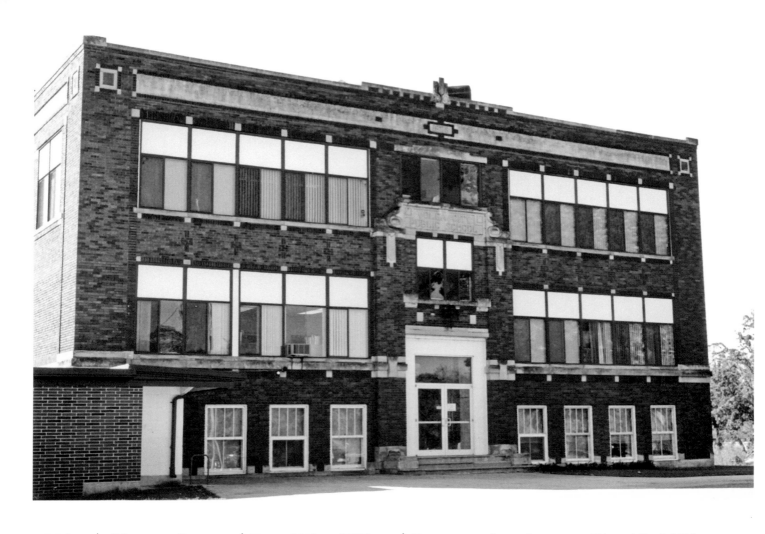

Volga | Clayton County | Royal Blue/White | Boatmen later became Blue/Gold Bluejays

The Boatmen mascot name may well have come from the Russian song "Volga Boatmen."

Learning Takes Fuel

Early school lunches and school lunch programs

Learning Takes Fuel

Early school lunches and school lunch programs

Students attending early schools brought their lunches from home in a lard pail or a burlap bag. This practice persisted for quite some time; however, parents often sought out other ways to ensure their children had nutritious meals. It was not unusual for parents to take turns providing a hot lunch for all students to supplement the lunches they brought from home.

Like so many changes in schools as the number of students increased, the way students were fed during the school day also evolved. Historically, the federal government's involvement in education has been limited, leaving the primary responsibility to the states. Prior to 1958 the federal government's involvement was mainly confined to vocational education, impact aid, and school lunches. These programs were primarily established because of national interest and to sell farm commodities, not to help children. During the Great Depression in the 1930s, federal involvement was heightened "to meet the needs of an impoverished nation."[xv] At that time the Federal Surplus Commodities Corporation was established to send surplus food to schools. In an attempt to stabilize prices, the government bought surplus crops, giving the food to schools and hiring unemployed women to cook meals for school children. ◆

Wadena | Fayette County | Purple/Gold | Wolverines

Walford | Benton County

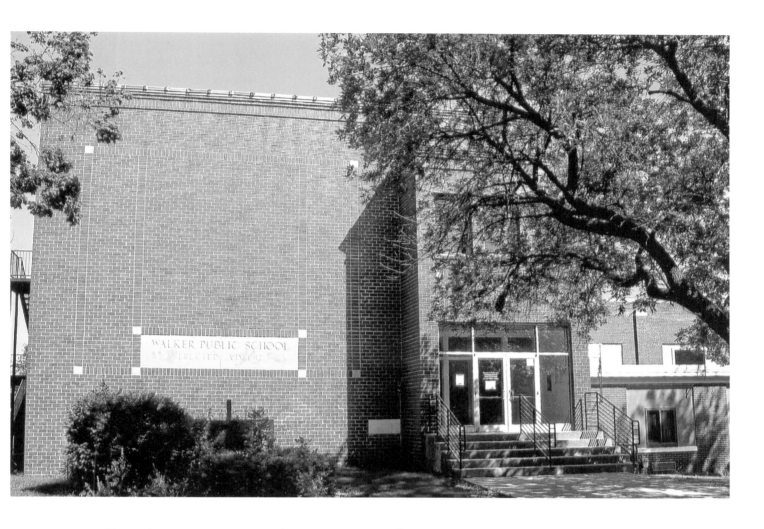

Walker | Linn County | Blue/Gold | Indians later became Warriors

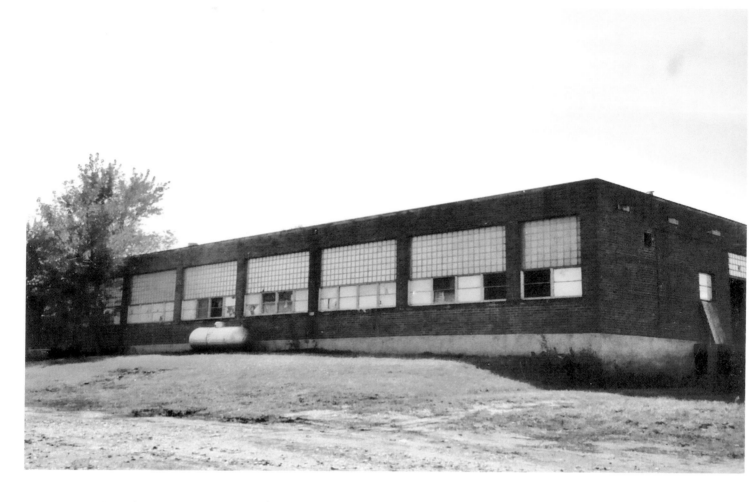

Webb | Clay County | Red/Black later became Orange/Black | Spiders

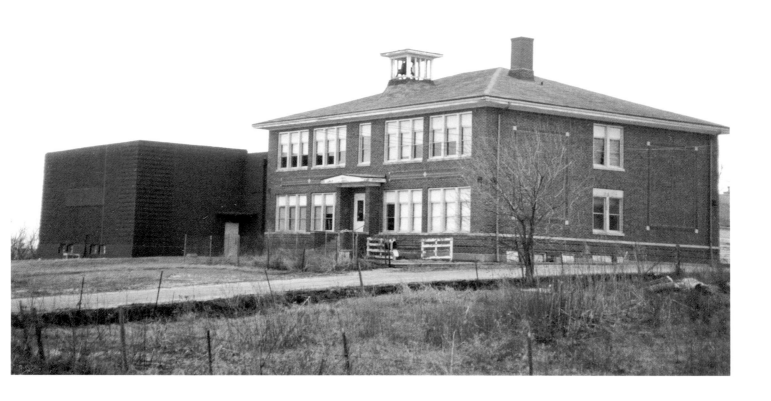

Weldon | Decatur County | Orange/Black

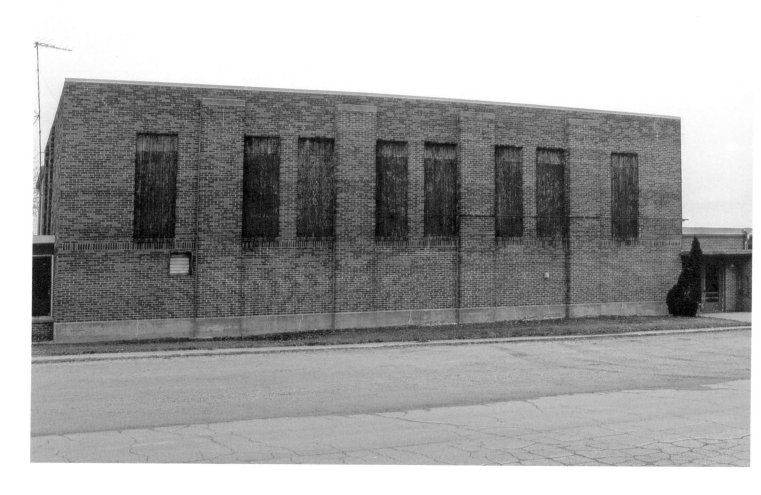

Wesley Gymnasium | Kossuth County | Red/White | Pirates

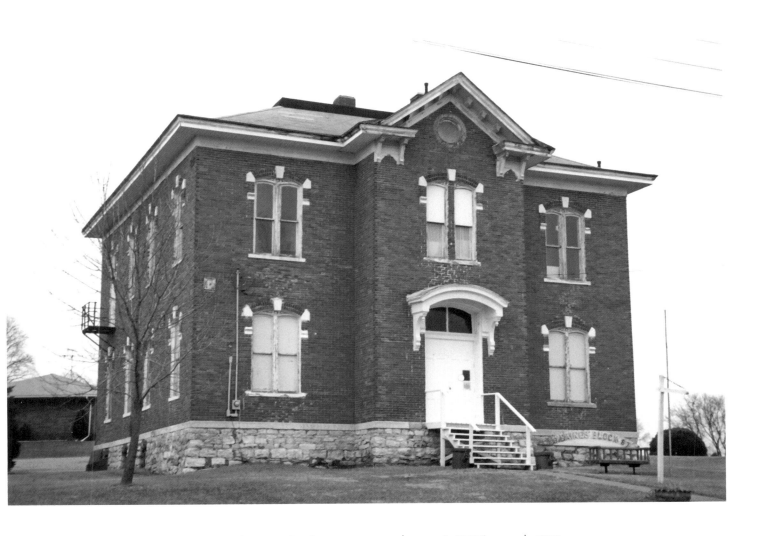

What Cheer | Keokuk County | Red/White | Warriors

Built in 1887, the brick school museum is open every Fourth of July.
What Cheer was the home of Ed Thomas, NFL High School Football Coach of the Year in 2005,
from Aplington-Parkersburg.

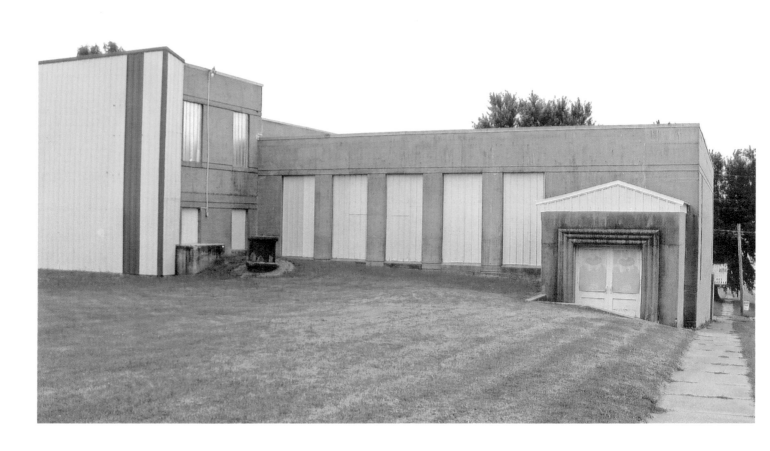

What Cheer Gym

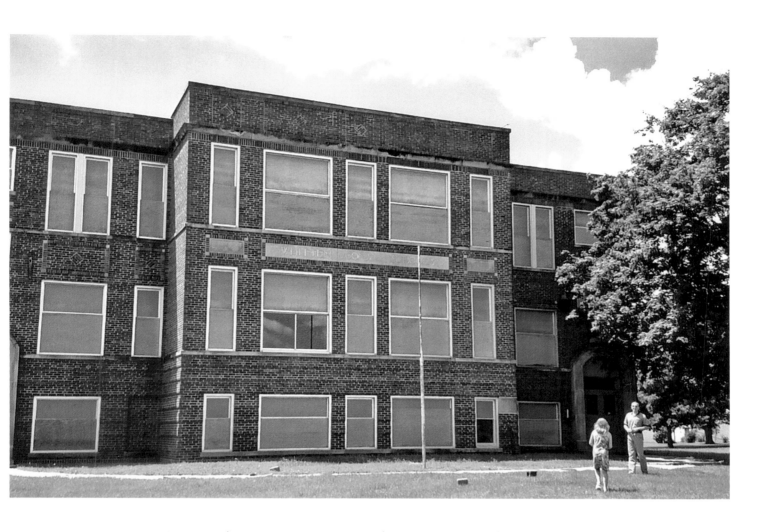

Whitten | Hardin County | Red/Black | Warhawks

Whitten was the birthplace of Denise Long, 1968-69 Girls State Basketball Hall of Famer.

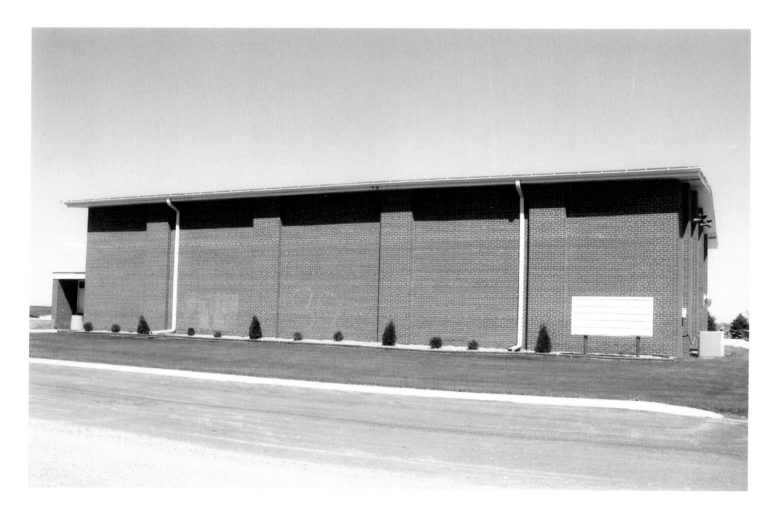

Williams | Hamilton County | Red/White | Red Birds (girls)/Cornhuskers (boys)

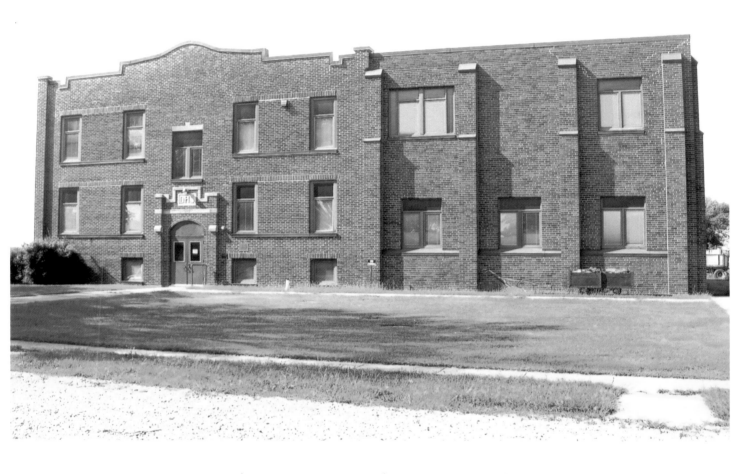

Williamson | Lucas County | Red/White | Red Devils

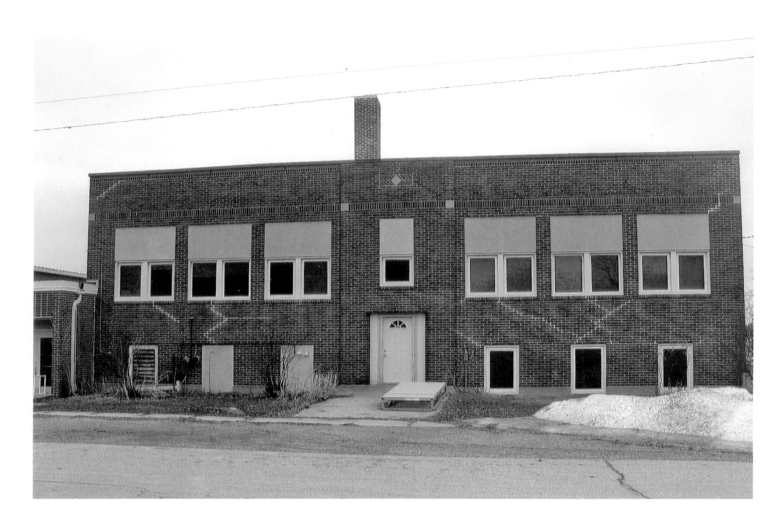

Woden | Hancock County | Blue/Red | Cardinals

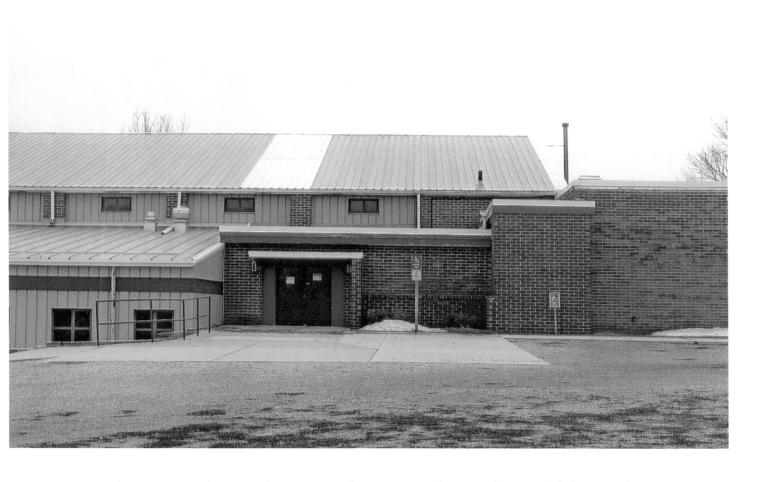

Woden-Crystal Lake | Hancock County | Purple/Gold | Panthers

Linda Albers, Softball Hall of Fame, 1963

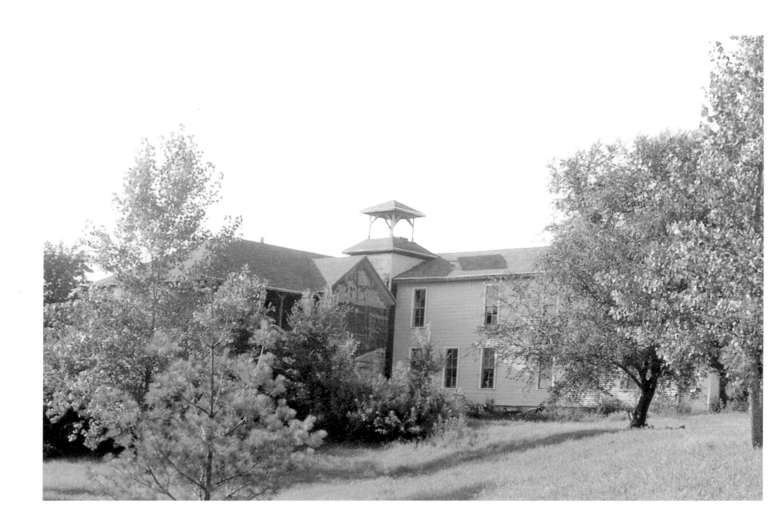

Woodburn | Clarke County | Red/White

Woodburn and St. Mary's scored 140 points in a boys basketball game, February 1, 1957.
It was the fourth most points in one game in Iowa high school history.

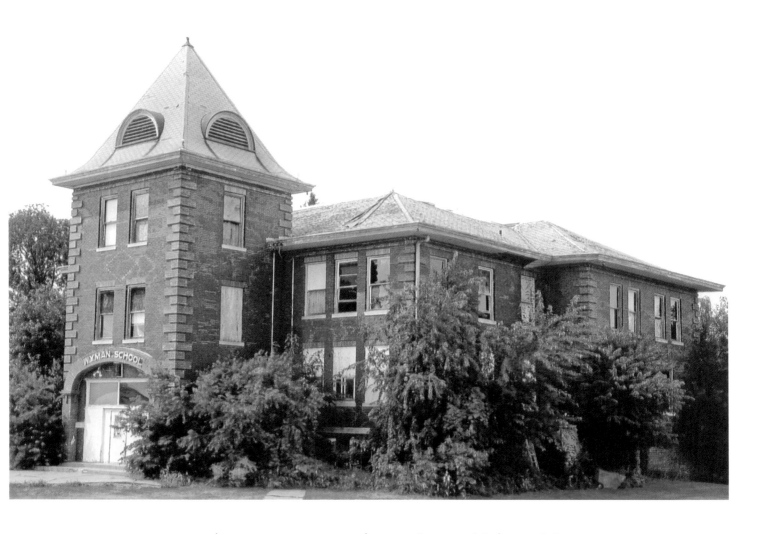

Wyman | Henry County | Purple/Gold | Welshmen

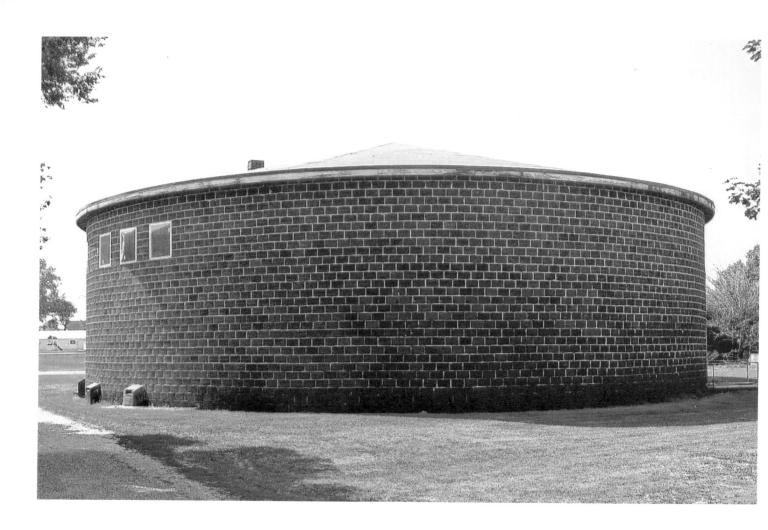

Yale Gym | Guthrie County | Blue/Gold | Bulldogs

Yarmouth | Des Moines County | Purple/Gold | Tigers

Conclusion

Our search for Iowa's old schools enabled us to travel roads never before taken, highlighting the beautiful scenery Iowa has to offer. We saw the real Iowa through our search for old and sometimes forgotten schools. Generous, kind, and helpful people were willing to give us directions or visit with us and answer questions about their town and their school. They are so proud of their school's history. We are aware that there may be schools that we missed, some closing as this book went to publication. If your high school is still standing and not pictured in *For All the Small Schools*, please forgive us for not making it to your town and showing your place in Iowa school history.

"After you graduate, it's not just your class you're going to miss, it's everybody that made your high school experience what it was. Happy times will come and go but the memories will last forever." - Anonymous

UNKNOWN SCHOOLS

In the course of our travels, we photographed several schools that we failed to identify. We've included them here in the hopes that readers of this book will recognize the schools and contact us at daveelse@cfu.net. Please reference the photo number below in your emails.

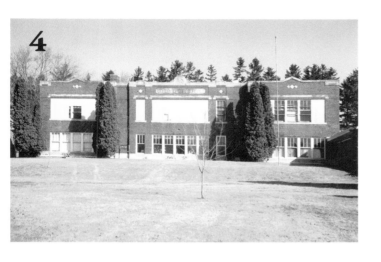

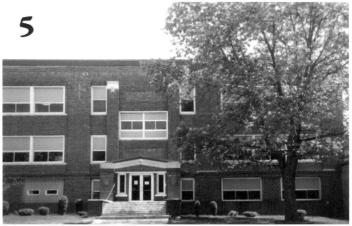

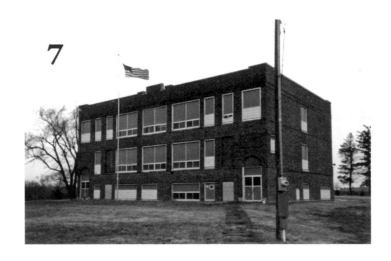

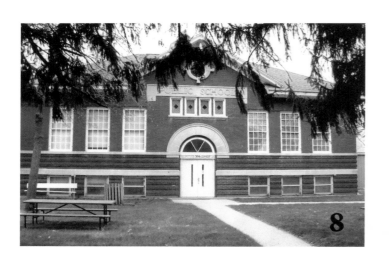

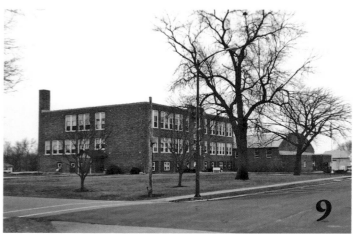

ACKNOWLEDGMENTS

In taking pictures, researching Iowa schools, and writing this book, there are numerous people who made contributions either by visiting with us, recounting stories, giving us directions, providing us access to their town museums, or answering our questions. There is no kindness that went unnoticed.

Bud Legg, longtime Iowa high school coach and Iowa High School Athletic Association historian, shared his unending knowledge of Iowa high schools. Over many years Bud has committed to identifying the school colors and mascot of every high school that ever existed in Iowa. He worked closely in this endeavor with Paul Juhl, a longtime Iowa educator who is now retired. We simply could not have completed this work without Bud's help.

Bernie Saggau, former Iowa High School Athletic Association executive director, Senator Charles Grassley, Chuck Offenburger, Bud Legg, and our son Jim Else were kind enough to read the manuscript before going to press.

Jan Stofferan, museum curator of McCallum Museum/Brunson Heritage House in Sibley, helped us in securing a picture of our high school in Sibley. Paul and Pam Bisgard and Eldon and JoAnn Peterson provided assistance and support throughout the project. Linda Else offered photography advice, Shannon Erb provided tech support to facilitate organization, and Amanda Kluesner assisted with research.

NOTES

[i] Schwaller, Karen. "Lake Center Consolidated School Remembered." *Sioux City Journal*. March 29, 2003.

[ii] *IHSAA Bulletin*. April 1928. Boone, Iowa.

[iii] Information provided by Bud Legg, Iowa High School Athletic Association.

[iv] Johnson, Everett D. *A Brief History of the Iowa High School Music Association*. Boone, Iowa: Iowa High School Music Association, 2002.

[v] Johnson.

[vi] Provided by Craig Ihnen, Iowa High School Speech Association.

[vii] Legg.

[viii] Boone, Bill. *The Evolution of Girls Basketball Uniforms and the Early Game*. September 27, 2011. girlsbasketballuniforms.blogspot.com.

[ix] *A Brief History of Football in Iowa High Schools*. Iowa High School Athletic Association Archives. http://www.iahsaa.org/football/ARCHIVES/FB.0.Timeline_overview.pdf.

[x] Morain, Tom. "One-Room Schools." *Iowa Pathways*. http://www.iptv.org/iowapathways/mypath.cfm?ounid=ob_000114.

[xi] Schwieder, Dorothy. *History of Iowa*. http://publications.iowa.gov/135/1/history/7-1.html.

[xii] Nielsen, Lynn. "The Development of High Schools in Iowa." *Iowa Pathways.* http://www.iptv.org/iowapathways/mypath.cfm?ounid=ob_000311.

[xiii] "One-Room Schoolteachers." *Iowa Pathways.* Adapted from the original article by Sherri Dagel, *The Goldfinch* 16, No. 1, Fall 1994. Iowa City: State Historical Society of Iowa. http://www.iptv.org/iowapathways/mypath.cfm?ounid=ob_000254.

[xiv] Mahannah, Fred L. *Supplement to School Laws of Iowa.* Des Moines, Iowa: State of Iowa, 1933.

[xv] Brimley, Vern and Rulon Garfield. *Financing Education in a Climate of Change.* Boston, MA: Pearson, 2008.

The Iowa Girls High School Athletic Union Archives, including Hall of Fame information, contributed significantly to the book. You can access the information at ighsau.org.

AUTHOR BIOGRAPHIES

Barb Else established and taught preschools in the Iowa communities of Greene, Holstein, and Atlantic. She also taught elementary school reading for twenty years in the Parkersburg and Aplington Parkersburg School Districts. After raising four children, she went back to school, graduating with a Bachelor of Arts degree from Buena Vista University. Barb received a master's degree in education from Vitterbo University in LaCrosse, Wisconsin. Her graduate study research was on the impact of parental reading with children.

Dave Else has been a middle school and high school teacher and coach, elementary school principal, and superintendent in Iowa school districts. He was director of the Price Laboratory School and the head of the Department of Teaching at the University of Northern Iowa from 1988-90. For the last 23 years he has been director of the Institute for Educational Leadership at the University of Northern Iowa and associate professor in the Department of Educational Leadership and Postsecondary Education. Dr. Else has a PhD in educational leadership from Iowa State University. He and Barb have been married for 50 years as of August 15, 2014.

CPSIA information can be obtained at www.ICGtesting.com
Printed in the USA
BVIW12n1457301115
428030BV00017B/30

* 9 7 8 0 9 9 1 6 5 2 8 1 5 *